DRAWING
FOR ART STUDENTS AND ILLUSTRATORS

BY
ALLEN W. SEABY
*UNIVERSITY COLLEGE,
READING.*

Copyright © 2013 Read Books Ltd.
This book is copyright and may not be
reproduced or copied in any way without
the express permission of the publisher in writing

British Library Cataloguing-in-Publication Data
A catalogue record for this book is available from the
British Library

Drawing and Illustration

Drawing is a form of visual art that can make use of any number of drawing instruments, including graphite pencils, pen and ink, inked brushes, wax colour pencils, crayons, charcoal, chalk, pastels and various kinds of erasers, markers, styluses, metals (such as silverpoint) and even electronic drawing. As a medium, it has been one of the most popular and fundamental means of public expression throughout human history – as one of the simplest and most efficient means of communicating visual ideas.

Drawing itself long predates other forms of human communication, with evidence for its existence preceding that of the written word – demonstrated in cave paintings of around 40,000 years ago. These drawings, known as pictograms, depicted objects and abstract concepts including animals, human hands and generalised patterns. Over time, these sketches and paintings were stylised and simplified, leading to the development of the written language as we know it today. This form of drawing can truly be considered art in its purest sense – the basic forms on which all others build.

Whilst the term 'to draw' derives from the Old English *dragan* (meaning 'to drag, draw or protract'), the word 'illustrate' derives from the Latin word *illustratio,* meaning 'enlighten' or 'irradiate'. This process of 'enlightenment' is central to drawing and illustration as we know it today. Medieval codices' illustrations were often called 'illuminations', designed to highlight and further explain

important aspects of biblical texts. This was the most general form of illustration; hand-created, individual and unique. This changed in the fifteenth century however, when books began to be illustrated with woodcuts – most notably in Germany, by Albrecht Dürer.

The first creative impulses of a painter or sculptor are commonly expressed in drawings, and architects and photographers are commonly trained to draw, if for no other reason than to train their perceptual skills and develop their creative potential. Initially, artists used and re-used wooden tablets for the production of their drawings, however following the widespread availability of paper in the fourteenth century, the use of drawing in the arts increased. During the Renaissance (a period of massive flourishing of human intellectual endeavours and creativity), drawings exhibiting realistic and representational qualities emerged. Notable draftsmen included Leonardo da Vinci, Michelangelo and Raphael. They were inspired by the concurrent developments in geometry and philosophy, exhibiting a true synthesis of these branches – a combination somewhat lost in the modern day.

Figure drawing became a recognised subsection of artistic drawing in this period, despite its long history stretching back to prehistoric descriptions. An anecdote by the Roman author and philosopher Pliny, describes how Zeuxis (a painter who flourished during the 5th century BCE) reviewed the young women of Agrigentum naked before selecting five whose features he would combine in order to paint an ideal image. The use of nude models in the medieval artist's workshop is further implied in the writings

of Cennino Cennini (an Italian painter), and a manuscript of Villard de Honnecourt confirms that sketching from life was an established practice by the thirteenth century. The Carracci, who opened their *Accademia degli Incamminati* (one of the first art academies in Italy) in Bologna in the 1580s, set the pattern for later art schools by making life drawing the central discipline. The course of training began with the copying of engravings, then proceeded to drawing from plaster casts, after which the students were trained in drawing from the live model.

The main processes for reproduction of drawings and illustrations in the sixteenth and seventeenth centuries were engraving and etching, and by the end of the eighteenth century, lithography (a method of printing originally based on the immiscibility of oil and water) allowed even better illustrations to be reproduced. In the later seventeenth and eighteenth centuries, the previous combination of the arts and sciences in drawing gave way to a more romantic and even classical style, epitomised by draftsmen such as Poussin, Rembrandt, Rubens, Tiepolo and Antoine Watteau. Mastery in drawing was considered a prerequisite to painting, and students in Jacques-Louis David's Studio (a famed eighteenth century French painter of the neo-classical style), were required to draw for six hours a day, from a model who remained in the same pose for an entire week!

During this period, an increasingly large gap started to emerge between 'fine artists' on the one hand, and 'draftsmen' / 'illustrators' on the other. This difference became further complicated with the 'Golden Age of Illustration'; a period customarily defined as lasting from the

latter quarter of the nineteenth century until just after the First World War. In this period of no more than fifty years the popularity, abundance and most importantly the unprecedented upsurge in quality of illustrated works marked an astounding change in the way that publishers, artists and the general public came to view artistic drawing. Arthur Rackham, Walter Crane, John Tenniel and William Blake are some of its most famous names. Until the latter part of the nineteenth century, the work of illustrators was largely proffered anonymously, and in England it was only after Thomas Bewick's pioneering technical advances in wood engraving that it became common to acknowledge the artistic and technical expertise of illustrators. Such draftsmen also frequently used their drawings in preparation for paintings, further obfuscating the distinction between drawing/painting, high/low art.

The artists involved in the Arts and Crafts Movement (with a strong emphasis on stylised drawing, and a powerful influence on the 'Golden Age of Illustration') also attempted to counter the ever intruding Industrial Revolution, by bringing the values of beautiful and inventive craftsmanship back into the sphere of everyday life. This helped to counter the main challenge which emerged around this time – photography. The invention of the first widely available form of photography (with flexible photographic film role marketed in 1885) led to a shift in the use of drawing in the arts. This new technology took over from drawing as a superior method of accurately representing the visual world, and many artists abandoned their painstaking drawing practices. As a result of these developments however, modernism in the arts emerged – encouraging 'imaginative

originality' in drawing and abstract formulations. Drawing was once again at the forefront of the arts.

There are many different categories of drawing, including figure drawing, cartooning, doodling and shading. There are also many drawing methods, such as line drawing, stippling, shading, hatching, crosshatching, creating textures and tracing – and the artist must be aware of complex problems such as form, proportion and perspective (portrayed in either linear methods, or depth through tone and texture). Today, there are also many computer-aided drawing tools, which are utilised in design, architecture, engineering, as well as the fine arts. It is often exploratory, with considerable emphasis on observation, problem-solving and composition, and as such, remains an unceasingly useful tool in the artists repertoire.

The processes of drawing is a fascinating artistic practice, enabling a beautiful array of effects and creative expression. As is evident from this short introduction, it also has an incredibly old history, moving from decorations on cave walls to the most advanced, realistic and imaginative drawings possible in the present day. It is hoped that the current reader enjoys this book on the subject.

PREFACE.

In the first place I must offer humble apologies to my students, past and present, whose failings I have so ruthlessly exploited for my own purpose. They will, I trust, pardon me for holding them up as horrid examples rather than shining lights.

Next I must tender my acknowledgments to my master and friend, Mr. F. Morley Fletcher, to whom I owe everything in art, and especially for his teaching, as I understand it, of the use of expressive line.

I have to thank Prof. Edith Morley for reading a very untidy manuscript, and Mr. C. C. Pearce, A.R.B.A., for suggestions. I must also thank Mr. A. S. Hartrick, R.W.S., for allowing me to reproduce two Paris life studies (FIGS. 16 and 25A), Mr. E. S. Lumsden, R.E., for several drawings (FIGS. 18, 28 and 44), Miss Dorothy Johnston (FIGS. 21 and 31A), Mr. C. C. Pearce (FIG. 12), Mr. H. Hampton (FIG. 43), Miss Agnes Forbes and other students for various drawings and sketches which are only intended to serve as indications of method.

My thanks are also due to the Hon John Fortescue, of the Royal Library, Windsor Castle, for permission to reproduce the Holbein drawings, to the British Museum authorities, and to Mr. W. B. Paterson, who obtained Mr. W. A. Coats' consent to use his Crawhall drawing.

The line blocks, as can be seen, are mere scribbled diagrams with no pretence to draughtsmanship.

Lastly, in a book planned as this is, there must necessarily be a certain amount of repetition. Perhaps this is not altogether bad for the student; as all teachers know, important matters need more than one telling.

<div style="text-align:right">A. W. SEABY.</div>

UNIVERSITY COLLEGE,
 READING.
April, 1921.

CONTENTS.

Chapter		Page
I.	INTRODUCTION	1
II.	THE BIAS OF VISION	7
III.	PROPORTION	13
IV.	TYPE FORMS	22
V.	CONSTRUCTION	30
VI.	TONE STUDY—PRELIMINARY	34
VII.	TONE STUDY—EXERCISES	38
VIII.	THE FIGURE—INTRODUCTORY	49
IX.	THE FIGURE—THE SEARCH FOR FORM	61
X.	THE FIGURE—TIME SKETCHING	73
XI.	RELATED FIGURES	80
XII.	EDGE STUDY	85
XIII.	ARTISTIC ANATOMY	94
XIV.	DRAWING ON TONED PAPER	101
XV.	EARLY AND MODERN REPRESENTATION OF FORM	103
XVI.	DRAWING FROM MEMORY	107
XVII.	ANIMALS.	118
XVIII.	LANDSCAPE	128
XIX.	PLANT FORM	133

XX.	DRAWING AS A PREPARATION FOR PAINTING	140
XXI.	CONVENTION	151
XXII.	DRAWING FOR ILLUSTRATORS	161
XXIII.	THE DRAWINGS OF THE MASTERS	166

CHAPTER I.
INTRODUCTION.

In these days, when daily prophecies are made concerning the art work required in the near future, in the shape of pattern and costume designing, poster and advertisement work, illustration, etc., when one sees in the press a great campaign of correspondence teaching with the promise of remunerative employment to every student who "completes the course," with the implication that no long training in art study is necessary, and that there *is* a royal road to art, it becomes necessary to insist upon the importance of draughtsmanship in the classical sense, as understood by Holbein, Velasquez, Ingres, Menzel, and Degas. This technical power or faculty, call it what we will, is not a conjuring trick, a mere sleight-of-hand to be learned as a series of "tips," but must be acquired, if at all, by severe training, and by intellectual visual effort. It must be searched for rather than picked up, and learned from one whom the student trusts, putting himself in his teacher's hands with confidence, not regarding him as one standing behind a counter ready for a fee to cut off a small snip of the fabric of art teaching, to show, say, how tricks with a water

colour brush are performed, or how to draw a pretty face. When the student has arrived at some measure of the knowledge of art, he will press into his service all the refinements of technique which he can acquire from any one who can teach him, but without that, he is the more a charlatan, the more dodges and manipulative processes he can command.

The following chapters, therefore, are concerned with drawing as a *study*, and an attempt is made in them to emphasize the importance of a student-like attitude of mind, and a wise docility in carrying out tasks not perhaps in themselves very interesting, but necessary if the draughtsman is to be well equipped. Nor should readers cavil at such a term as "tasks," for though the emotional side of art is now-a-days insisted upon, and rightly so, yet it is all the more necessary that the artist shall be absolutely the master of his instrument, if he is to possess the souls of his listeners. And if this striving and study is necessary in music, still more is it in pictorial art.

On the other hand the study of drawing cannot proceed without the active interest of the pupil. The notion still lingers that drawing is a discipline, that students should be made to do it because they do not like it. But when the eye loses its interest and pertinacity, a particular drawing is better laid aside, for further work will resolve itself into tinkering, embroidering or stippling, mere occupation without observation. If the study has been made on right lines, if placing, proportion, movement and construction have been grappled with, the drawing has earned its place in the

INTRODUCTION.

stairway of art study, for it has raised the student a step above his previous attempts. A real responsibility rests on the student, who should ascertain for himself how far he can take a drawing, though the art teacher can do much to help him by exhortation and even example. Many students are slow to recognise the necessity of testing their powers of observation and expression in any one drawing; some artists have only forced themselves to this long after their school days were over, as witness Degas, who shut himself up for two years while he searched his powers of observation to the utmost in producing his exquisitely finished pictures of Paris street life.

After some experience of teaching drawing it seems to the writer that certain essentials of study, not only perhaps in drawing, but in all art are :—(1) the development of the sense of proportion, and by this is meant more than getting one's measurements right, but a feeling for good proportions, such as is generally admitted was innate in the Italians to a higher degree than in the northern peoples, and the reason lies at hand, for the former never lost touch with the classic canons of proportion, while the architecture and sculpture, which formed their environment, showed them proportion embodied. (2) Hardly less important is the quality of sincerity, of being oneself, of not apeing another's style. Art Students, from their very temperament, are quickly impressed, not least by the work of the cleverer students. Later on they follow the manner of their master or of artists they admire. There is not much harm in this up to a certain point, and indeed art tradition has been built

up in some such way. On the other hand the student with character and individuality, while showing in his work admiration for others, will feel within himself a wish to follow his bent, to do things his own way. From this comes character, a quality in art work, which is spontaneous, and not to be striven for consciously.

As for "style," that comes only to a few, and an art teacher has to leave it out of his calculations, happy if years after, the work of a former pupil is seen to possess that elusive and rare quality. But one can show one's students to some extent what style means in drawing; the rhythmical line of Botticelli, Ingres and the Oriental masters, the veracity and clarity of Holbein, the structural drawing of Durer, to name only a few masters. Certainly every school should have reproductions of drawings by masters, early and modern, not in order to frighten students, or even that they should copy them, but to instil into their minds the qualities that the best drawings possess.

The student should study such reproductions, or better still, the actual drawings in the British Museum, at Oxford and elsewhere. He will see that each master has a rhythm peculiar to himself, not only a conscious rhythm, such as the marshalling of the masses as we see in Rembrandt's Hundred Guilder print, with their pyramidal or wave-like forms, all leading to the central group, or a similarly conscious effort to achieve a calligraphic flow of line as seen in the Chinese and Japanese masters; but a sub-conscious rhythmical stroke or accent, by which we know the artist as we might recognise him by his handwriting. The ample curves of

Rubens, the sweet flowing line of Guercino, the staccato rhythm of Fragonard, the square cut forms of Rembrandt, as seen in his brush drawings, are examples.

But this rhythmical movement of the hand cannot be taught, and the student should not consciously strive for it, or he may acquire not rhythm, but merely a mannered touch.

Composition has been dealt with incidentally, but this is a subject which demands full treatment, while the following chapters are concerned with how to draw. In practice, however, the two are interwoven, and as composition comprehends all the subjects of art study it stands easily first, and should be given a corresponding position in any art curriculum.

Too long has art teaching been concerned with mere imitation, whereas the first stroke on a sheet of paper involves attention to other things. It implies a choice, for it fixes the dimensions, determines the placing and the movement; in other words the first steps of a drawing have to do not so much with imitation as composition. It might be put this way, that the student who studies art mainly through composition and allied subjects will draw well enough, while the student who does nothing but copy may miss the very kernel of his art.

The opening sentences of this introduction show that the writer is on the side of those in authority who advocate sustained effort as against slick sketching. It happens that he has had to deal with art students from all parts of Britain, and from abroad, and of but few could it be said that they had been put upon the right road, that ideas of proportion, of construction, and of

movement had been steadfastly pressed upon them, and he has reluctantly come to the conclusion that the teaching of drawing is often wanting in clearness, that what may be called the rudiments—how to set about a drawing, how to carry out the successive stages, have not been inculcated. Too often the student shows by his muddling attempts that he has not been *taught* to draw, and this applies with equal force to the more brilliant students. This is a serious matter, and no number of gold medals for overworked, or, on the other hand, tricky drawings, will put the matter right. The kindness of heart which fears to criticize with faithfulness is cruelty in the end, for students are often so wrapped in their own manner of work and way of seeing that only the plainest speaking will shake them free.

Of course no teacher can command "good" drawing from his pupils, but their work shows clearly enough what sort of teaching they have received. Perhaps a great part of the truth lies in this, that the teacher may be thinking more of the drawing than of the pupil, more anxious for the successful completion of the work than that the student should proceed by logical and artistic steps. A study abandoned because of wrong method may lose a medal, but it may be for the student's welfare, for while a drawing may be tinkered into shape, may be "pulled out of the fire," yet during the process the student is learning to draw badly, to attach importance to dodges and contrivances for making a bad drawing appear better than it is.

CHAPTER II.

THE BIAS OF VISION.

For good or ill the invention of perspective gave an enormous impetus to art *study*, as distinct from practical apprenticeship in the studio or workshop. When the science is held to include reflections and the representation of shadows, it occupies the same field as that study we call Drawing. Photography, erroneous as is its perspective, judged by human eye standards, gave a fresh lease of life to the subject, or as the Post-Impressionists would put it, riveted the perspective fetters yet more firmly on pictorial art.

That is to say, the study of form in the Art School is necessarily based upon appearances, and at once the art student parts company with his brother in the street who has an absolute contempt for appearances in the sense in which the term is here used. In order to establish the relation between reality and experience gained by the eye one may observe as far as it be possible an infant's visual sensations. Shortly after birth it evidently notices a light as marked by the movement of the eyes and head. A little later it tries to reach brightly coloured objects presented to it (as the saying

is, it cries for the moon), and the observer will note how tentative and uncertain are its efforts, the difficulty it has in reaching with its hand the exact position of the object.

If with one eye closed small objects are picked up from the table, the adult will appreciate the infant's difficulty, for with this handicap it is not easy to estimate the exact distance the hand has to travel to grasp the object.

The child has perforce to continue its investigations. It hurts itself by knocking against objects, or falling over them, until by dint of practice and sad experience it has become at a quite early age what may be called "distance perfect." It has learned to look into space as compared with the artist's way of looking *at* space. This power of measuring distances is essential to the preservation of life, and the knowledge is being used throughout our waking moments. From the appearance of things the actual is reconstructed.

Hence a Philistine, sub-conscious contempt for appearances, for light and shade, change of colour caused by shadows or distance, and apparent changes of form owing to foreshortening. To the non-artist these are illusions, deceptions making the daily walk in life more difficult perhaps, but easily to be overcome by wariness, by the determination not to confound the "shadow" with the substance.

Hence the teacher finds that all beginners make their drawings, in a sense, too like the object; their ellipses are nearer the circle, and their horizontal surfaces wider, than the position of the object warrants.

Again, every art teacher knows that in a junior class

practising object drawing, there will be at least one case where the pupil has not drawn the appearance of the object as he sees it from where he is, but as it would appear if he were in another position. Sometimes two drawings of an object may be found almost identical in appearance, yet made by students several feet apart.

In this case the student, who has evidently expended some intellectual energy in thus projecting himself into an imaginary position, does so because he feels that the view he actually has would give but an imperfect idea of the shape and function of the object, and this gives the clue to so-called errors that we see in old work. The Egyptian symbol of a man shows the head in profile, the shoulders in front view and the legs again in profile. The Assyrian bas-relief makes the king twice the size of his attendants, while the mediaeval illustrator causes his hero to appear several times in the same picture among houses, trees, etc., rather less in height than himself. Children, for the same reason, depict a profile view of a face with a front view of the eye, and often add another eye, nose and mouth as well, or they depict both ends of a house in one drawing. In all these cases appearance is ignored. The delineator is obsessed by realities, and is occupied in presenting the largest possible content of the objects depicted.

Similarly, if an object with which a young pupil is familiar, such as a kitchen bellows, is laid upon the table as an exercise in the drawing lesson, the apparent change of shape due to foreshadowing is apt to be ignored, with the result that a view is given of the bellows in plan, with the side view tacked on as it were. The students see by

a kind of mental vision, the ground plans of objects as a bird's eye view, because that imaginary position enables them to visualize objects more easily. Such drawing cannot be called wrong; it merely denotes an early, and in these days of realism and photographic vision, an inconvenient convention. It is not a question of difficulty in the sense that the lines are intricate or hard to follow, for these may be of the easiest, but rather a misunderstanding between teacher and students, the former being concerned with the modern or sophisticated aspect of art, the latter still making use of traditional conventions.

And indeed the historic art periods of greatest charm came before perspective and light and shade had been treated scientifically. One might cite the splendidly alive and characteristic animals of the Egyptians, the Greek vase forms with their linear purity, the early work of the mediaeval illuminators, Chinese and Japanese drawing, and the detailed vision of the naturalistic painters of the quattrocento. In all these periods the vision was artistic, and triumphed over inconsistencies of representation as judged by later standards.

Consideration of this deference to the claims of reality enables the art teacher to appreciate the difficulties his students have in grappling with the figure. Beginners make the head too large for the body, the face too big for the skull; the hair like string or wire, pre-occupied as they are with realities, which cannot be compassed on a plane surface. Their vision may be said to be anthropomorphic, for they regard everything from the human standpoint. A house at the end of a long avenue of

trees, for instance, is likely to be drawn much larger than it appears, because it is the home of man, and as such is unconsciously emphasized.

In this connexion it may be noted that there are no such beings as pupils totally untrained in drawing, for all have been taught to draw in early childhood, but by means of a series of recipes or symbols. How to draw a man, horse, tree, etc., are questions freely asked by children with the expectation of an immediate ready-made answer. In later stages of drawing practice these old symbols or images re-appear, and hide or fog the object set before the students, who often draw, not what they see, but the object coloured or biassed by this sub-conscious image of long ago which, as it were, they behold with an inner eye simultaneously with their vision of what is before them.

This sub-conscious image plays strange pranks with the drawing. Sometimes the student substitutes his own features and physical proportions for those of the model, or may be the features of the previous sitter appear on the drawing.

Students' figure drawings often betray to an amusing extent the type they fancy in the opposite sex, while equally common is the inability to portray an alien racial type. The usual Italian model is transformed into a square-profiled Englishman. When one looks for it, "the English look" on students' drawings of foreign models is quite ludicrous. The physiognomy of even an allied race like the Dutch is absolutely differentiated from that of the English type.

Much concentrated observation and searching for the accents which make up this differentiation of race forms, are needed. The student has to teach himself to get, as it were, outside his own personality, in which a young person is often impregnably intrenched, and subordinate himself to his model. He has to set himself free from these sub-conscious, anthropomorphic fetters already alluded to. Perhaps the only way to achieve this is through sympathy with his subject. Too often students barely consider the model as a human being; they are quick to find some variation in the pose from what they saw before, and hasten to correct it, very much as they would alter a lay figure.

Apart then from dealing with faults of construction and proportion the teacher's chief difficulty is to get students outside themselves. The well-being of most young people, their exuberant vitality, their good spirits and freedom from care, make it difficult for them to visualize other than in terms of their own personality. In other words artists begin to see more truly as the illusions of youth pass from them; they at length see things as they are.

CHAPTER III.

PROPORTION.

To give the student some idea of the meaning of proportion should be the teacher's early aim, and it will entail endless teaching, for when proportion is felt, as well as measured, little more will be left to teach.

The teachers of the humanities claim that their studies give a sense of proportion in human affairs. The art teacher may also contend that the practice of drawing, rightly pursued, leads to the same end, that a child who has made a well proportioned drawing has begun to develop the sense of proportion, a step towards the building up of the good citizen, who looks at affairs with a steady eye. Exercises which otherwise might develop the sense of proportion are often smothered by rules. Students are coached assiduously in the number of times the head measures into the body, or in constructions involving middle lines, or in blocking out details in squares or triangles, while traces of the once elaborate scaffoldings of verticals and horizontals with which students used to commence a drawing may yet be found.

As Mr. Water Sickert once wrote, "There are too many props introduced to help the student, with the

result that the edge of observation is somewhat blunted."

The same may be said of perspective, the formal rules of which, hastily learned by rote, tend to atrophy the powers of observation. Students sometimes seem to think that so long as receding parallels are made to vanish *somewhere*, all is done that need be expected of them, with the result that on looking at the drawing we see it to be merely a travesty of the forms of what has been placed before the eye.

The writer once visited a school with some students training to become teachers, to watch the drawing lesson. Some children were drawing a box placed before the class, and at the close of the lesson the students were asked to pick out the best drawing. Papers were handed in showing some knowledge of perspective rules, and there was a chorus of dissent when the writer showed the drawing he had chosen, for not a single line was in correct perspective. But it had the right proportions, it *looked like* the box, whereas the other drawings were too long or too high.

Of course the student can always ascertain the proportions by measurement, but the appeal to be fruitful must be mainly to the eye. The living model, whether draped or nude, affords practice in proportion readily appreciated by students, for they know people best, and are familiar with their own build and proportions.

What are known as common objects do not, to the same extent, develop in the student this critical faculty. Most junior students calmly make extensive alterations in vases, etc., without any qualms of conscience, while, out of doors, such objects as trees make still less appeal

to the sense of proportion, for they are assumed by the beginner to have no contour or shape, and are accordingly hacked and chopped about to fit them within the limits of the paper.

With junior pupils drawing a middle line as a commencement causes misproportion, the drawing almost invariably being too wide.

Sometimes bad proportions result from the anthropomorphic bias. Young students generally draw the hands and feet too small, because small hands and feet are thought to be becoming. On the other hand they make the face too large for the head because it occupies a corresponding share of their attention.

But to a great extent this neglect of proportion arises from bad method, which goes along with confused vision. The drawing is often begun at the top and worked downwards, the student trusting to his luck to get the whole on the paper. Hence the legs get crowded into less than their share of the space, or the feet perhaps have to be omitted.

Too often the student proceeds in a random way which positively stultifies feeling for proportion. One often sees drawings slipping off the paper, as it were, or pushed to right or left, without artistic reason for so doing.

Right methods will do much towards securing proportion. No details should be drawn at first, but a line from head to foot establishing the whole form. Every figure, every object will furnish some such line. This line once found, the proportion of the parts can proceed steadily and safely.

The preparation of "blocking out" is often strangely misunderstood by the student, who produces a mere scribble of the figure, full of badly scrawled detail, features, fingers and toes dashed in anyhow, and criticism is countered by the casual remark that the drawing is "only sketched in." Such method, or want of it, is vicious in every way. Every line from first to last should be well considered, so that at any stage the drawing may be workmanlike, in good proportion, and expressive of the model, *so far* as it has been taken.

Bad proportion often results from looking *along* the contours rather than surveying, taking in the *mass* of the object. An early attempt should be made to see all the figure from head to foot.

One may put it in this way, that so long as beginners are pre-occupied with detail in contour, that is, with the forms, without making the necessary preparation of noting their *directions*, failure to secure good proportion is inevitable.

Obviously one corrective is to draw the *whole* figure every time. The art teacher is familiar with the lying excuse of the student who for want of room omits the legs, that he did not intend to draw them. Such scraps of figures defeat one of the great aims of the study.

The figure prepared or indicated, the student can then concentrate on a passage that appeals specially to him, but set out from head to foot it *must* be, if the exercise is to be of any value as a study in proportion, or of the action of the figure.

This method gives the clue to the treatment of the vexed question of erasure. One sometimes sees a student

rubbing out, or trying to do so, a large portion of a drawing at a comparatively late stage. Such alteration is mere vexation of spirit, and an acknowledgment of a bad beginning. With a studentlike and artistic commencement little or no erasure is necessary, for the proportions should be fixed by the first strokes planted upon the paper. This requires a certain firmness and patience on the part of the teacher, and a self-denial and inhibitive power not always readily at the command of the student, who comes to the study of the model with the notion that it is possible and commendable to transfer that figure bodily to the paper. For has he not seen this done in the work of the artists he most admires?

Generally the procedure is this. The beginner commences to draw the figure in a "blocking out" of his own fashion. Horrified at the starkness of his effort, he hurriedly covers over the first lines with detail, hoping thus to secure likeness, with the result that a figure appears represented by contour lines and looking boneless and sawdust stuffed. Hence the necessity of the student learning what is at first alien from his thought, (preoccupied as he is with realizing the object or figure before him), that there is a stage which comes before *drawing*, namely *preparation*, in which the placing on the paper, the proportions, and the directions of the forms have to be studied or analysed without reference to naturalistic treatment. It may be safely said that many students leave art study without having secured the discipline and training which rigorous search after a good preparation alone can give.

To some students it is an objection that these first

strokes get in the way of the drawing, have to be rubbed out, spoil the paper, etc. To this one may reply that neatness is but a minor virtue in drawing study. Cleanliness has been said to come next to godliness, but it certainly lags a long way behind.

As a matter of fact the first strokes disappear under the later work, and if rightly placed are astonishingly useful as part of the completed study. The form comes perhaps just outside or inside the first line. In the work of the genius (?) who draws his line and his detail all "at one go," the result is seen in knotty swollen contours, mere exaggerations of the form.

Students often use a sheet of paper upon which to rest their hands in order to avoid soiling their drawing. They thus compel themselves to draw piecemeal, stultifying their feeling for proportion, and losing the inestimable advantage of seeing the whole of their work all the time.

Many poses, especially where the figure is seated or reclining, suggest a simple pyramidal or triangular construction such as shown in FIG. 1. If the sides of the triangle are right in direction, which is easily ascertained by holding the pencil against the model and comparing with the lines on the paper, then the triangle is *similar* to that formed by the pose, and the proportions therefore are correct. This enables the student to proceed with the drawing without hesitation and embarrassment; the mind being at rest as regards the first lines undivided attention can be given to construction and artistic expression.

As far as possible drawings should be made sight

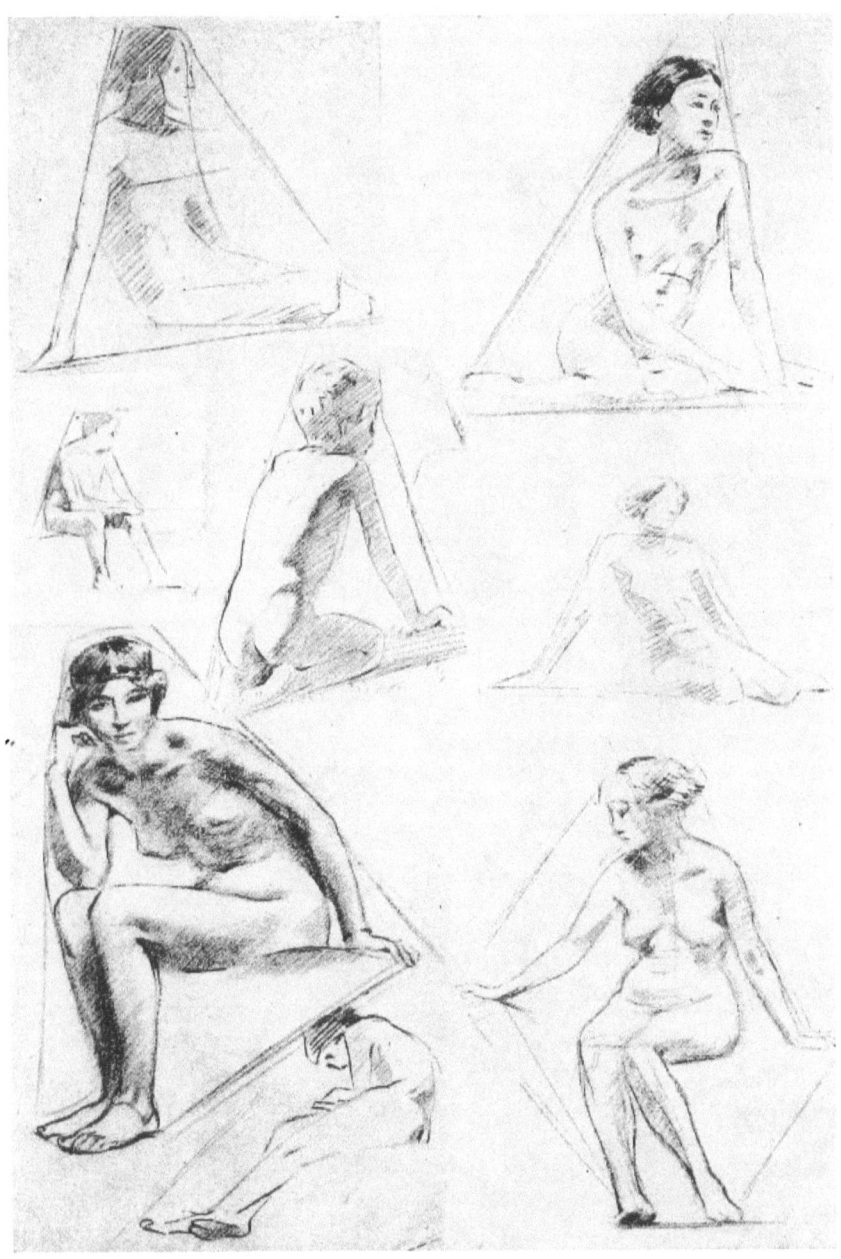

Fig. 1—Sketches of seated or reclining figures whose proportions are easily ascertained by assuming them contained in triangles.

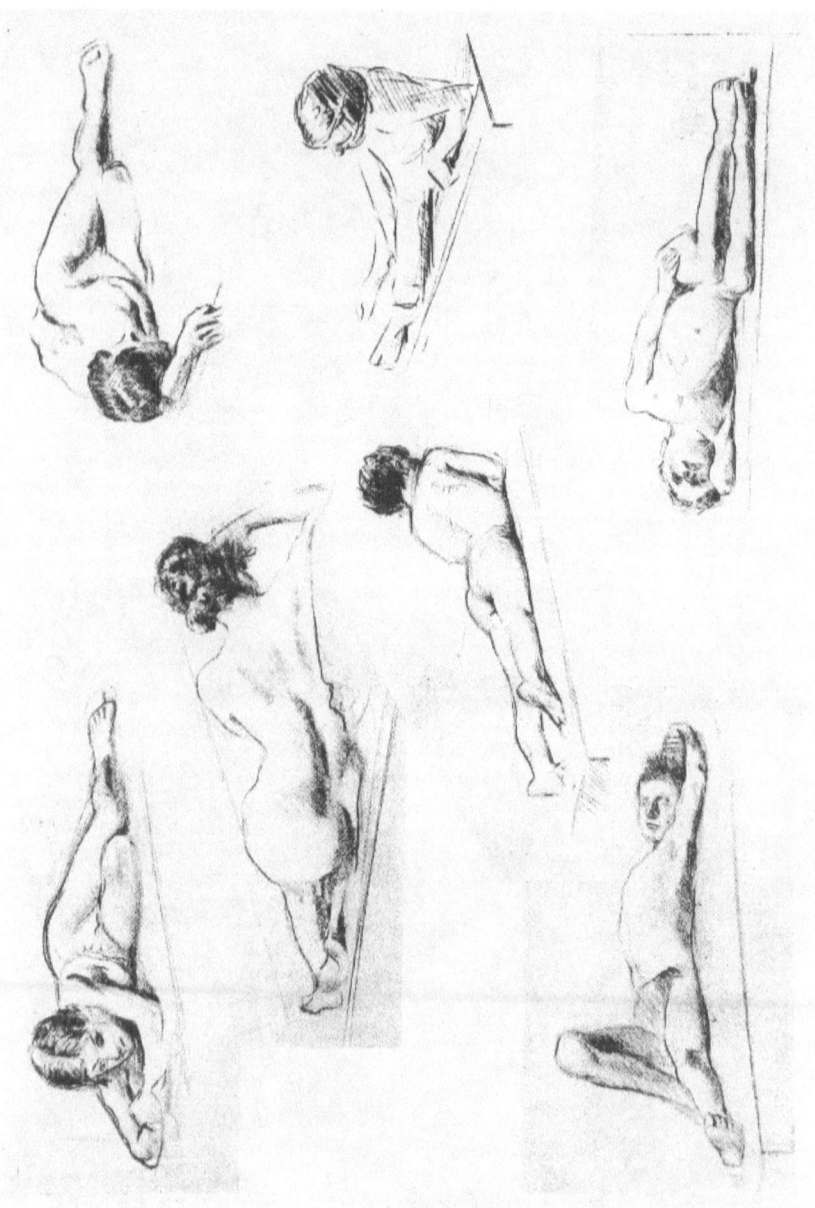

FIG. 2.—Sketches of recumbent figures which depend for their correct foreshortening on a horizontal receding line, which is present in the edge of the bench.

size, that is the size of a tracing on a pane of glass held before the model. Faults in proportion often occur in drawings *commenced* somewhat larger than sight size, for as the student works, he forgets the scale with which he started, with the result that the proportions of his extremities and details tend towards sight size, that is too small for the general proportions of the drawing.

CHAPTER IV.

TYPE FORMS.

YOUNG students, promoted to the antique or life class, are apt to shake hands with themselves on their emancipation from the thraldom of perspective and model drawing. No more cubes and cylinders, say they in effect; we shall now feast our eyes on sinuous form and subtle modelling.

They have, however, to learn that the principles of appearance are invariable, and apply equally to the representation of living form and inanimate objects.

For example, every time the face is drawn, unless its relation with the eye level be appreciated, the student is certain to have trouble. If the model's head is on a level with the student's, the drawing may pass muster, even if no attention has been paid to perspective, but if the eye be below or above, then the law of receding parallels must be observed if the features are to be intelligently represented.

Again, beginners often fail to observe the planes of the head. Especially is this so in regard to the three planes of the front and side views, with the result that the students are unable properly to place the ear, which

TYPE FORMS.

persists in coming forward in a distressing way. (FIG. 3).

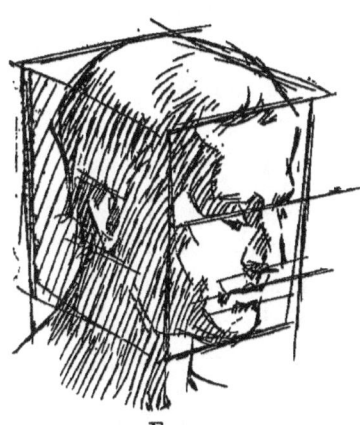

FIG. 3.

All forms, omitting the sphere, may be derived from two type forms, the square prism and cylinder. Of course by multiplying the faces of the prism one arrives eventually at the cylinder, but it will be convenient to keep them separate because each represents a different method of construction. The cone and pyramid may be ignored because as shown in FIG. 4 they are derived from the cylinder and square prism respectively.

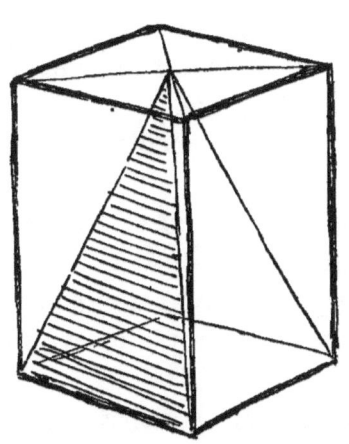 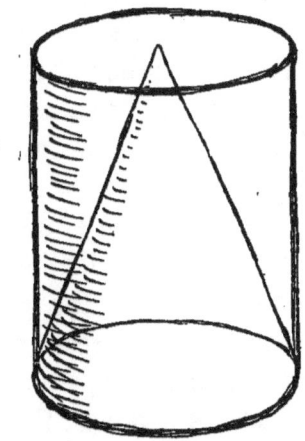

FIG. 4.

The representation in perspective of objects based upon the square prism, depends upon the apparent convergence of parallels, which is another way of saying

that things appear smaller as they are removed from the eye.

But the cylinder, though for the purposes of formal perspective considered as embedded within a square prism, and involving a somewhat intricate construction for obtaining the curve of the circle in perspective, as regards its circular end, needs not the aid of receding parallels, because when foreshortened, the circle appears as an ellipse, which should be drawn as such without any construction other than determining the direction of its long axis (always at right angles with the axis of the cylinder).

Most natural organic forms are based on the cylinder as the trunk and limbs of animals, including human beings, (though for purposes of representation these are better considered as based on the square prism), and most stems of plants and trees. Of fashioned objects, all pottery and other objects of wood or metal produced by some form of turning or lathe work, are based on the cylinder, as also tinware bent or beaten around cylindrical moulds.

Based on the square prism are framed structures as furniture and buildings, which man finds it convenient to construct with the right-angle. In the same category are building materials as bricks, cement and wrought stone, also boxes, books, etc.

Fig. 5 shows the principle of constructing the cylinder which should be followed, no matter what may be the position. It is true that some students, remembering their lessons in formal perspective, laboriously construct a prism first, but this is dreadful slavery and

TYPE FORMS.

unnecessary, since the two straight lines forming the sides, and the two ellipses stare one in the face. Some students construct the ellipse on its long and short diameters, but these aids ruin the feeling for the curve. Sometimes the ends appear pointed owing to the fact that arcs of circles have been drawn. As a matter of fact no progress in object drawing is possible until the

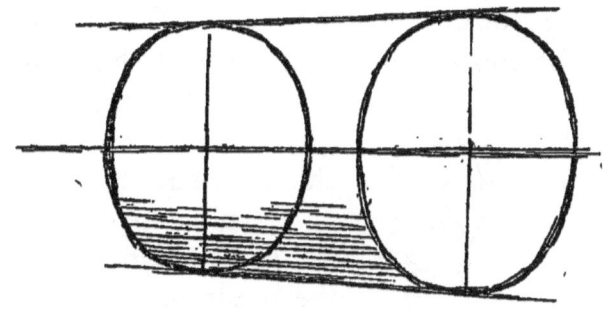

FIG. 5.

straight line and ellipse can be drawn freely in any position with a single movement of the hand and arm. If the student lacks this facility five minutes practice at a blackboard every day for a week at squares, circles and ellipses will set him free of these forms for life. One may observe that beginners are apt to draw the lower half of the horizontal ellipse flatter than the upper—to notice the defect is to cure it.

To the student who is content to subordinate himself to authority—and all really great artists have done this in their student days,—this constant reference to the type forms is no trammel, but a help, supplying him at once with a standard of form and a method of drawing. The head has been referred to as an approximation to

the prism. The wrist is another detail of the figure which gives trouble to students. The teacher has constantly to point out the way the wrist forms a link between hand and arm, how it modifies the contour of the arm, and the distressing effect caused by the failure of the student to *see* the wrist.

The male wrist may be compared in shape and size with a large box of matches, and this prism coming between the more cylindrical form of the forearm and the flattened form of the hand, gives this part of the arm its characteristic shape. (FIG. 6).

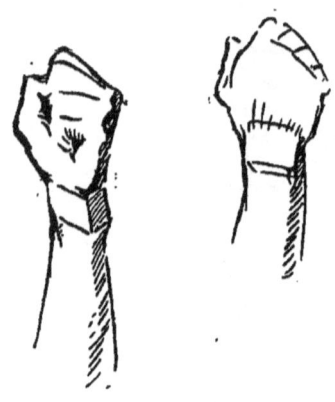

FIG. 6.

Coming to the figure as a whole, the student must relate the great planes of the body with the faces of the prism, or fall under the penalty of failing to secure vigorous modelling.

The straight edge of the prism representing the head is replaced by the undulating line of forehead, cheek-bone, cheek and jaw, where it turns from the light (FIG. 3), and this line marks the intersection of front and side of head, two planes which present great difficulties to beginners obsessed as they are by the features. It should be borne in mind that the edge in question *is a contour* when seen from another point of view, and that it must relate with the contour of the further side of the head. All this applies with equal force to the trunk

TYPE FORMS.

and limbs. The squareness of the trunk especially should be seized upon, otherwise a woolly unstructural roundness is apt to result. This intersection of the front and sides of the torse is very complicated and broken, but must be watched for. (FIG. 22).

This principle of the great planes is shown very clearly in the statues of the Egyptians. Often the limbs are absorbed so that the finished figure remains as a block. The reason, of course, lay in the material, the hardness of which prevented the sculptor from indulging in undercutting and over-modelling. (FIG. 7).

Ruskin, whose practical art teaching is always worth consideration, gave close attention to type forms. His remarks in "Modern Painters" on the construction of trees, etc., should be read carefully. His analyses of cloud forms is also very interesting and useful.

All cloud systems should be considered as horizontal. The vanishing line presents some difficulty, as owing to the earth's rotundity, the cloud horizon line is a little lower than that of the earth, but the point is not of much importance. A

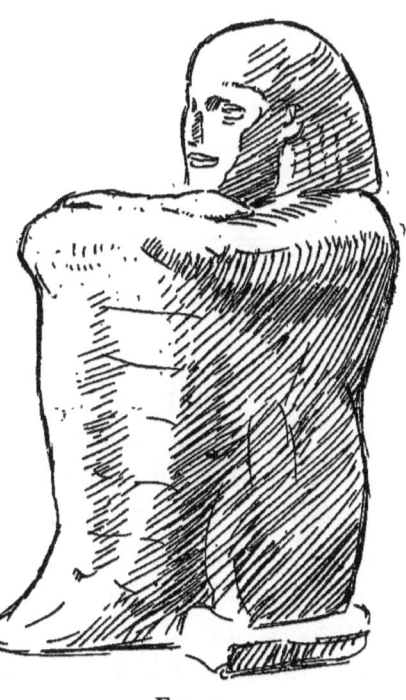

FIG. 7.

good exercise is a sky full of cumulus clouds, which may be likened to a number of match boxes held at a level above the eye. (FIG. 8).

The landscape painter, Boudin, should be studied for his simple systems of clouds in which the horizontality is carefully observed. An example of his work is to be seen in the National Gallery.

FIG. 8.

When clouds are approaching the eye or receding directly from it, the appearance is sometimes that of a "vertical" sky, but even in this case every effort should be made to determine the horizontal surfaces, without which the effect of distance cannot be secured.

Students often lose their grip of type forms when drawing from a pose more or less recumbent. The bench upon which the figure is lying will, if carefully observed, supply the general directions of the latter. (FIG. 2). Neglect of these simple lines accounts for

TYPE FORMS.

many failures to secure correct fore-shortening. The same may be said of quadrupeds, as dogs and horses, drawings of which often look vague and unstable

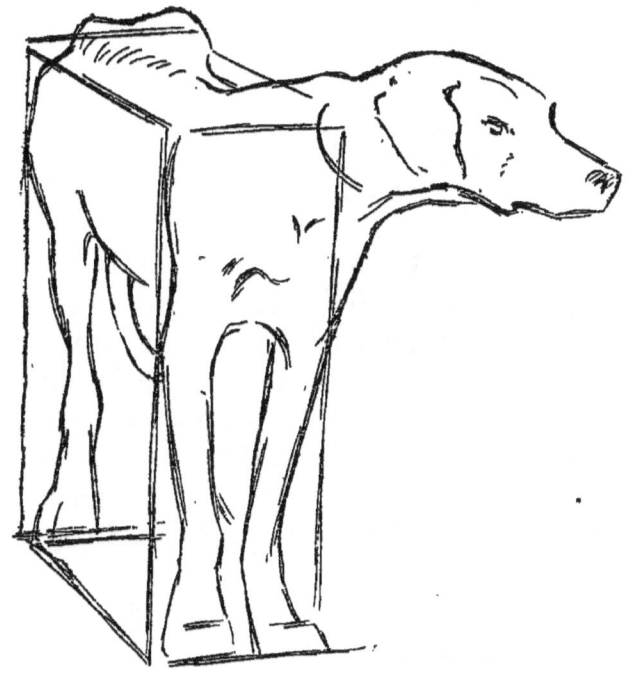

FIG. 9.

because their relation with the type prism is not sufficiently appreciated. (FIG. 9). A well-known advertisement depicts in an alpine landscape a cow much too long for its height, because the prism which forms its underlying shape has not been properly foreshortened.

CHAPTER V.
CONSTRUCTION.

No word is on the art teacher's lips more constantly than "construction." Therefore, as with other technical terms, it is most necessary that the student shall understand the word in the sense that the teacher uses it. All specialists are apt to utter a jargon, when they imagine themselves to be talking with the utmost simplicity, and only by constant questioning and discussion can teachers be sure that they and their students are in agreement as to the meaning of the terms used.

This word "construction" has two distinct meanings, both used indiscriminately by artists. First "construction" may mean the actual build of the object. To take a tin pail as example we may note that it is made from a sheet of metal bent into a cone, the two edges being lapped and soldered, that a flat strip is bent into a cylinder, lapped and riveted to form a base, and that the handle is semi-circular in form, composed of a strip bent on itself to give rigidity. One might continue in detail until the entire construction has been investigated.

The second use of the word refers to the *construction of the drawing*, an entirely different thing. When one

speaks of a drawing being well-constructed, one means that it is built up of lines and tones which suggest the actual construction of the object depicted.

Nothing is more difficult to the beginner than the advice to *construct* the drawing. He sees the model in all its complexity before him, and with a preconceived notion that drawing is *imitation*, cannot abstract his gaze from the details in order to search for the long enclosing lines of the figure, and those which indicate its build.

A great deal will have been learned if the beginner has been already taught to set up work in clay. In a way, the modeller is obliged to "construct" his study, for he cannot at once arrive at a contour. He has to build his model up in simple planes before he can think of the surface modelling, though even here teachers of modelling speak with sorrow of the way students evade the problems of constructive modelling, and the haste with which they attempt the more superficial qualities before their study has been carefully set up with the great planes. On paper it is fatally easy to begin with surface markings before setting down the main lines of construction. There are two classes of students inclined to ignore construction—first the beginners who can see nature only as a mass of detail, and secondly those students, clever with their fingers, who fancy they can draw well enough without the trouble of "blocking out," and who arrive at a result, by means of their facility, which they think justifies them in ignoring construction. To the latter class of students one may say that a judge of drawing can tell unerringly how it was produced, and can see, through the facile execu-

tion, the weaknesses owing to lack of construction. Further, the greater an artist, the more likely is he thoroughly to construct his drawing.

Constructive drawing really means concentrated intellectual vision in the early stages, and presents this difficulty, that it is precisely at this time that students, owing to want of training, are looking at the model with embarrassment and uncertainty, which result in slurred and fumbling drawing. Many students, indeed, begin to draw after a cursory glance. The model should be well scrutinized for some little time before drawing is commenced. *It is during the first few minutes that the drawing is made or marred. Further work adds detail, but substantially the drawing remains the same.* This is perhaps the most important caution that can be written about drawing. As already mentioned, what generally happens is that students begin to sketch out the pose and proportions of the model in a more or less haphazard way, and being stricken with horror at its aspect, add detail after detail in the hope of making it "more like."

To some extent the preliminary construction of a drawing has been dealt with under the head of type forms. The essential lines are those which give at once the movement and the mass: these are not necessarily based on actual outlines. A standing pose is best commenced with a line from the pit of the neck to the heel of the foot supporting the weight. Shoulders are often drawn as two isolated forms, the result of aimless wandering round the contours, giving the impression of a boneless figure, a rag doll stuffed with sawdust. Attention to the lines of the collar bones, sternum, arch

CONSTRUCTION.

of ribs and pelvis will correct this as regards the torse. The legs are especially prone to look like Christmas stockings, because the inner lines of structure have been omitted. The bulk of the knee, the line of the tibia (in the front view), the lines defining the ankle, and suggesting the stirrup-like movement of the foot within the ankle, and the backward swing of the heel are important. Especially should be noted a forward direction in the side view of the leg above the ankle, due to the tendon of the tibialis anticus. This escapes many students, with the result that the leg takes on a lumpy, Indian club-like look. This change of direction, though slight in the leg, is to be seen clearly in the forearm, where the thumb muscles crop up varying the contours in harmony with that from elbow to wrist. It should be noted that the angle forming the crook of the arm is considerably above the elbow, owing to the position of the supinators. In the knee joint the hamstring tendons cause the angle at the back to come lower than that in front. In both cases students often show great perseverance in trying to place these angles at the same level with distressing results. It should be added in regard to these torsions and variations that at almost any point a hollow is balanced by a swelling on the opposite contour. Examples of the above constructional points may be observed in the figure drawings reproduced in these pages.

The student who wishes to progress should constantly submit his drawing to those more advanced for detailed criticism of his construction.

CHAPTER VI.
TONE STUDY—PRELIMINARY.

Young students, especially if they have been kept at outline work, consider it a great privilege to be allowed to "shade," and the unfortunate distinction they draw between "drawing" and "shading" is responsible for their oftentimes slow progress in the study of form.

First the terms used must be explained and adhered to. Here, as in ordinary speech, the "shadow" is cast by the object on a surface, while the "shade" on the object is divided from the light portion by the "line of shade."

It should be noted that if the object rests on the ground the line of shade is continuous with the shadow edge and encloses a space of dark. (FIG. 14). This is often ignored by beginners, who divide the area into two portions, shade and shadow, which to their sharp sighted eyes is clearly separated by the reflected light on the edge of the rounded object. Thus students under the influence of that anthropomorphic bias already mentioned, will draw the shade area of a limb yet leave its cast shadow adjoining, to be completed later because they deem a shadow to be negligible compared with an object.

TONE STUDY—PRELIMINARY.

The line of shade is of great importance because it represents a contour seen from the direction of the light. It may be grey and indefinite when the light-area is extensive, as a large window admitting daylight, or sharp and dark when the luminant is a point of artificial light, but it is always present. Students sometimes shade as if the dark gradually merged into the light. This is a convention which is not supported by observation, and should be discouraged.

A certain amount of light is reflected to the object from the floor, walls, etc. This is not traceable on the side towards the light, but may be observed in the shade area, especially a contour in shade. It follows that the shade area appears darkest as it approaches the light area, that is to say near the edge of shade. The rule as stated in art school diction is that "the darkest dark is near the lightest light." This is clearly seen in small isolated darks.

The forms within a shade area often present great difficulties to beginners, who see them necessarily by reflected light. They outline these forms with black, or darken unduly the concavities, and are distressed to find that these lines and darks persist in coming forward, and ruin the unity of the shade area. To remedy this they should note an interesting contrast between the conditions of the expression of forms in (1) areas in light and (2) areas in shade.

First, the surface forms *in the light are expressed by darks*, excepting, of course, the high lights. The eyelids are defined by darks below the brows, the nose and lips by darks, and the ear by lines and patches of dark.

In the shade areas, however, forms are expressed by reflections or lights. If this region is indicated by a general tone, the forms within need little more attention than the careful working of the reflected lights. Of course, an actual cavity receiving no reflected light, such as the nostril or ear orifice, may have to be darkened, but otherwise the principle holds good.

Between the two areas there is another important difference. According to the intensity of light the forms in the light areas are well defined, and show clearly. In the shade area forms are ill-defined, edges are soft, somewhat as we notice shapes in twilight when men look "like trees walking." All painters from Rubens onwards have been well aware of this. Rubens used his impasto for his light areas, but was particularly careful to keep the forms within his darks quiet.

Similarly the student when working at the shade area must remember to hold the reflected lights under control. Too often he emphasizes them until they actually look like "lights" blazing out of the darkness, as if the figure were lit from within, or made of glass or china. Or again he strengthens with dark the outlines of the forms within the shade area, with the result that they refuse to retire, and obstinately stand forward. There can be no hard lines in the shade, owing to want of illumination.

As the luminant is generally from above, the darks in light areas occur below the forms, while the main reflection, coming from below, the reflected light is seen in the upper part of the concavities of the forms, much as the footlights illuminate those parts of the actor's

features. FIG. 10A shows the general principle of working both light and dark areas. The drawing was made by artificial light.

CHAPTER VII.
TONE STUDY—EXERCISES.

THE art student takes great interest in materials, as witness the prosperity of the artists' colourmen, and certainly the proper selection of materials and their right use will go far to assist him in his career. It will be well to glance at the commonly used drawing materials found in the art schools.

The drawings of the masters of the renaissance show the use of charcoal, black and red chalk, the pen and sometimes gold and silver points, and these continued to be the main weapons of the art student until the introduction of plumbago or black lead, although the black chalk point remained a favourite implement, the enormous cartoon by Maclise in the Diploma Gallery of the Royal Academy, of the meeting of Wellington and Blucher, being drawn with it. So much time, however, was wasted by students stippling up their chalk drawings with a finely pointed crayon that the stump was adopted as tending to broader work. Unfortunately this result was not achieved, for students found that by a dexterous and continued manipulation of the stump on suitable paper, a lustrous and pearly texture was

TONE STUDY—EXERCISES.

obtained. This could be again refined upon, by touching with a finely pointed chalk, and by "breading out" black spots, prodigies of industry being performed on such drawings. Thus did the misapplied industry of students defeat the efforts of teachers.

The stump has also other disadvantages besides this great one, of enabling a drawing to look better than it is in the eyes of its producer. The stump touch is always indeterminate or "muzzy," and where a sharpened edge is required bread or indiarubber must be used. This handicap causes an indirectness in the method. The student fumbles with the stump and then corrects with rubber, whereas a weapon capable of more direct and trenchant action must be put in his hand if he is to gain mastery over line and form. Also in spite of its indirectness the stump, with its ally the rubber, can be made to produce drawings hard and tinny in character, and students have been known to apply paper masks to the drawing and then rub vigorously with bread, thus obtaining that clear hard contour which they supposed the authorities wanted.

What then is the best material for drawing practice? The student, it must be remembered, requires an implement which will allow him to *search* for form; it must be to some extent tentative, allowing him to withdraw somewhat if he has overshot the mark. The black crayon does not meet this need, for any erasure alters the character of the tone, making it smoky or smeared. This applies also in some measure to the lead pencil, an implement capable of producing beautiful effects, but hardly one for *study*. It must be used directly or

greasiness results, also it misses the definite black of the chalk. Moreover the pencil is the implement for writing, and students when using the lead for drawing still go on *writing*, making zigzag, scratchy marks with the fingers, often closely resembling written words, which the teacher may pretend to decipher much to the disgust of his pupil.

Charcoal meets most of the requirements very well. It is easily removed, allowing several trials of the first stage of a drawing if reasonably used. It varies from the soft velvety black of a well burnt stick to one underburnt, and as hard as an H pencil. From a dense black, by a sweep of the finger, the tone can be lightened in a beautiful gradation up to the tone of the paper. No other implement gives gradation without great labour, and this labour, as mentioned above, is apt to degenerate into stippling.

By using the softer grades of charcoal in the early stage of the drawing, full emphasis of form and rich contrasts of tone can be readily obtained, while for detailed expression, harder charcoal will give all the definition that can be obtained with a pencil, chalk or stump. Charcoal is, of course, sharpened backwards, like a chalk point. It should be used with a paper of square grain like that known as Michallet or Ingres. Lights may be emphasized with bread, ordinary indiarubber being useless with charcoal, though "putty" rubber and tinder made from fungus may be used.

The student commencing the study of light and shade is often kept to the whitened models and casts whereas what he requires for the development of his per-

FIG. 10—A drawing in charcoal from an antique head.

FIG. 10A is a diagrammatic drawing showing the difference in treatment between the forms in light and shade areas respectively.

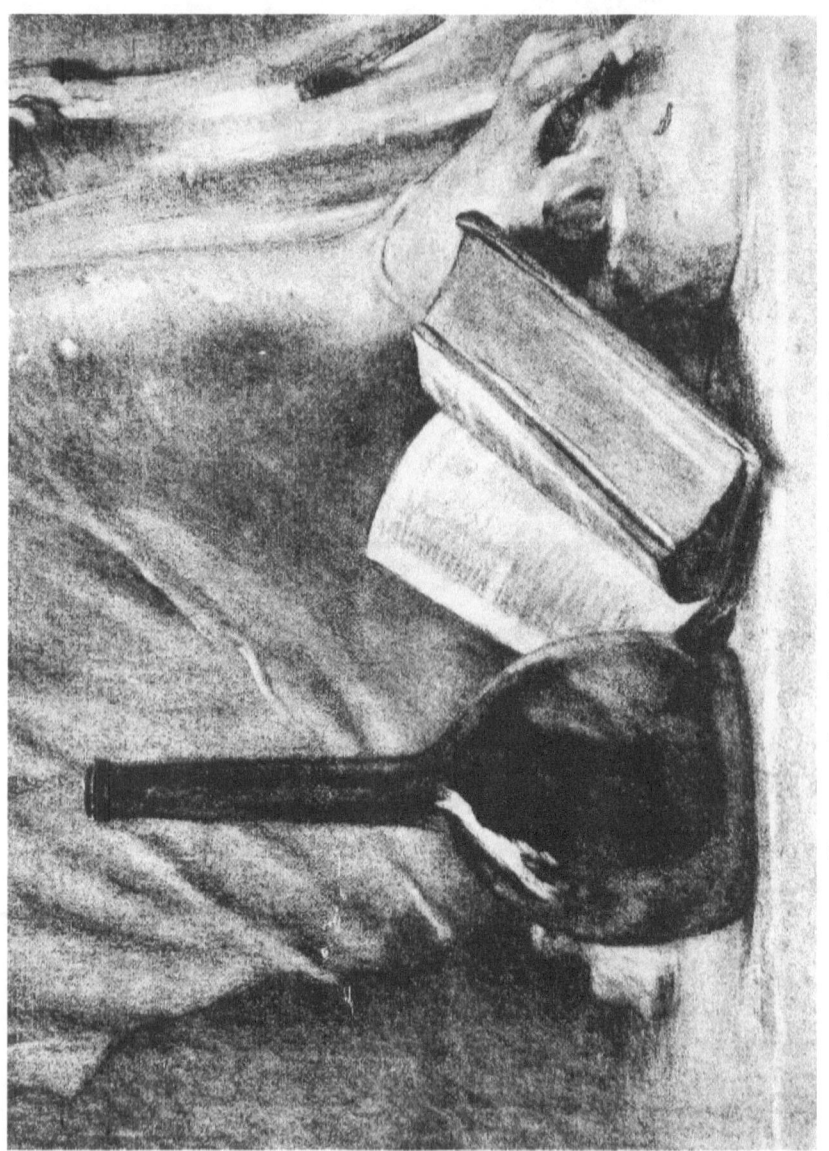

Fig. 11.—A study in charcoal of a still life group.

ception of tone is work from objects of varying tones and textures. The ordinary still life group fulfils these conditions fairly well.

If a simple group, say of three or four main tones, is set up, the student is at once faced with an exercise in composition. Any group may be treated as a square, upright, or oblong composition. The square being generally the refuge of the weak-minded composer and eliminated, a series of small sketches should be made until a satisfactory solution is obtained.

Now will come a tussle between the student's utilitarian or anthropomorphic tendencies, and his artistic vision. He is very apt, from past experience and prejudices, to grade the objects he sees according to the agreed value set upon them by mankind. A bottle being an object made by man to hold liquid necessary or grateful to him, the student ranks as the most important object present, and if allowed, will work away at it supremely indifferent to the remainder of the group. Another difficulty crops up here. The student from his childhood has been constantly exhorted by his parents and teachers to "do one thing at a time." This maxim he is apt to carry out by drawing and finishing the various items in a group one after another. He has to be taught that in artistic practice "one thing at a time" though just as important as in everyday life, means something quite different from what is in his mind.

Therefore the student will not make much progress until he sees the parts of the group as *tones* of various shapes. Especially should he refrain from carefully outlining each object by itself without relation to its

neighbour. At first he will probably find it difficult to put down *indications* of the objects in order to place them as desired. These first steps in a drawing as mentioned elsewhere, demand all the teacher's patience and the pupil's willingness to accept admonition, for they do not accord with the latter's preconceived notions. Above all he must not for a moment be allowed to imagine that charcoal being a substance allied with ashes and soot will not allow of delicacy and refinement of handling, and that these preparatory steps of placing and sketching in the main masses may be taken carelessly.

The masses having been indicated before any elaborate contouring is attempted, the main tones of the group should be set down firmly, with a soft stick of charcoal, and now the student should enjoy the *effective* use of tone which can be readily obtained with charcoal. Placed near the group, the drawing should give the same tone effect even in this early stage.

The forms of the objects may now be attended to, ellipses and other forms being carefully drawn. Attention should also be given to the *plan* of the group. It is easy enough to indicate the vertical aspects of things, but the position they occupy on a horizontal surface, that is the plan, is apt to be ignored. The student might be required to indicate the plan of his group on a scrap of paper, and to compare it with the actual position of the objects. By this means interpenetration of the objects is detected.

In order more completely to express the surface forms one of two methods may be followed. The char-

TONE STUDY—EXERCISES.

coal may be sharpened and the whole gone over, until it is well worked into the grain of the paper. This is a laborious process and calculated to disgust an ardent student. The second method consists in rubbing in the tones with the finger, stump, rag or brush, always respecting a very dark tone such as that representing the black of a bottle. If rubbed, this becomes smeared and dull. Some darks will now require strengthening, and the pellet of bread pressed between the fingers into a chisel shape may be used to take out lights, not as is often supposed, to make alterations or correct errors, which should have been done in the earlier stages of the drawing. Just as the charcoal makes with readiness dark forms, so the bread is an implement for shaping *lights*.

Lastly comes careful edge study. It should be noted that the places where the edges melt into the adjacent tone demand as much study as the definite edge. For instance a black bottle will probably have some part adjacent to shade, and the edge in this area may appear lighter (owing to reflection) than the tone behind it. All the edges must be followed and dealt with on this principle, yet the study should show the aim with which it was commenced—the representation of a few masses of varying tones. If these tones have become confused in the progress of the work, the study will have fallen short of success as an exercise in tone.

The exercise may seem humdrum to those like Rosetti, who scorned pots and bottles, and wanted to paint angels, yet it may safely be said that to attempt oil painting without the discipline afforded by a course of

form and tone drawing on some such lines as these, is to court failure. The problems of tone are here presented in the simplest way, and solved by the simplest means. The student who commences to study tone by means of oil monochrome, has such a varied equipment to contend with, that a great deal of his time and attention is occupied with his implements, his paints, palette, brushes and palette knife, paint rag, vehicles, etc. In charcoal he has a simple material which gives at once the most velvety blacks and palest greys, is amenable to varying degrees of manipulative skill, and lends itself to the rough sketch or complete expression. Also, unlike the stump, it does not delude the student with an extraneous beauty of surface. Anything approaching excellence to be seen on the paper, is deserved, and, unlike watercolour, it affords no lucky accidents. FIGS. 11, 12, 13 are examples of still life studies made with charcoal on Michallet paper, and show that this medium allows of the drawing being carried as far as may be desired.

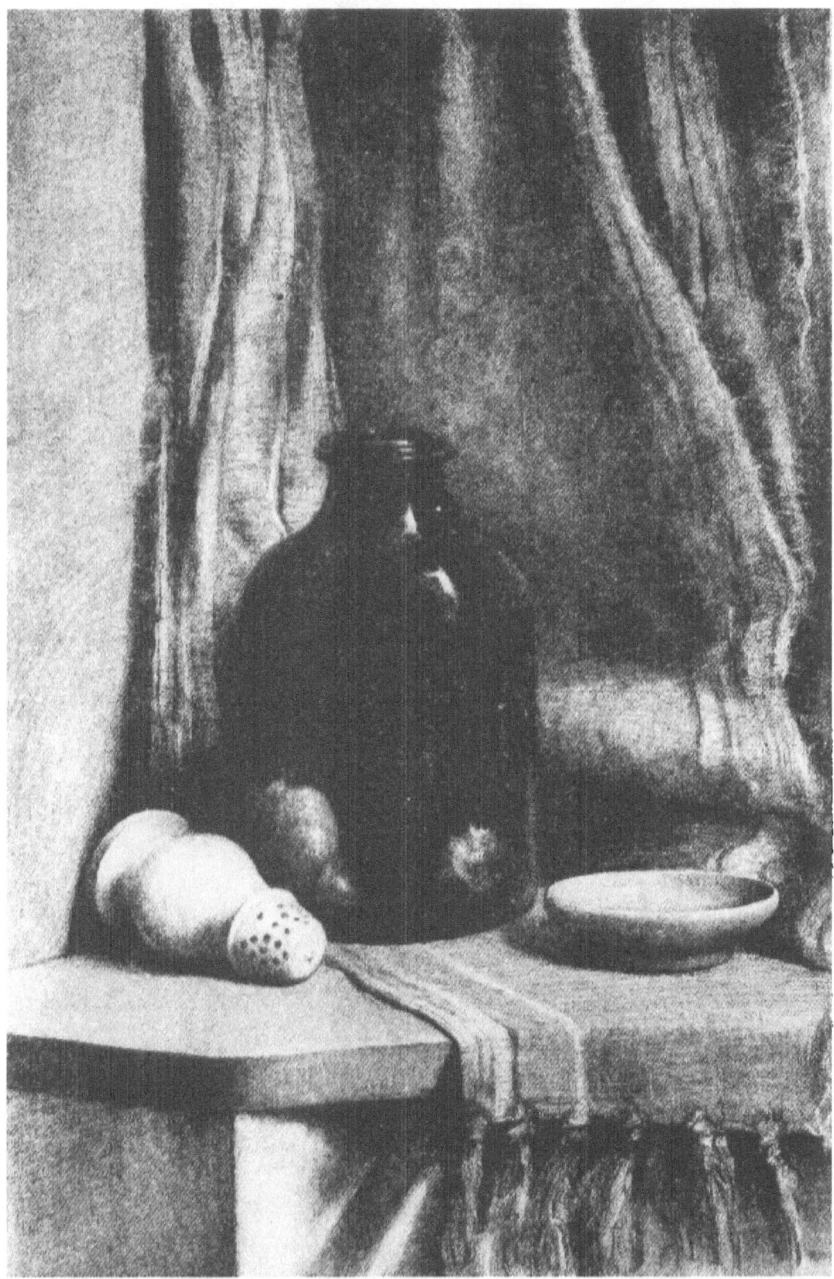

FIG. 12.—A charcoal study which shows how far the material will allow of a drawing being carried.

Fig. 13.

Fig. 14.

CHAPTER VIII.

THE FIGURE—INTRODUCTORY.

STUDENTS usually pass through the antique before being promoted to the life class. It is held that by working from casts they have time to gain facility in method, and also some knowledge of human proportions, both very needful, before attacking the living figure.

That this latter study requires all the equipment the student can command need not be questioned, but though young students may not be able to use their materials skilfully, and may not have a keen sense of proportion, they are familiar with the living figure, for they are human themselves, and acquainted in a practical way with their own structure.

On the other hand all art teachers must be aware of the disadvantages of using the antique as a sole means of training. The student cannot see the classical figures as the sculptor created them in marble or bronze, cannot see them as part of an architectural whole, and viewed thus, torn from their past, in the antique classroom, the dull plaster does not stir his artistic consciousness. He does not perceive the subtle variations from the living form, by which the sculptor sought to express his idea of a god-like person. The fine proportions and flow of line

escape him, and above all the statues stand so quietly that he finds himself quietening in his attack; he involuntarily slows down and loses that touch of fever which counts for so much in the study of drawing.

In ordinary school life educationists postpone an abstract study like grammar until the child mind has developed sufficiently to take interest in the train of thought. So it is with art students, who, after working from the living model, willingly turn to the antique, and study it with more profit and more enthusiasm for its noble qualities than would have been possible to them coming to it without preparation. The problems of the human figure they now see presented in typical form, and they recognise a canon of proportion which they can more readily grasp, after having observed the great variations in a series of living models.

Coming now to the study of the living figure, the student should understand that a great deal more than mere copying is implied, for it embodies many aspects of art study, spacing, composition, structure, and especially proportion.

There are certain difficulties which will surely meet the beginner, and these it may be well to discuss. First the anthropomorphic attitude of mind on the part of the student already referred to must be combated by the teacher. The former is likely to be obsessed by the figure before him to the extent that the necessity for imitation seems all important. The drawing, he thinks, must be made as like the figure as possible. In other words the student's power of *selection* is dormant. There are so many things to be attended to that the

THE FIGURE—INTRODUCTORY.

drawing is apt to be a mere assembling of members, trunk, limbs, etc., to say nothing of details such as fingers and toe-nails.

The teacher, therefore, has to point out the *aims* of drawing from the figure. These are not necessarily to recreate a material person by the accumulation of parts, and especially not to emphasize the nakedness of the figure, as beginners are prone to do. The figure is selected as a special subject of study because the nude form presents problems of line and structure more directly and trenchantly than any other material which can be set before him.

What should the teacher emphasize as the *first* step in studying the living figure? The answer may be given in a word—*movement*! The living figure is posing in a state of suspended animation, and a sense of movement there must be in any position of the figure. Either the movement has preceded the pose, or the latter is about to pass into action.

Beginners are often oblivious of this sense of arrested movement. Their figures are lumpy and stiff, and they rarely or never give as much action as the figure displays. If, say, the torse leans, they diminish the amount of inclination so that the figure seems to be sitting upright, or nearly so. Especially is this seen in the pose of the head, which often inclines in order to balance an obliquity of the torse or limbs. The novice rarely sees this. To him all heads are upright at attention. It may be said here that what the student suffers from in every branch of drawing is not, as he supposes, an unskilled hand, but an untrained eye. The teacher's efforts are

constantly directed to the development of the visual faculty, the power of analysing, judging inclinations, measuring proportions, finding the lines which indicate the structure, in all of which the eye needs to be trained. Cleverness, a kind of juggling, which produces effects akin to the lightning sketches at an entertainment, may be deemed essential by an indiscriminating public, but such ideas must be gently laughed out of a school of art, if they ever find utterance there.

It is to the eye then that the main course of direction and criticism should be directed. Even plumbing and measuring should be used only as a secondary aid, to corroborate criticism, for if these mechanical aids are employed too freely, the eye suffers and loses self-reliance.

Coming to the question of *movement* we realise at once that it is represented through direction. All figures, torses or limbs have a general direction, and these inclinations can be suggested by lines. A seated figure can be represented in direction by three lines. (FIG. 15.) Students unwilling to commence a study with such simple preparation generally show in their work a lack of vitality and movement; they begin by seizing on the forms, and consequently the general idea escapes them. The mischief occurs at the commencement of the drawing. No amount of delicate detail, if it be drawn piecemeal, will compensate for the lack of intelligent construction. The whole figure should be surveyed at the outset. Too often the eye wanders round the contours, with the result that the drawing lacks proportion and movement.

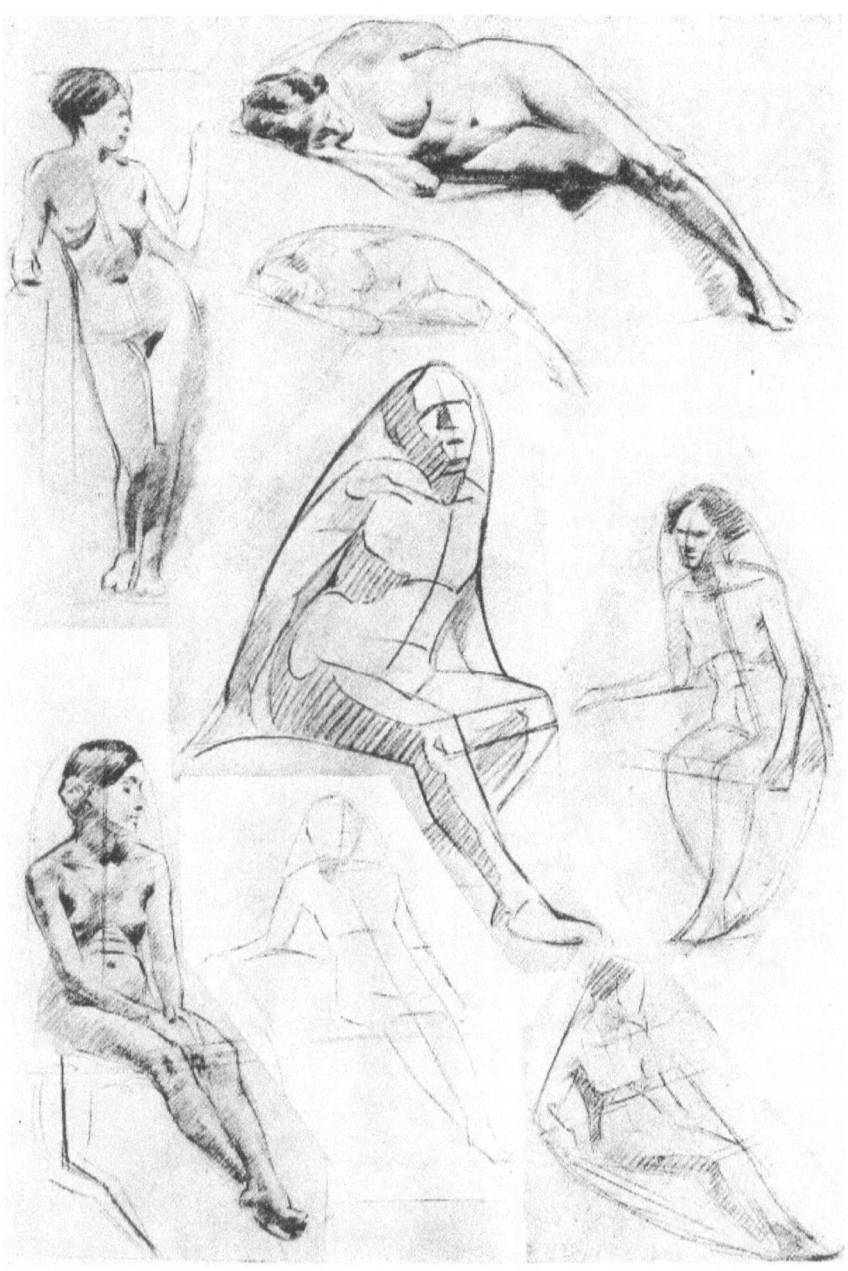

Fig. 15—Sketches showing the first lines or "directions" which settle the movement of the figure and its proportions.

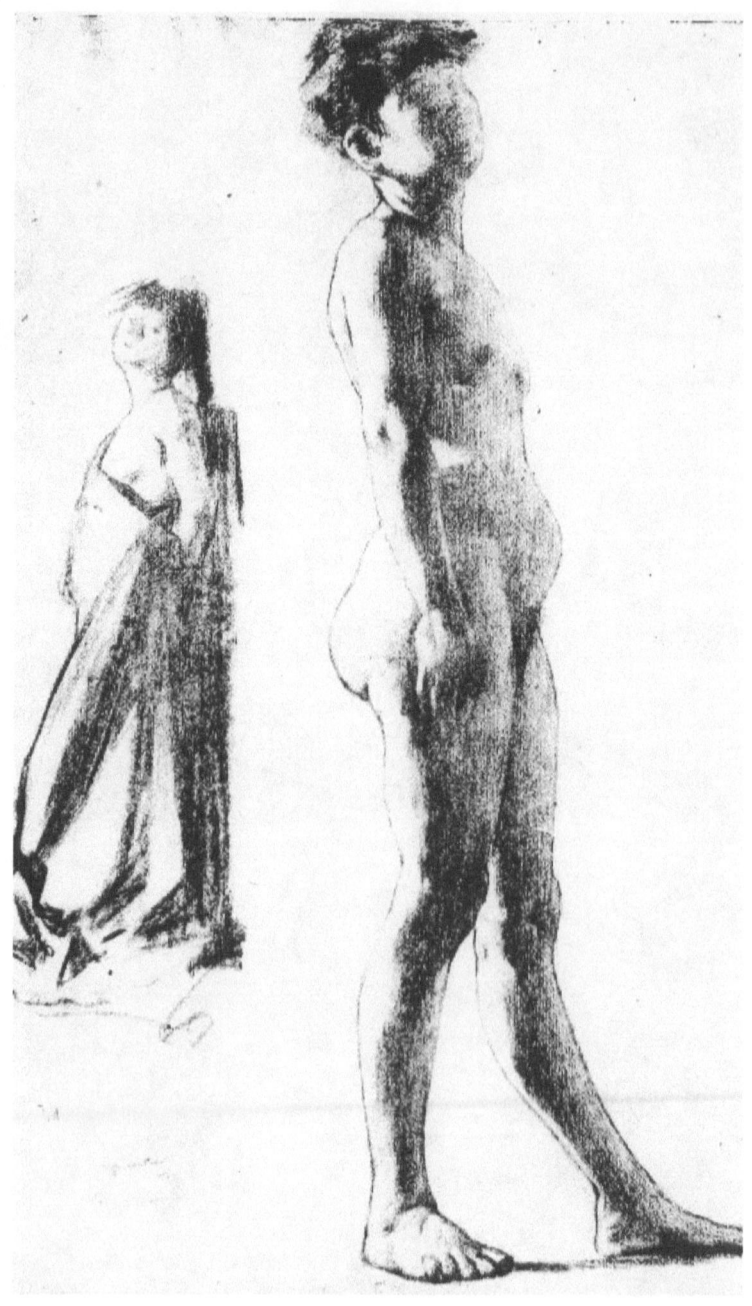

Fig 16—A drawing made with charcoal on Michallet. The appearance of weight and solidity is due as much to the quality of the line as to the shading.

THE FIGURE—INTRODUCTORY.

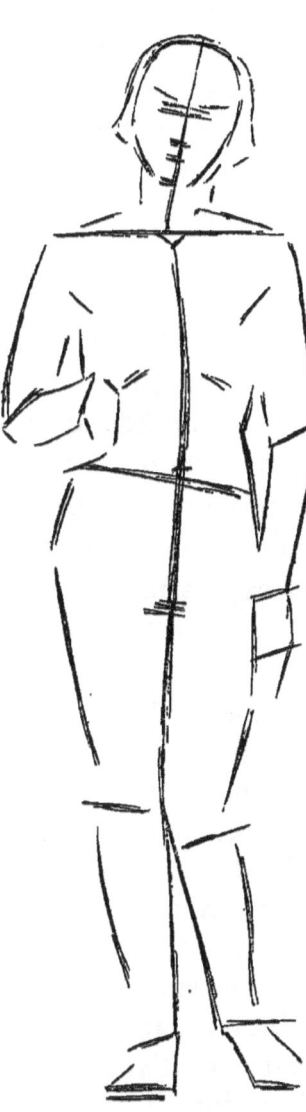

Fig. 16A.

The student then should determine a line on which to build the figure, this line occurring perhaps within the contour, or again coinciding with it.

When drawing a standing female figure, the student is often attracted by the rich and accented forms of the contours of the breast and hips, with the result that these features are exaggerated. The figure should be built on a simpler line, in this case a vertical through the pit of the neck and ankle of the supporting leg. It should be noted that this is not an arbitrary line, but one actually existing in the pose, being traceable in the median line of the torse, and again between the legs. (FIG. 16A).

Such a simple commencement is unpopular with the student, for it is head work, and requires studious analysis of the forms.

Unfortunately also the beginner has often acquired, from old habit and force of tradition a method of drawing which con-

sists generally in beginning at the top and descending piecemeal till the feet are reached, that is if there is room for them. Such a vicious method is common even among students possessing great facility. The case may be compared with that of a language student who has never heard French spoken, and is surprised when his tutor tells him he has a wretched accent, though he is entirely unconscious of having acquired it. Ingres used to say "Don't draw one by one and in succession, the head, then the torso, then the arms, and so forth. If you did you would be bound to fail in reproducing the harmony of the whole effect. Rather set yourself to fix the relative proportions existing between the several parts, and to gain the mastery over the life and motion, and in giving expression to this action, don't be afraid of exaggeration. What you have to fear is lukewarmness."

The teacher has another difficulty to face. He should not impose his own way of seeing on his pupils, and thus deprive them of their individuality, nor seek to bias their own self-expression. A student's feeling for form may perchance be somewhat stark, indeed may verge on ugliness, to the point of exaggerating or caricaturing the form, but the wise teacher will be shy of admonishing such a student, of advising him to look for smoothness, grace or beauty, because character, individuality and strength may be the chief note in that pupil's future work. There is room in the world of art for all manner of individual expression. The touchstone is whether it is sincere. Imitation, posing, conscious seeking after a

style on the part of students cannot be too loudly condemned.

But where the student's work is wanting because of his lack of method or of knowledge of materials, the teacher is on firm ground. The student must be taught everything, even how to hold a pencil or brush. In matters of method and of the use of the implements of his craft, he should put himself entirely in the hands of his teacher, who cannot guide his students unless they trust him.

That introduces the question whether the teacher should work at the model before or with his students, or confine himself entirely to the office of adviser and critic. The exponents of the new modes of teaching, as practised in junior schools, incline to the latter view. They say that directly a teacher demonstrates before his scholars, he is biassing their vision, is preventing their seeing the object for themselves, and is obtruding his own vision of things to the detriment of their personal expression. This is very true provided that the teacher's inhibition does not extend to *method*, which, as pointed out above, *must* be taught; but there is another aspect of the relations between teacher and pupils, an aspect which is of special importance in dealing with art students who are spending all their hours at the same study. They are apt to be discouraged after long toiling, and consequently may be tempted to look upon their teacher as he visits them on his rounds, merely as critic, carper and fault-finder. This is a real danger, and it is in the power of the teacher to overcome it. If he is wise he will regard himself not as one aloof, in another sphere,

that of the professional artist who occasionally condescends to criticise the efforts of the novice, but in the much closer relationship of an elder brother, who is willing to work at the same tasks as his pupils. It is certainly dangerous always to paint and draw before the students, but to work with them occasionally is to exhibit a spirit of comradeship which at once stimulates the class to its best efforts.

Again a student sometimes confesses inability to proceed with an exercise, and if the teacher is convinced that the case is genuine, and works on the drawing, showing in what ways the pupil's vision has fallen short, and giving a demonstration of how far a drawing may be carried, much good may result.

From this it follows that the student should not flag or sulk at the continuance of his task while the teacher is willing to interest himself in it. R. A. M. Stevenson, in his life of Velasquez, has some interesting comments on the methods of the great teacher Carolus Duran, which should be read by all students, weak-kneed or otherwise.

In order to secure proportion students should work at a distance of some yards from the model. Then the natural tendency to draw sight size can be utilized. By holding up the drawing alongside the model (FIG. 17) the proportion may be checked very effectually. Students should never be admonished to "draw large," "to fairly fill the paper," because violence is thus done to the natural scale of the drawing, the eye and hand travelling, as it were, at the same rate. This is the most direct road to good proportion, and, as Mr. Walter Sickert has pointed out, was the method of the masters.

THE FIGURE—INTRODUCTORY.

If the drawing is too small in scale to allow of adequate treatment, the student should go nearer the model or use a finer point.

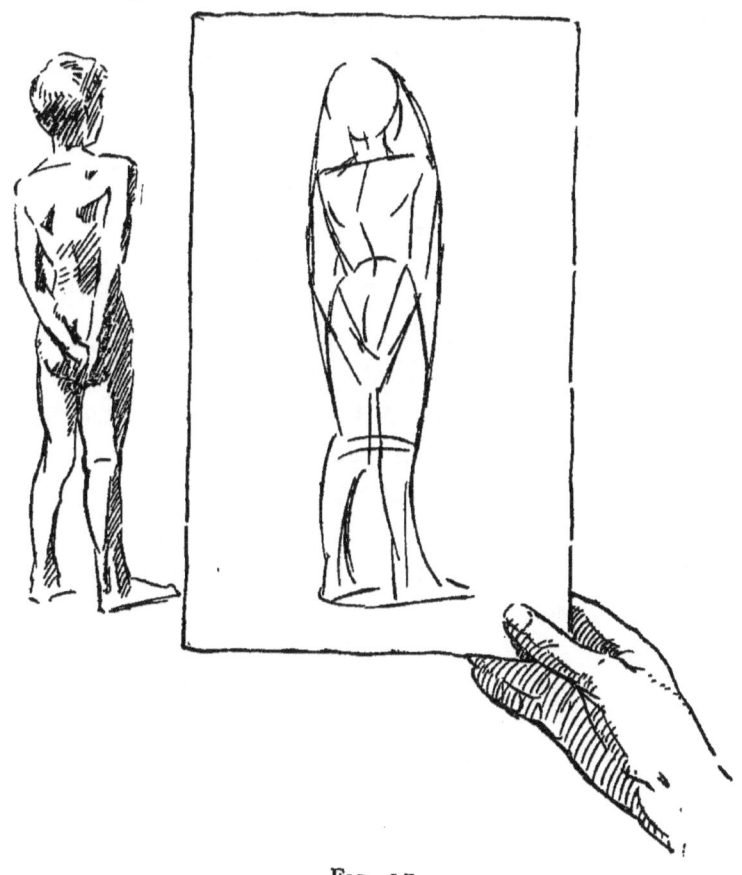

FIG. 17.

The drawing should be frequently viewed at arm's length. Students often hold the drawing too close, so that the lower half of the paper is practically out of sight, with a consequent detriment to the proportions.

A few words may be said on the vexed question of

backgrounds. Some teachers, in their zeal for complete expression, insist that their students shall indicate the tone of the background, with any accessories that may be present. This it must be contended, is a mistaken view, for backgrounds imply tone study, but drawing from the figure is not merely an exercise in tone; structure, flow of line, composition, etc., demand their share of attention. The student is not concerned with the photographic aspect of the figure, nor is he studying tone as such; other exercises can be devised for that side of art study. To make tone studies of the figure with its background is to degrade it from its high purpose; but this does not imply that it should be drawn as existing by itself—isolated in space, for by the use of expressive line the tone of background can be suggested. The degree of emphasis of the edge treatment will show whether the background is darker or lighter than the general tone of the figure. This aspect is considered in detail in the remarks on Edge Study.

CHAPTER IX.
THE FIGURE—THE SEARCH FOR FORM.

THE beginner often shares the general opinion of the outside public that drawing is a kind of legerdemain, a conjuring trick done with clever fingers, a tour de force thrown off lightly with no trouble or study. Of course there are varying degrees of facility among students, and where one accomplishes a task with seeming ease, others may flounder or fail. But the history of art shows clearly that a want of facility has not prevented men from achieving fame, while among good judges the exhibition of cleverness and of smart handling, removes a painter from the highest place.

The facility of a master of drawing has been attained by close study, and by what has been called the "search for form." That is to say mastery over technique does not come by gaily tracing contours with a pencil, but by more or less painful efforts to track down the subtleties of form. It is difficult to make students understand this, for they suppose that mere practice will give facility, whereas the eye should be trained by exercises demanding a rigorous scrutiny of form, and needing all the intellectual capacity which can be brought to bear.

Drawing from the figure may be divided into two

main types of exercise. One, very important, is the time sketch, recording the main facts of the figure, and varying the method and visual search according to the time at one's disposal. Generally the time sketch deals mainly with movement, flow of line, and character as shown in the pose. Such work requires supplementing by more searching and detailed expression of form, which indeed enables the student to arrive at the more summary methods of the time sketch. The student who sketches only on a small scale, and for limited periods of time, will not be sure of himself, nor be aware of how far he can pursue his scrutiny. In other words, he has not really learnt to *search for the form.*

The materials with which to engage in this detailed expression of form have not been agreed upon generally. The pencil or crayon point leads to redundancy of strokes, and is wanting in breadth. Further, neither allows of the tentative technique necessary in this kind of exercise. To mention the stump is to condemn it, for it is incapable of making a definite stroke.

Charcoal, as indicated elsewhere, supplies the best weapon for this particular kind of attack. With it can be produced with ease broad masses of tone, and also, when well pointed, lines can be drawn as finely as with a pencil. It has a full range of tone from velvety black to palest grey.

FIGS. 10, etc., were drawn with charcoal on Michallet or other square grained paper, the sheets of which, measuring about 19" x 24", are of the dimensions most suitable for normal eyes. If one draws to a larger scale it is difficult to keep the whole of the drawing under

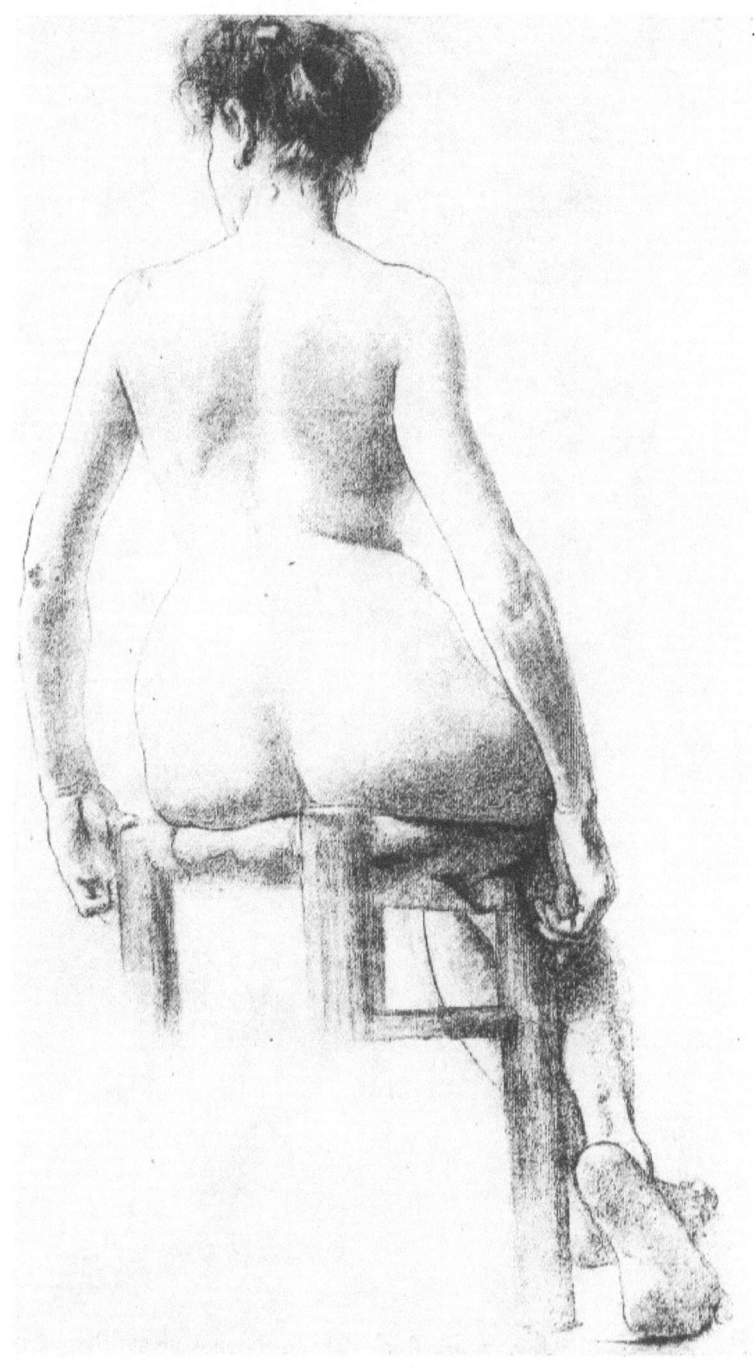

FIG. 18.—A charcoal drawing much rubbed and otherwise ill-treated since its completion. An example of edge study. Every inch of the contour has been carefully studied.

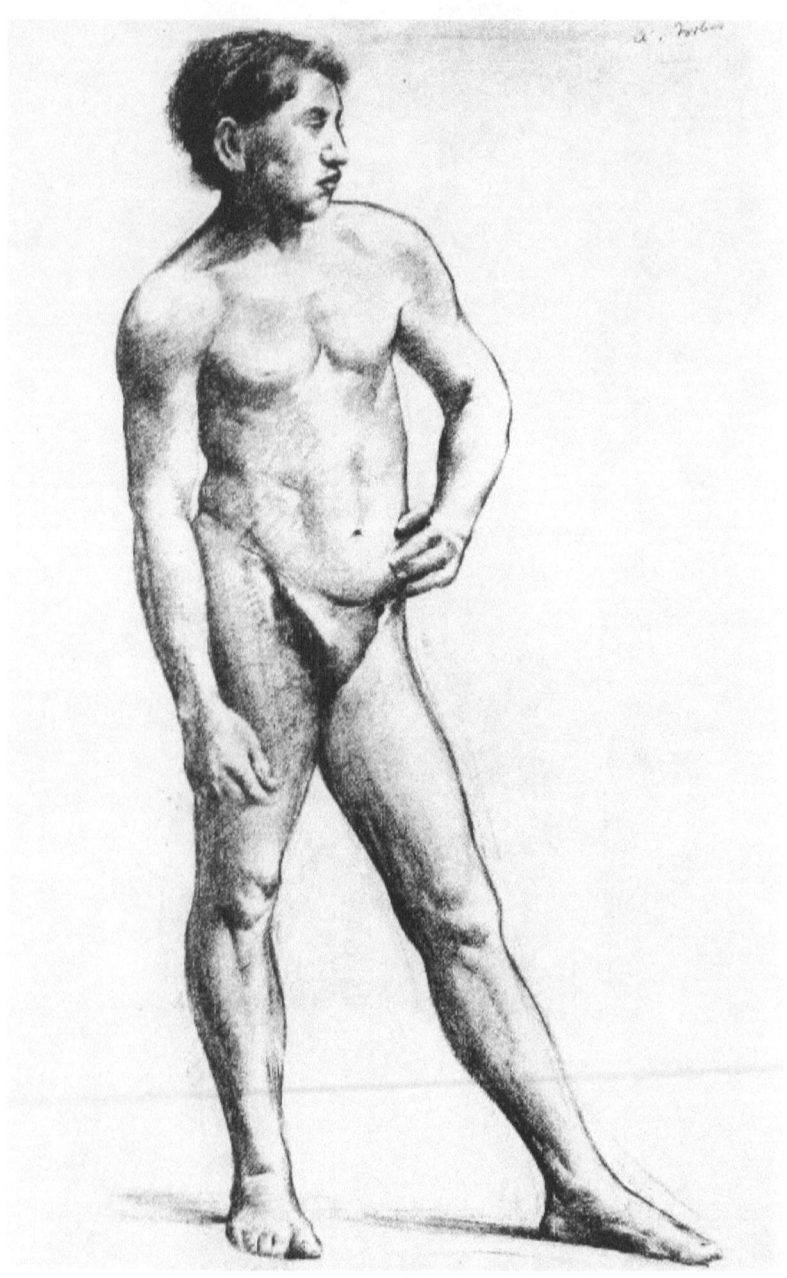

FIG. 19—This drawing, with all its defects, shows a great interest taken in the pose by the student and a determination to secure an expression of it.

THE FIGURE—THE SEARCH FOR FORM.

surveillance, and errors in proportion, and in gradation of accent, are apt to occur. Even if drawings, say for a large mural decoration, were wanted, they should be drawn first to this scale, and then enlarged by squaring or other method. There are some life drawings by Albert Moore, at South Kensington, drawn full size or nearly so, but the method does not seem to possess compensating advantages.

The procedure is the same as indicated elsewhere. The student should, as always, mark top and bottom of his drawing, and at once find the main line from head to foot. Next follows the general structure of the figure with a plan lightly sketched in of the masses of dark tone. It is at this point that the proportions of the drawing should be scrutinized, and if found wanting, the charcoal strokes, which at first should be light and delicate, can be obliterated with a few flicks of a duster. It cannot be emphasized too strongly that this stage is most crucial, and tests severely a student's powers of selection and analysis. The drawing, no matter how many hours or days are required for its completion, will be substantially in proportion, and general scheme of light and dark, what it is at an early stage. Hence the importance of self-criticism, and if necessary of beginning afresh. No alterations of moment should be made at a late stage. The time for erasure has then passed, and if great errors of proportion reveal themselves as the drawing progresses, they convict the student of heedlessly slurring over his first steps, and of failing to build on a sure foundation. Hints on further procedure are given elsewhere.

With regard to extremities, hands and feet, the charcoal drawing on Michallet paper gives opportunity for working these out in detail. In some schools such studies are made full size, and certainly the difficulties of constructing properly the head, hands and feet demand that considerable time shall be spent on them. On the other hand the nude figure should be used primarily to give right notions of proportion, construction and movement, and until the student is well grounded in these, it seems a pity to distract his attention from the main lines of the figure in order to focus it on detail, however important. A great deal can be done, as indicated elsewhere, in showing that the action and construction of the figure demand the consideration of the extremities, and involve at least construction of their mass forms. Poor drawings of hands and feet always show a lack of construction, and of articulation with the limbs.

Studies from the nude are sometimes almost pornographic in appearance because the student is (quite innocently) doing the wrong thing. He tries to reproduce a naked person, making a sort of inventory of physical characteristics, so many fingers, toe-nails, etc. Such drawings usually lack the higher interests of the figure, the flow of line, the rhythm of the accents of light and dark, the unity of the long line of shade running down the figure and revealing the "cubist" typical shape. These things sought after, the student cannot go far wrong, no matter how much he hankers after realism.

Unfortunately this wrongly realistic drawing has in

THE FIGURE—THE SEARCH FOR FORM. 67

the past been rewarded, on the ground that the student has been honest and sincere, qualities however which students evince rather by what they omit than by what they put in.

Another evil resulting from insistence on reality is loss of rhythm. One often sees a figure with carefully shaded details, all of about the same weight of tone, and the dark masses monotonous in character. The drawing looks fussy and over-elaborated, while reference to the model gives an impression of simplicity and breadth. The student has been too busy to catch the rhythm of the modelling. The darks have been referred to as accents, and certainly tone rhythm is akin to that of music. The figure, perhaps, has dark hair, the contrast between that and the white brow giving the strongest accent. Lower, on the face and neck the accent of dark is weakened, to be strengthened again, say, at the armpit, while the shade areas on the torse and lower limbs again diminish in strength—an ebb and flow, or rhythm throughout the figure, giving at once variety and breadth. This supplies a method of procedure. The main masses of middle accent should be struck, the stronger and weaker accents following in their places, and keeping their relative pitch. Mention has been made of the division students arbitrarily make between drawing and shading. They often show that they do not consider shading as drawing. They work away laboriously at some dark patch without ever exploring its borders, its varying contour, or indeed without considering the structural use of their darks. Shading is only useful where it is expressing structure and revealing form. It should

be busy, that is giving due emphasis to the line of shade which emphasizes the meeting of the planes.

Form is expressed by light against dark, and this form should be drawn and then be backed up by shading. Shading without drawing may be compared with bringing bricks into a field without attempting to build with them.

As pointed out elsewhere, any object is seen divided into two areas, light and dark. In the former are planes and forms sharply defined under usual conditions of lighting. In the shade area which under normal lighting is the further removed from the eye, the forms are quiet and subdued. Hence an equal distribution of focusing is destructive of unity. There is no need to pore into the crannies of the dark area, for Nature forbids it, while the light area affords abundance of opportunity for searching study. Often, however, the would-be finished drawing shows that the eye has not fully explored forms; the test may be applied to the meeting of angles, such as the line of armpit, where it meets its shade edge. The lines may have been brought together in some fashion, but what happens at the junction? What is the actual shape of the dark patch? The student must ask himself these questions as he approaches such passages, for unless he exercises a vigilant scrutiny his drawing will be full of insufficiently observed shapes. Lastly, light and shade is not merely utilitarian, does not serve only to reveal the forms, but has a beauty of its own well worth the closest attention. If we look say at an interior by Velasquez, we are conscious of a subtle yet clearly marked series of beautiful passages of light and shade,

FIG. 20—An unfinished drawing showing the use of charcoal in expressing varying textures.

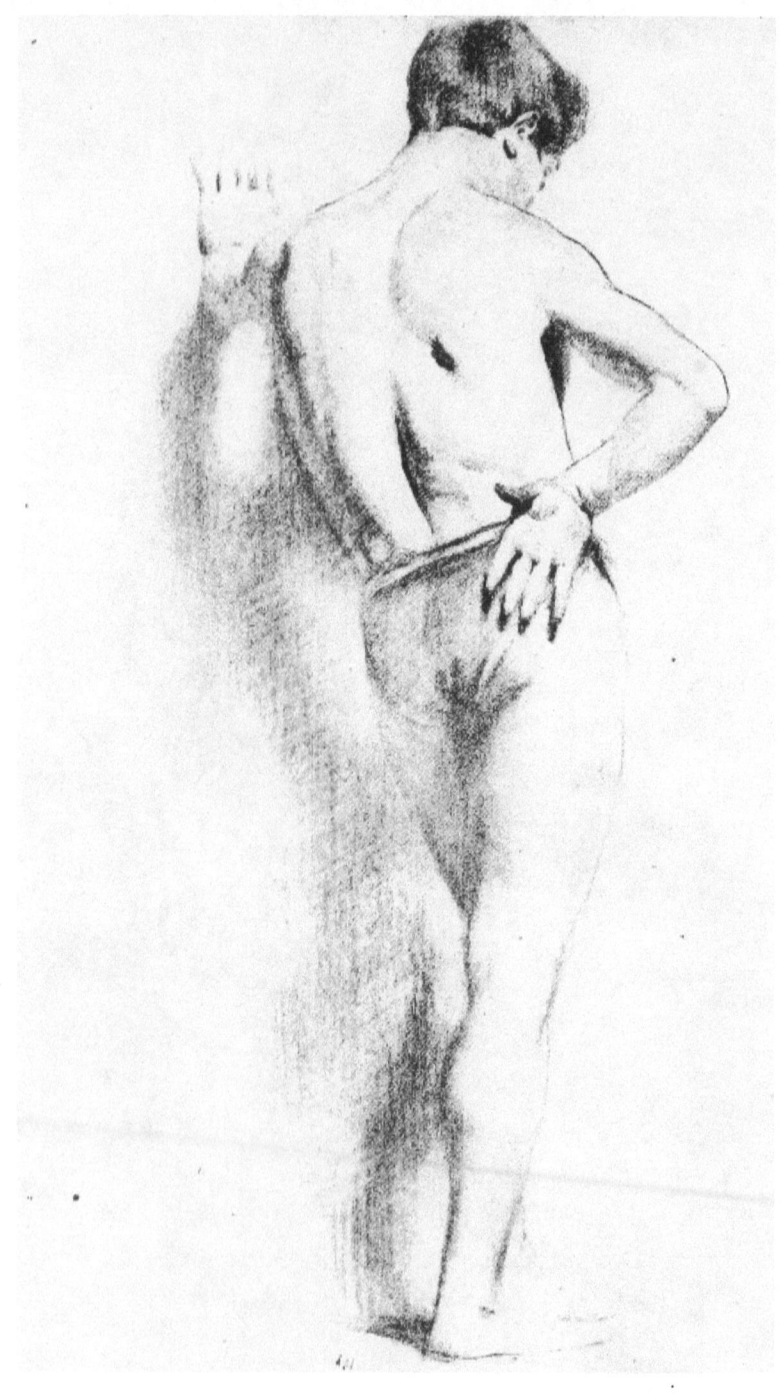

Fig. 21.--Drawing with charcoal on Michallet paper.

of rich velvety darks against liquid lights, or of light edges melting mysteriously into background tones. He showed us how to look at the beauty of tone in nature, and the seeing eye discerns it everywhere. What can be finer, for example, to be seen in any wood or clump of trees, than a trunk in full light with a dark spray cutting across it, or some such passage in constantly varying sequence as the eye examines the scene. Equally beautiful are the tone passages in the nude figure posed before a quiet background. The semi-translucency of the flesh seems to enhance these contrasts, and presents some of the most subtle and varied effects that light reveals. An arm in strong tone against a gleaming chest, or the darks of a hand or knee against a thigh fully illuminated are things to wonder at, and not merely because they are striking examples of the relief of one form against another, of what one may call the stereoscopic appearance, but because they are *beautiful* passages of light and shade. To judge from students' drawings they sternly ignore beauty of tone. They say in effect that they are not to be turned aside from their purpose, which is to draw a human being, to fix the pose and the proportions, to indicate the structure, and to express the details. If they really were *selecting* from the model, the teacher would be delighted, even though they omitted what he considered an essential part of their training, the study of tone. But he finds that these effects of light and shade are ignored because the students fail to see them, or to be attracted by their beauty. Shading, to them, consists in industriously striping or stippling their study with tone, monotonous

yet full of the wrong variety—too many lights in the dark areas, and too many darks in the light—while their shading has often no *drawing* in it; they fail to follow the boundary of the shade patch, nor do they give the variety of its edge, for they do not perceive the "invisible" spots, the places where the outline melts away, nor, on the other hand, the trenchant, brilliant edge where a dark comes sharply against the light, or where the contour of the figure in light contrasts with the darker background.

On the other hand there are passages of the utmost subtlety generally in the lighter areas where a well-lit form comes against another similarly illuminated. A common example is that of the thighs and knees of a seated figure. The near thigh and top of the knee seen against the further thigh presents a border hardly visible except to a keen eye, so little difference is there in the tones of the two thighs, yet the edge of the near thigh is there, and though faint, must be expressed by a clear line, or in some cases by the sharp edge of a delicate tone suggesting the upper plane of the thigh. Students often represent this delicate edge as a thick black line like a cart track, partly because they do not perceive the refinement of the passage, but also perhaps because they do not realize the different intensities their drawing implement is capable of. They should understand that a 6 B pencil, if used delicately on the right paper, will draw a line as lightly as a 6 H.

CHAPTER X.

THE FIGURE—TIME SKETCHING.

The time sketch, as it has come to be called, is without doubt the really vital and testing exercise of the whole course of drawing study.

The search for form, by means of the antique and life, the study of tone, vigorous and prolonged as they may be, are deliberate and experimental. They correspond somewhat with the slow accumulation of knowledge in a science laboratory, but in the exercise under discussion the student has to set down his impressions directly, in a limited time, and therefore practically without erasure. In the result his artistic personality exhibits itself on the paper plain to any judge. The point to which he has trained his observation, his knowledge of structure, and of the principles governing plastic representation, are embodied in the drawing, and his weakness, his failure to profit by teaching are there also. It is a simple test—to make a drawing, but it stands in judgment on the student's previous study. His careful drawings, which have taken days and weeks to produce, are now seen to be not so much drawings as searchings for form more or less tentative, though with-

out their discipline he would come ill-prepared to the more direct exercise.

As suggested above, the figure should be drawn about sight-size, and the *whole figure always*, not merely those portions which seem the most interesting, or which chance to occupy the paper. It is true that Alfred Stevens, Leighton and others often drew fragments, but they were not *studying*, but accumulating facts they wanted for a particular job. Reference may be made here to Mr. C. H. Holme's comments on this point in his "Science of Picture Making," where he deprecates students having to work all parts of a drawing to the same dead level of finish. That is also condemned emphatically in these pages, but it is true also that a course of art study, like any other, is bound to include much serious continuous study. It cannot all be at fever heat.

Art and art study is perhaps best looked upon as a game, a long, vigorous pastime, affording a few moments of ecstatic pleasure, with interludes of close application —but nevertheless a sport—and many sportsmen will accept the above as a pretty close description of their own favourite pursuit. And as such it is necessary to play the game properly, to have the sporting temperament—to hold on, to observe the rules, and to keep one's temper under all circumstances.

Therefore, given the essential condition of the exercise, that the figure is to be doing something, standing firmly erect, sitting passively, or lying prone, it will be seen that there is no hardship in indicating the whole of the figure. The sense of proportion is the more fully

THE FIGURE—TIME SKETCHING.

exercised, and also it is extremely important that the student should see that the pose nearly always demands the representation of the whole figure. This is shown clearly in the erect pose. It is necessary that the lines should be brought down to the feet—that these shall be clearly indicated, so that the figure stands firmly and with weight. How often does one see in the drawings of students, standing figures which sway, which could be blown over with a breath, or seem almost to float?

In many cases the composition of line is shattered by the omission of the extremities. Further, by drawing the whole figure, the student is obliged to *place* it, to see that it goes on the paper nicely. The effect of piecemeal drawing often shows itself very plainly. A glaring instance is the absence of an extremity for which there is *no room*. Another is the biassing of the student's sense of proportion by the proportions of the paper—the inanimate sheet which is often allowed to dictate and dominate the proportions of the drawing. If the figure occupies the long way of the paper it is often drawn too long; if it occupies the short way of the paper it is disproportioned in the opposite direction. The fewer rules the better, but one at least is necessary, that in commencing a drawing of the figure the extreme limits shall first be settled. The first lines not only suggest the movement, they also fix the limits and the placing. Then come the main facts, the essential structure, expressed by lines of direction. No attempt at detail or the refinement of outline should be made at this stage.

Next comes the establishing of the chief planes, the division of the figure into dark and light, or rather the

determining of the edge dividing these planes. This edge again should be simplified, for it is quite as complex as the actual contour, being indeed a contour from another point of view—that of the light. The stage is difficult for the novice, obsessed as he is by his own division of the study into drawing and shading. It would be well if the term "shading" were dropped altogether,

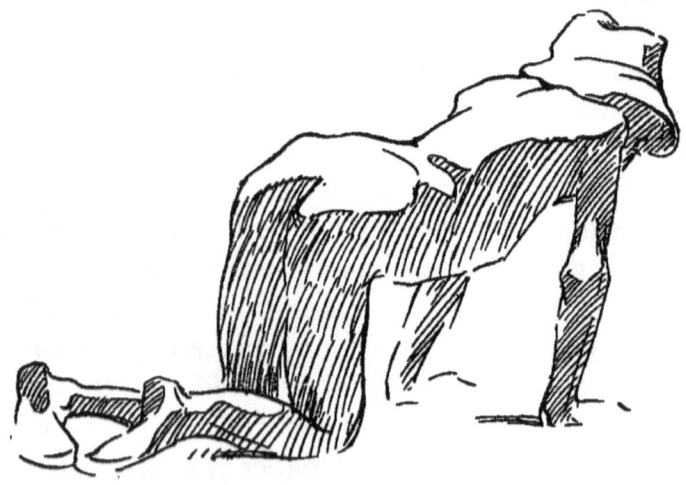

Fig. 22.

as its use by the teacher is apt to cause confusion, the student understanding it to mean shading of details. Expression by tone, however, follows a parallel course with line expression. As the contour must first be grasped as a "direction," which later will be resolved into the subtle line created by the overlapping of muscular and bony contours, so shading or expression by tone must first be seen as a mass or plane without variation, this and the subtleties of edge being left to a later stage. Fig. 22 shows the form divided into two planes under the

influence of sunlight, which maps out the figure in this trenchant way. Study of the nude in sunlight is valuable because of this clear division of planes. Also the halftones and darks lose the dull, sooty quality they are apt to take on in the studio. All is definite and lucid without blackness.

Students often spend much time on minutiae of shading while oblivious to the general plane of tone, just as great variety of curve and hollow in the contours of a drawing of the figure may be accompanied by neglect of directions and proportion.

The figure now being set out in its essentials of direction and plane, the drawing should be held alongside the model for self-criticism. This is the stage for second thoughts, for alterations, the next stage will be too late.

The student should now retrace his steps and set out on these simple indications, the structural lines giving the general build of the figure. Next comes general work in expressing form. The line is drawn and then backed up by the adjoining tone.

Lastly comes the edge study referred to in detail later. The subtleties of the contour and shade edges are worked at, and the influence of the background on the contour of the figure.

In each of these stages the figure has been worked over from head to foot, and the resulting finish is not that of piecemeal tinkering, but of right method and artistic treatment by logical steps. Further, the method ensures that the interest is sustained during the exercise. Too often the student, after completing the head or other

interesting passages, turns to the remainder with something akin to disgust or weariness.

Of course it is not to be supposed that the method suggested above should be adopted continuously. The time allotted to a pose may vary. Quite short poses of ten or even five minutes force the students to attempt the figure as a whole, otherwise when time is called they find themselves left with a fragment. In these brief attempts the stages suggested above have to be compressed, but even if omitted they must be kept in mind. As a rule a beginner requires from 20 to 30 minutes to set down his impressions in order. The following arrangement for a two hours' session has at any rate met with the approval of students after several years' experiment. First a sitting of forty-five minutes, followed by ten or fifteen minutes' rest. Next a pose of twenty minutes or the same time given to a memory exercise. The remainder of the sitting is occupied with ten or five minute poses, these being taken last because they engender a certain excitement which makes a longer pose seem dull and slow.

Referring again to the question of *movement*, mention may be made of the theory of Dynamic Symmetry as set forth by Mr. Jay Hambidge. It is not proposed to enter on a discussion of the theory here; it will probably provoke much discussion and controversy, but two points of interest in drawing from the life arise out of it. First it would appear that a maximum amount of movement obtains when the figure is contained within a square. If the rectangle enclosing the figure is narrower than a square, the action subsides, the figure shuts up as

it were. If the rectangle on the other hand is wider than a square, the action begins to partake of a creeping character which is emphasized as the rectangle is widened.

Secondly, the division of the enclosing rectangle whatever it may be, by diagonals and other oblique lines to important points give the maximum of movement within that rectangle. If the directions pass to less important points the action flags and weakens.

CHAPTER XI.
RELATED FIGURES.

WHEN the pupil has learned to draw a figure with some sense of proportion of line and appropriate expression of detail, it is time to devise other exercises. Too often students plod at the single figure year in and out. For their compositions they take a figure from their sketch book, add others, and then wonder why they do not come together happily. They will not because they have been seen isolated, and remain so even if a number are crowded together. When we watch people in real life or in the cinema, constantly their gestures and movements form a link between them. In dancing, which is the art of movement, the line is consciously rhythmical, but in ordinary intercourse, and all the more so because movements and gestures are unstudied, the line expresses also emotion in varying degrees. Two people meet, and their heads incline in conversation, the more earnest speaker laying a hand on the other's shoulder. These movements establish a sympathetic line or bond of union which creates a unified and controlling form. The speakers are not now two but one, and the lines pass from one to another. In a more

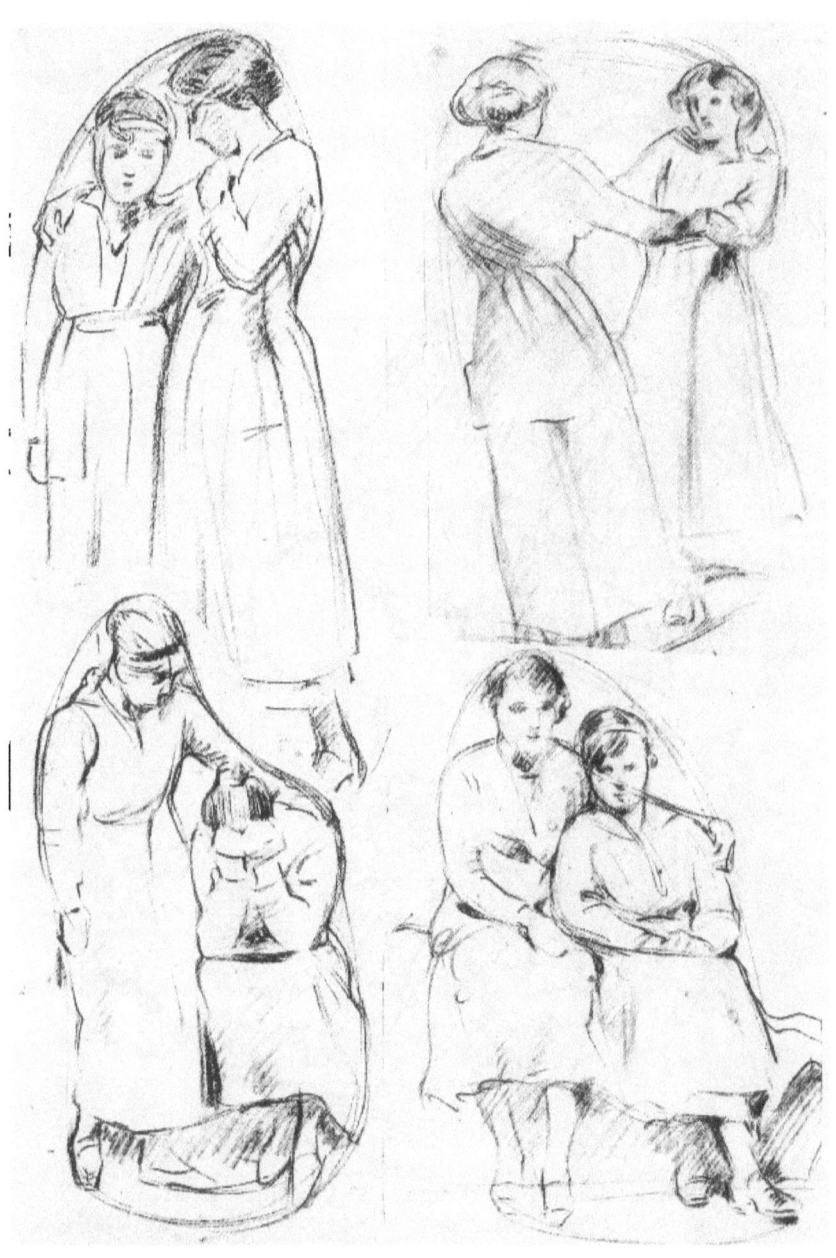

Fig. 23.

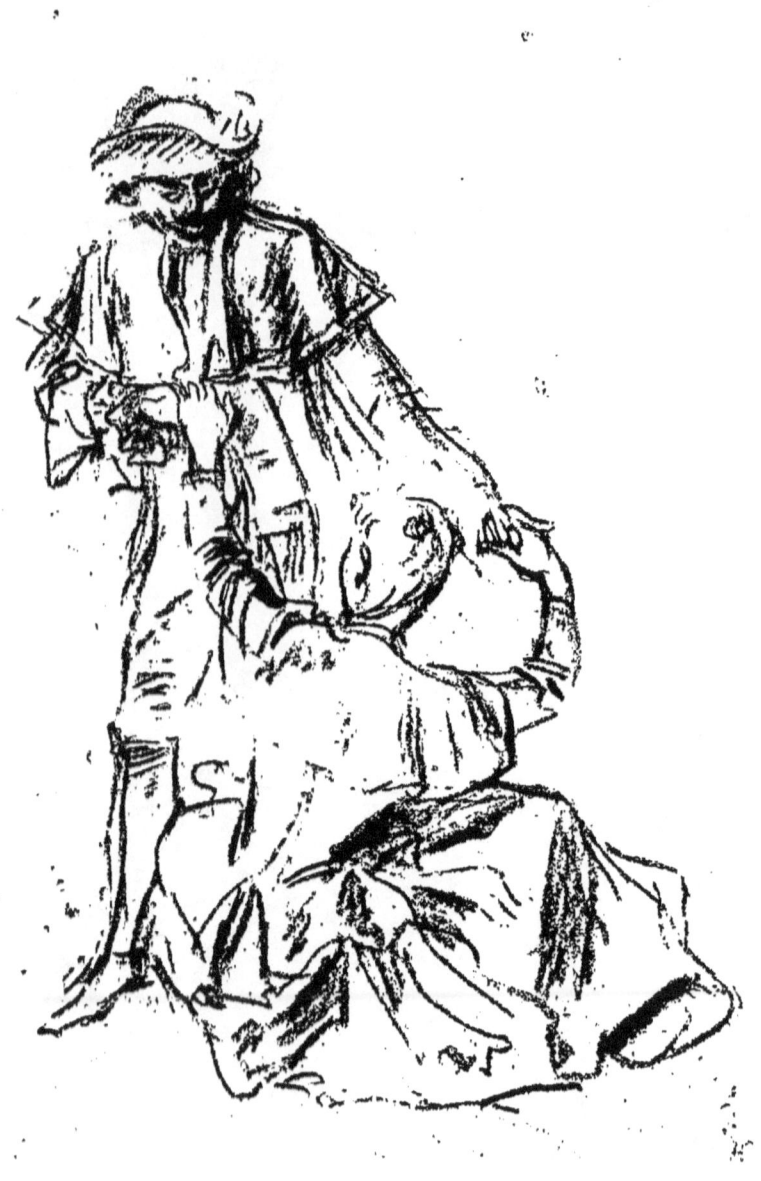

Fig. 24 A chalk drawing by Watteau. The lines of the arms flow together, continued by the lines of the drapery on the lady's shoulders. One almost expects the lady to rise.

obvious case, one figure bowed in grief, and the other bending sympathetically towards her, the lines flow together so obviously that the idea of consolation in sorrow is complete without the necessity for appropriate facial expression. The lines of the figures express the emotion.

In such exercises these controlling lines must be sought for at an early stage. It is worse than useless to draw first one figure and then the other, for the eye is then seeing the figures detached. The combination must be looked for. (FIG. 23—25).

In such associations as two figures pulling or holding hands, the lines formed by the united arms and hands must be drawn, and the two hands as one.

Two figures seated or standing with arms entwined furnish a good instance of the controlling line.

The sympathetic relations of the feet should be noted, and the variations in their position. Attention should be given to the hands which in the figure in grief form a cup in which the face is held, or where clasped round the knees follow the shape of the latter. (FIG. 23). Or again they form a bowl when they are used to drink from.

These exercises may be followed by combinations of three or more figures. There is no need to wait for professional models, for pupils in turn will be ready, for a few minutes, to act their parts.

Such work will enable the student to face the unconscious emotional gestures and combinations of real life, whether sympathetic or antagonistic.

A friend once told the writer that when making

studies for a series of compositions of wrestling, so violent were the movements that he had only time to select a contour, say pyramidal in shape, indicating the figures locked together, with perhaps a suggestion of the space between the legs. Afterwards, with the aid of models posed to fit into the sketch, the structure and detail of the wrestlers could be examined.

CHAPTER XII.
EDGE STUDY.

If a white ball be placed before a grey background, the contour of the light side will tell against that grey. The contour of the dark side will tell also, the background being a tone midway between light and dark.

Then, at two points, where the light contour melts into the dark one, the outline disappears, ceases to exist to normal sight. (FIG. 14). Drawings or paintings of objects can only be made to relieve, to take on roundness or solidity of appearance by following natural lighting, by noticing where the outline is lost. This is difficult to see and to represent, so accustomed are students to searching not for form, but for contours.

It need hardly be discussed at this stage whether the achievement of such relief to the point of losing the sense of the flatness of the plane on which the object is depicted, is necessary or artistic. The really vulgar portraits in the galleries are those which the admiring public declares to be almost "coming out" of their frames. But the art student has to learn the use of all weapons. For the poster he uses the broad outline which reveals everything, but flattens it also. In these

pages the student is not considered as composing, but as striving to acquire a mastery over structure and movement by means of the appearance, and to do this he must know how far he can go in the way of realistic treatment.

Experiment will prove to the student that whenever the whole contour is clearly defined, a flatness results. If the figure is viewed with the light behind it, it shows dark and flat; if the light is behind the spectator the figure is seen all in light without shadow, and again a flatness results. All realistic painters have used strong light and shade, from Caravaggio onwards, and all such have made use of this melting of the contour at the half-way points. In other words a continuous outline implies an incompletely expressed figure.

This paradox supplies the clue to the study of form by light and shade, in its simplest terms.

The object, whether cast or living figure, should be placed before a background midway in tone between the light and dark, that is, equal in tone to the half tone of the object.

Now in nature there are no outlines—only edges. Yet one must use outlines; one cannot be always smudging in backgrounds in order to reveal the form. The outline is not a part of the object, nor of the background, but an *imaginary* line sensed by the eye, and representing the *degree of contrast in tone between the object and its background.* This contrast can be represented by a line varying in intensity or even width. The line takes the place of a more or less mechanical background tone, and gives opportunity for close edge study

EDGE STUDY.

which is practically absent where backgrounds are insisted upon.

From the character of the outline it should be possible to determine the tone of the background. One can see on looking at FIG. 18 that the model was posed before a low toned background, although this background has been omitted intentionally. This is expressed by the strength of the line where the light falls on the contour, and by the softness of that part of the contour in shade, which approached the background so nearly in tone that a clearly drawn outline would have falsified the relations.

To put backgrounds behind studies of the antique or living model is to waste time better spent on edge study, and confuses drawing with painting, which consists essentially in *spreading* tone.

Drawings by students who overlook this principle of expressive contour, have a vague indeterminate effect. The contour of the light side is often drawn timidly and faintly with the mistaken notion that *any* line on that side is too dark. Or worse still, a hard line is drawn all round the contour. In this case students are trying to draw the figure by itself as if it could exist without an environment, which is unthinkable. Expressive drawing implies not only the figure but its background. All other drawing is mere diagram making, very necessary at times, but alien to the aim in this connexion, of realising the figure as completely as direct and student-like methods will allow.

The old way of simplifying the student's task was to place a white screen behind the object. This was

supposed to represent the whiteness of the paper drawn upon, thus freeing the student from any trouble in regard to the background.

But a moment's consideration will show that this ruined the exercise. First, the glare of the background unduly forced forward the contour in shade, which was furthest from the spectator (because generally the light is behind him, though to the left or right). Also the blackening of the edge by contrast destroyed the effect of reflected light, which students had been taught to allow for, and still did, though they saw it not.

Lastly, and most important, the emphasis of the pose is determined by the way the light falls on the figure, and this emphasis was destroyed by the white background, the contour on the light side being rendered ineffective, thus spoiling the pose, and making unity of treatment impossible.

Another feature of edge study which should be mentioned is the nature of the edge, both of the light and dark areas. How shall it be drawn or painted so as to express the volume of the form? The beginner looks at the edge of an object, and puts down a line accordingly. But solidity or mass is not to be compassed in that way, for if one looks at any round object, as a flower pot, the eye is naturally attracted to the line of shade dividing the light area from the dark that is, the eye forgets to look at the contours. Hence in representing solidity, the student should follow the action of the unbiassed eye, and should not, when drawing the contours of the object,

look directly at them, but at the line of shade, when these contours will at once fall out of focus and blur somewhat.

Here one comes upon a very important and interesting controversy already mentioned, which has agitated art schools of all periods. Not seldom the student is implored to be honest; to draw what he sees, to follow nature faithfully. But before a student has worked at a drawing five minutes he finds it quite impossible to follow this advice, for the conventions of his materials, and especially the limitations of pictorial representation, restrict his efforts, and he will be wise to try to understand these limitations. Honesty one can rule out of the argument; it is for greengrocers, not for artists, at least in this connexion.

The immediate problem before the student is whether he shall emphasize the edges of his object, with the result that he loses the effect of roundness, the object appearing as if cut out of card, or whether he shall concentrate on the volume of the object by blurring his edges. The primitive Italians and Netherlandish painters adopted the earlier method, and we see their work to be essentially flat in spite of much pains taken to model the form. Leonardo da Vinci, and those who followed him, have chosen to accentuate the roundness by blurring the contours. If the Venus of Velasquez in the National Gallery be examined, it will be seen that the contour of the cheek and shoulder has been brushed to and fro so that the edge is almost lost. Sir Joshua Reynolds often made edges wonderfully enveloped.

Early portraits (three-quarter view), however, show the hard edge of the further cheek; consequently the

nose, weakened by contrast, appears pressed against the face. If the contour of the cheek be covered by the hand, the nose at once relieves or comes forward.

Holbein's lines are hard because he was drawing with the definite purpose of providing himself with exact contours from which to paint. His drawn portraits were to be translated into painted ones, and he wanted exact form. The Windsor Holbeins show the contours marked by tracing on to the canvas.

The moral of all this seems to be that success in modelling form does not depend on keen eyesight. Extreme keenness of sight is often a disadvantage to young students, and not always taken into consideration by teachers, whose sight is losing its first sharpness. We see the result of powerful sight in Holman Hunt's pictures. Doubtless he saw like that, for he could distinguish the moons of Jupiter with the naked eye.

Fig. 18 shows that the contour of a figure need not consist in an unvarying line such as is produced by a piece of wire. It should be noted that the expressiveness of the line is conditioned by the way the light falls on the contours. Students wishing to give variety and interest to their outline often accentuate it in an arbitrary way, especially where bony forms crop up, without reference to the lighting. But natural lighting will give this emphasis more truly than any invented and artificial method.

Judged by this standard many careful and well constructed drawings are yet mere diagrams, because the variety of the edge is disregarded. This is seen, too, in cases as mentioned above where the contours of two

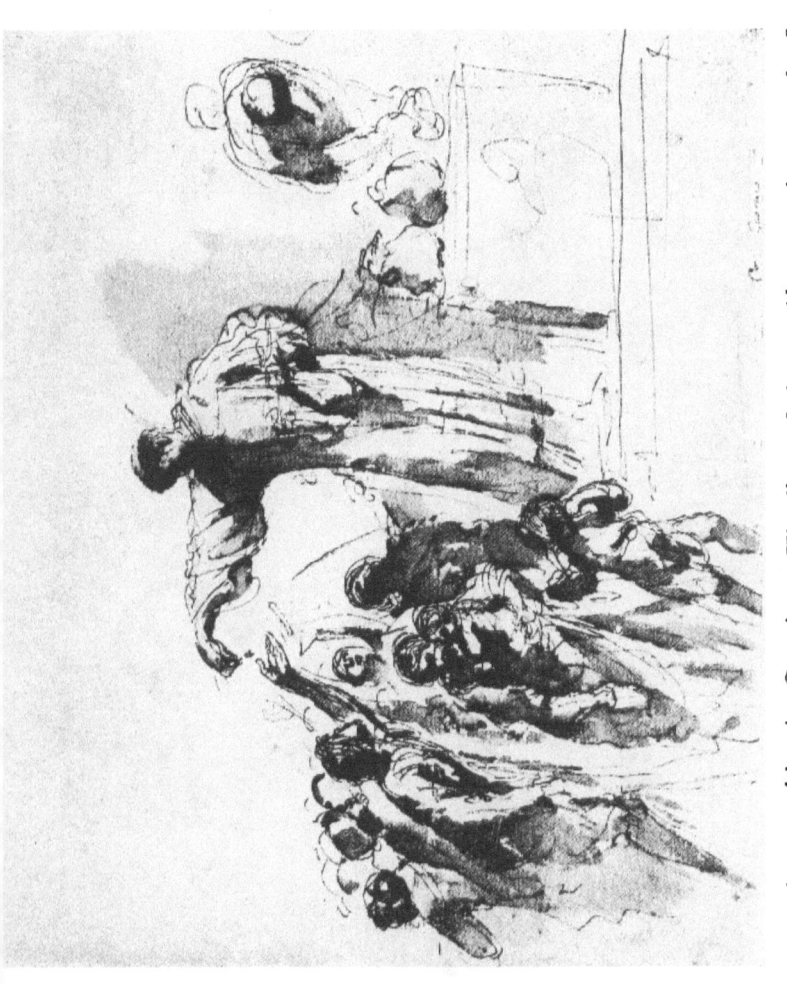

Fig. 25.—A composition by Guercino. The lines of the monk's gown rise upwards, flow along the arm and down the forms of the recipients, with a beautiful feeling for movement and rhythm. See chapter on "Related Figures." [British Museum.

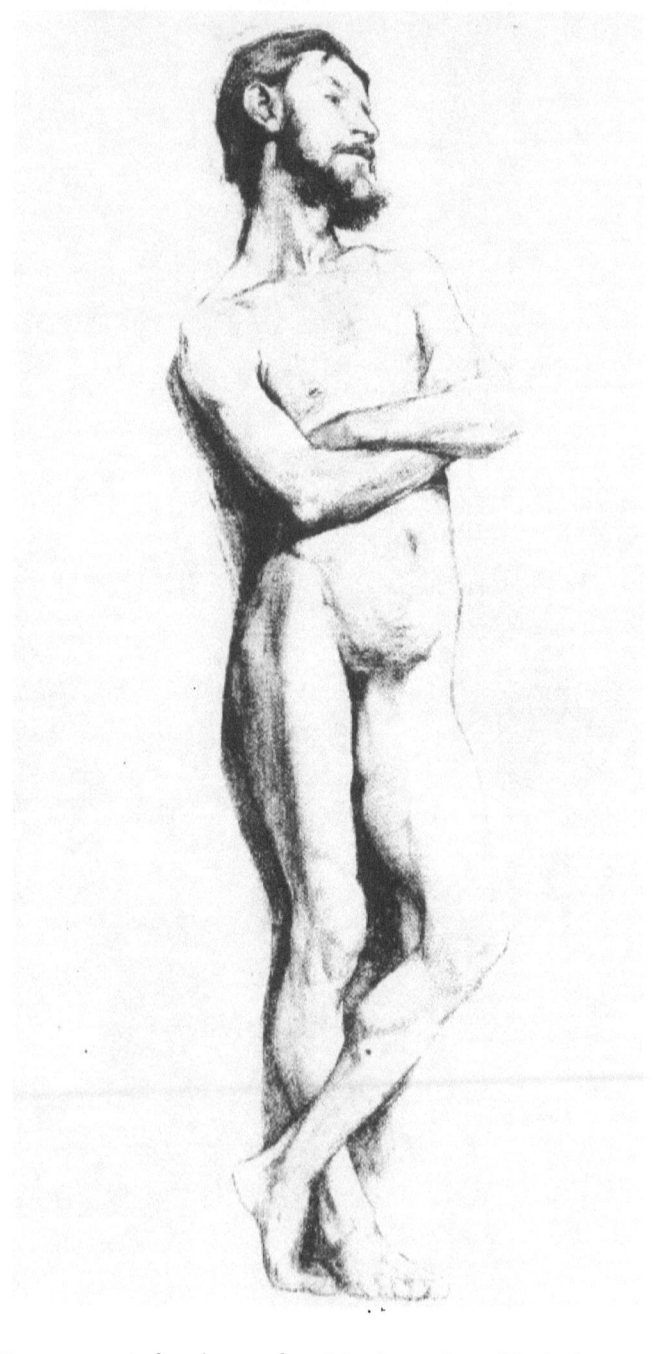

FIG. 25A—A drawing made with charcoal on Michallet. An example of variety of edge treatment.

forms both in light, overlap, the nearer contour being delicate and perhaps scarcely visible. These delicate, sharp-edged contours demand the most refined handling.

Appreciation of variety of edge may be stimulated by consideration of the dogma that "the opposite contours of an object vary in emphasis." The fault generally consists in drawing the contours say of a limb with lines of the same strength. Observation will show that they vary. Further, if two contours come together so that a Y shape occurs, the three arms of the Y are never of equal strength; the line of emphasis will ignore one arm, otherwise the eye would be pinned down to the meeting point of the three lines. These irregular Y's, of course, occur at many points in any pose, as armpit, neck and shoulder, ankle, and various creasings and overlappings.

CHAPTER XIII.
ARTISTIC ANATOMY.

ARTISTIC Anatomy, so-called, like perspective, when ill-digested, often leads a student astray. Many drawings from the figure are mere anatomical diagrams, looking as if the model had been flayed. Fresh from their books of diagrams students search the figure for anatomical details. They even ask the model to tighten the knee or the armpit, so that they may mark more definitely the forms of those regions. This does not mean that anatomy should not be studied, but that it should be used as a key to the construction of the figure, rather than displayed for its own sake. Moody, in his "Lectures and Lessons on Art," a book now out of print, but one well worth the careful study of the art student, says :—

"Intellectual work is the hardest work of all. . . . Just consider, for instance, the result of avoiding the effort necessary to master the position and details of the ankle. The want of that knowledge will probably plague you at least twice a week : it will delay your work, you will get into trouble every time you draw the figure, making altogether a sum total of annoyance, unsatisfactory work and feelings a hundred times

greater than the expenditure of time and thought which would have been necessary to surmount the difficulty at first."

First in importance is a clear knowledge of the bony framework and its articulations. It settles the movement and the proportions, and at the joints where the bone crops up and shows almost its actual build, it indicates the important accents of form by a squareness and clear cut shape, which must be appreciated if the drawing is to avoid wooliness. On the other hand the muscular masses fill up the gaps and suggest the first great lines of the pose.

All the parts of the skeleton which determine the surface forms should be carefully studied, and especially the shoulders and hips. The former may be described as a floating girdle, for they are attached only by the collar bones (to the notches in the breastbone), the remainder being free except for muscular and tendinous attachments. Hence the comparative freedom of action, while the complexity of structure, the combination of clavicle, humerus and scapula, add to the difficulty of expressing the forms. The hips, on the other hand, form a fixed girdle, firmly attached to the backbone. The two halves of the shoulder girdle can move independently, but the hip girdle moves only as a whole, like a basket tilted. When in a standing pose the hips are aslant, this means that the model is resting the weight on the leg to the side where the hip basket is higher, and therefore a vertical line drawn, say, through the pit of the neck, will pass through the ankle of that leg, which slants inwards in order to support the weight. The other leg, which carries little

or no weight, droops with the lower side of the hips, hence the knee of that leg is lower than that of the supporting leg. And by way of compensation the head and shoulders often slant in the opposite direction, forming a series of radiating lines which cross the long lines of the pose at right angles, and steady it. (FIG. 26).

The main articulations may be reduced to their simplest terms by a diagram such as is shown in FIG. 16A, similar to FIG. 26. Something like this construction must form the commencement of every drawing of the figure which has any claim to movement and structure. All the articulations including the shoulders are represented by cross lines. It is for want of the study of these crossings or articulations that the draw-

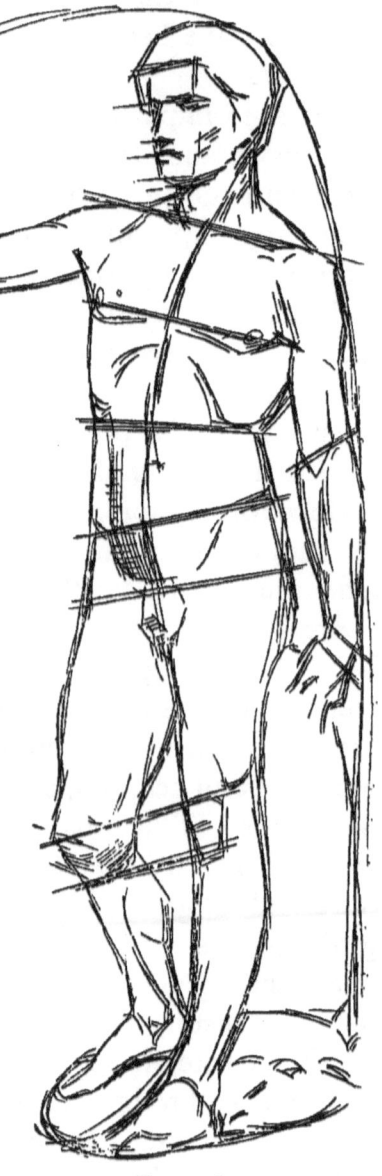

FIG. 26.

ings of beginners look boneless and yet wooden, for they appear to have no ankles, and wrists, to say nothing of hips. It should be noted especially, and the skeleton largely supplies the reason, that these crossings of the extremities are oblique. This is seen clearly in the elbow and ankle. In the latter the obliquity is caused by the fact that the inner ankle is higher than the outer, a matter of the bony construction. In the elbow the slant comes from the origin of the supinators being higher than those of the flexors.

FIG. 26 shows these slanting crossings at an early stage in the drawing. The point to be borne in mind is that anatomical construction corroborates right procedure in drawing the figure.

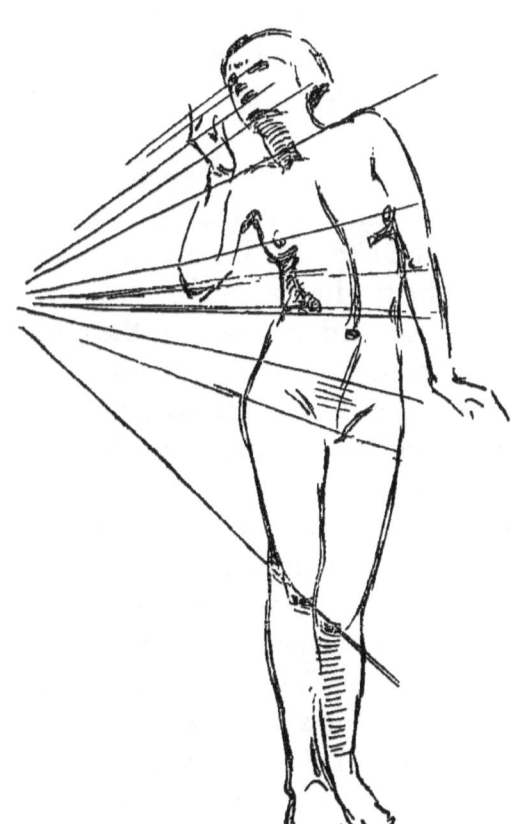

FIG. 27.

In poses with some degree of torsion as in FIG. 27, these cross lines, all marking the bony or muscular structure, radiate from a point at no great distance from the

figure. The greater the movement the closer in is the point of radiation. The matter has an interest for students as showing a structural basis for the composition of line which sometimes mystifies them. They are apt to think that these rhythmical lines, whether in the direction of or across the figure, are imagined by the teacher, and a real service is rendered by showing them cause and effect.

The old fashion of learning the muscles singly and detached is answerable for much of the wrongly applied anatomical drawing mentioned above. Usually they are seen in groups, and should be studied as such.

Too often the only glimpse students have of the nude figure in action is when the model walks to and from the throne. A regular exercise should consist in the model moving freely at will, the students marking the changes of form which take place.

This is not a book on artistic anatomy, for which students should study the regular manuals.

An anatomical detail often misinterpreted is the function of the neck muscle (sternocleido mastoid) in turning the head. When the neck muscle on the right contracts, the skull rotates, the mastoid process of the skull being brought forward, and it follows that the head is turned to the *left*. It is often supposed that the contraction of a sterno-cleido turns the head to that side, but observation of what takes place will correct the error.

Fig. 28—A drawing with black and white chalk on grey Michallet paper. The reticent use of the white chalk should be noted.

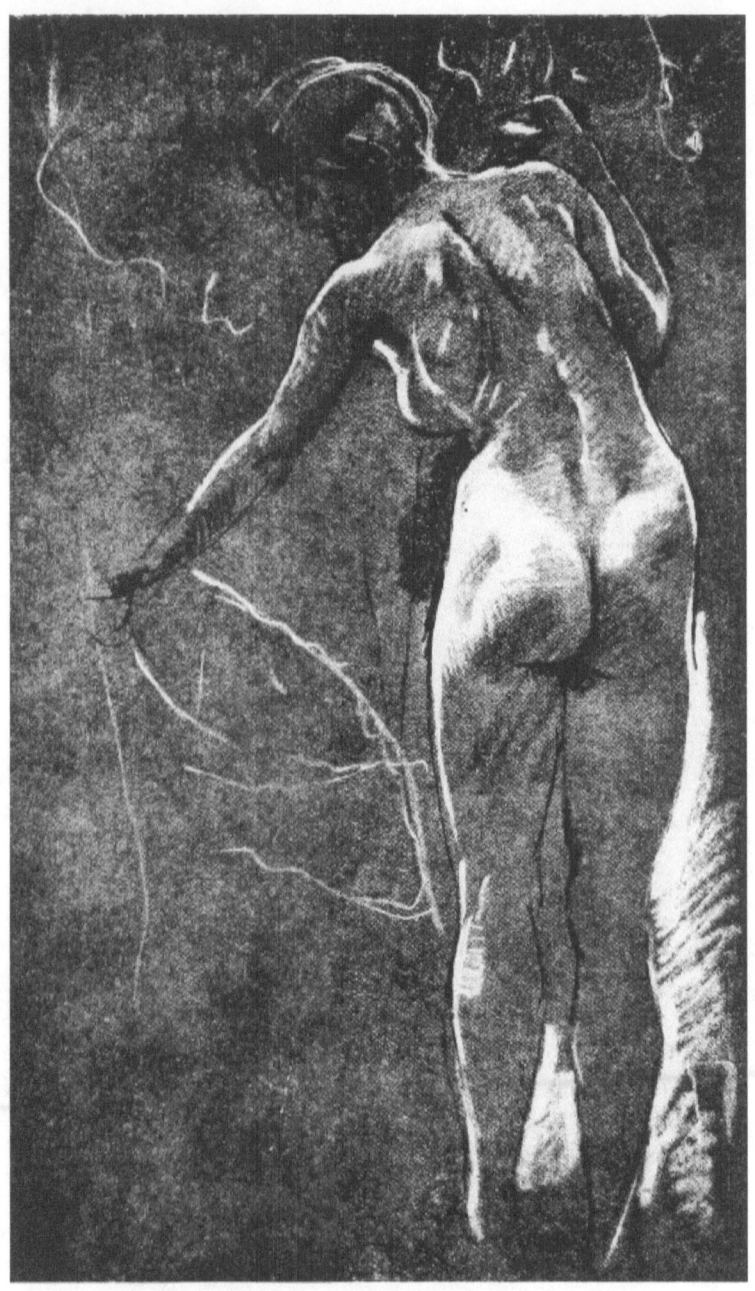

Fig. 29—A drawing on blue paper with black and white chalk by J. M. Swan. The simplicity of the work should be noted and the way the white chalk is used to divide the figure into a few planes. Large areas are untouched. [British Museum.

CHAPTER XIV.

DRAWINGS ON TONED PAPER.

TONED paper with black and white chalk is often used by painters, when making studies, for carefully chosen, it provides a ready-made middle or half tone, and hence saves time and labour. Especially is it suitable for drapery studies, and Lord Leighton's drawings in this medium are well known.

Students of painting should use this method sometimes when drawing, for it fosters modelling "in the light." With pencil or black chalk on white, as the tone of the object approaches the tone of the paper, so work has perforce to cease. That is to say, on white paper most of the modelling is done on the dark side, and the tendency is to leave the lighter tones more or less empty. Work on toned paper is concerned as much with the light passages as with the dark, and hence follows more closely the method of painting.

One common error may be noted here. It is that of first making a completed drawing in *black* on the toned paper, (and owing to its completeness the eye has subconsciously disregarded the tone of the paper and assumed it to be white), afterwards using the white chalk freely for the lights, with the result that all the tones are falsified.

When drawing on toned paper the figure should be

examined in order to determine which areas may be assumed to be equivalent in tone to that of the paper. The *black* chalk may be used first to place the figure, to indicate the chief darks, and to suggest the main structure, then the *white* chalk should be substituted in order to place the lights. Generally the *white chalk should not touch the black* (except for cases of special emphasis), a space of plain paper being left between the two, representing the tone chosen as standing for the tone of paper.

Often when working on toned paper the student darkens unduly the parts approaching half tone, only finding at the close of the exercise that the tone of the paper would have sufficed. *The untouched paper is the best part of the drawing* if it is in the right place and corresponds with the tones of the model. (FIG. 29).

In drawing from draped figures evidence should be sought of the form beneath. Beginners draw the drapery only, as if on a clothes horse. They sometimes stop short at a sleeve, having omitted the continuity of arm and hand. Even in a fully clothed figure much of the form is suggested by the planes and by the pull of the drapery from the points of support, this often resulting in a beautiful series of radiating curves. It should be remembered that the deep parts of the folds represent the figure, for there the stuff rests upon it, and these shapes should be carefully searched out. (FIG. 28). A good deal of interesting matter concerning drapery will be found in Leonardo da Vinci's "Notes," and in Moody's "Lectures on Art," while the subject is dealt with in Lanteri's "Modelling," Vol. II.

CHAPTER XV.
EARLY AND MODERN REPRESENTATION OF FORM.

IF an early painting be examined, even one so late as Botticelli's Venus, certain mannerisms are noticed which are of great interest to the student of form.

The painter has evidently not worked directly from the model. The treatment is "sympathetic" rather than the result of observation. He has perhaps drawn on his reminiscences of classic sculpture, or even from contemporary engravings of the nude.

Judged by modern standards, there is a lack of construction in the figure generally, and especially is this seen in the feet, which, like those in contemporary work, never seem to stand firmly on the ground, perhaps because extreme foreshortening forbids the clear representation of all the toes, which were invariably shown. All this in no way detracts from Botticelli's beauty of line and suavity of form. He might be said to claim kinship with the Chinese and Japanese masters, so easy and fluent are his contours.

Italian Art of the Trecento and Quattrocento periods exhibit generally lightly shaded forms. The expression is empirical rather than that of personal observation, a convention derived from wall painting.

Leonardo da Vinci changed all that and formulated the rules governing the expression of form by light and shade. In his work are seen the "lines of shade" and their soft or smoky (sfumato) appearance. He was the first notable academic, and on his work the teaching of light and shade, as now taught in schools of art, was founded.

Since Leonardo the study of drawing has depended upon "appearance." The photograph, essentially light and shade as it is, and simulating the endless gradations of natural lighting, has tightened the chain of tradition. Consequently students are told to be truthful, honest, to draw what they see, to *copy* nature—impossible task and misleading advice. Moral issues are needlessly dragged in. The main thing is for students to be *artists*. But if the test of appearance be conceded, if the object with its environment is to be represented, what are the limits of the convention which is called drawing?

First it is clear that it is quite impossible to show on a plane surface all the gradations of light occurring on a curved surface. In attempting to do so the student merely deceives himself, loses his way, and consequently all profit from his study of drawing in line and tone.

The great realistic painters, such as the Dutch and the Spaniards, chose a few tones. They painted in the general tone, and into this they brushed the dark and the light tones. On the latter they placed the high light, and in the dark the reflected light. Their practice shows that these few tones are the essential ones.

Drawings made with the stump are specially open to

EARLY AND MODERN REPRESENTATION OF FORM.

the objection that by continuous working, students delude themselves with the idea that they are making a complete expression of the tones of the subject, whereas the fictitious relief, apparently destroying the plane surface of the paper, is a vulgar and meretricious quality, crushing the student's powers of artistic appreciation.

Students should understand that all drawing is a convention, and that it is impossible fully to realise any object, except by means of a trick, (the history of Art is full of instances, from the grapes of Appelles onwards), and should be urged not to *copy* the object, but to express those essentials of form which they can discern. In a sense the more they try to make their drawings like, the more they cloud and confuse their artistic intelligence. Every drawing done should be an artistic effort, and made with artistic intention, for drawing cannot be divorced from art.

This disposes at once of the old-fashioned practice of outline drawing. Outline or contour drawing, such as the outlines of ornament (with sections) drawn by an architect for a carver to follow, is a convention used professionally, but as *study*, pursued for long periods, it is destructive of interest in the appearance of things.

Nothing written above is intended to relieve the student from the responsibility of taking his drawing as far as possible. We have only to look at the great masters, at the early work, say, of Velasquez, Rembrandt, Franz Hals, and at the drawings of Holbein, to see what an amount of eyesight they put into their work, what an incredible amount of pains they

took with mere details of dress, etc. Velasquez spent himself in studying the effect of light on homely pots and pans, to a degree which hardly any modern student has felt necessary. A friend of the writer once reported a conversation with a great living sculptor and decorator who, speaking of the modern pseudo-decorative effect obtained by the slurring of detail, declared that he would exhibit the very pores of the skin on his figures if it could be done. He meant that the most realistic mode of expression is possible in the hands of a true artist, and not only not incompatible with but enhancing the decorative effect he may wish to secure.

CHAPTER XVI.
DRAWING FROM MEMORY.

MANY professional artists from necessity have had to train themselves in drawing from memory long after their student days were over. The translation of the writings of Lecocq de Boisbaudran has had some share in the interest now taken by schools of art in the subject. Lecocq especially emphasized the necessity for the visual retention of a definite form, and drawing being taught in those days from flat copies, he naturally used them, thus obtaining the clear precise statement of fact which he desired. His first exercise was the outline of a nose, and from this his teaching extended over the whole field of representative and imaginative art.

Memory drawing as practised at present often takes lines quite other than those of Lecocq, sometimes missing his basis of definite form. Pupils are sometimes shown an object of intricate construction for a few moments, and are then expected to reproduce it from memory. They may have looked at it superficially, but they have not really examined it and made themselves thoroughly acquainted with its proportions and structure. Consequently after their memory vision has

become dim, they elaborate their so-called drawing from memory, with imaginary details. They must *know* the object intimately before they can draw it from memory; its construction, and especially its proportions, should be ascertained; it should be scrutinized from various points of view, and, if need be, handled.

A class of students drawing from memory gives the art teacher some puzzling moments. The slackest art student is often found to be far ahead of his fellows in the power of visualizing, and reproduces seemingly without effort, while students with more developed sense of form may find the memory exercise very difficult.

Galton, in his "Inquiries into Human Faculty," tells how in a "series of queries related to the illumination, definition and colouring of the mental image" addressed to "100 men, at least half of whom were distinguished in science or in other fields of intellectual work," he asked them to visualize "the breakfast table." The answers showed that while some saw the scene perfectly clearly, in full light and colour, with the objects so sharply defined that they could, as they said, have drawn them had they the power, others experienced gaps in their memory, a dimness of illumination, an indistinctness of form, while a number would not admit that they had any power at all of vizualizing.

Whether the power of drawing from memory be a "gift" or not, there is no doubt that the best results are obtained when memory work is regarded not as merely part of the study of drawing, but as a *system* in itself, such as, for instance, that practised by the Japanese. (FIGS. 30, 30A).

The late Joseph Crawhall was an example of a training in art exclusively through memory work. His early studies were directed by his father, who taught him to observe, and then make records from memory. India-rubber was not allowed, and attempts, one after another, were thrown aside until the desired impression was secured. All through life this habit of seeking after a completely artistic expression of his visual memory, persisted, and his friends have told their sorrow at seeing him destroy beautiful drawings, which, however, lacked some quality he sought. His desire to express himself was spontaneous, and overwhelming when it manifested itself, and often at the most inconvenient times. Another interesting feature was the sudden emergence of impressions which had lain dormant for a long period. One of his latest drawings, the subject of which was an episode from the Spanish bull-ring, was made fifteen years after he had actually witnessed such a scene. (FIG. 31).

His choice of subjects, animals and birds, and of his medium of expression, watercolour on linen, show him to have been much influenced by the Japanese. It is significant that at his death his studio was empty save for two partly finished drawings. There were no records of study, no bundles of notes, and no stacks of drawings, for as mentioned above, he destroyed all imperfect work. His drawings are hard to see, no public galleries having acquired any, but a good many reproductions of his work can be seen scattered among the volumes of the "Studio."

But while Crawhall may have been a case of a special gift, it is evident that all art students can profit by a

training in memory, and gain from it certain important benefits.

Whistler is an instance of an artist who trained himself to draw from memory, and Menpes' account of the way he studied his nocturnes on the spot with a friend, turned his back on the scene, and described the effect; kept it before his consciousness during the evening, and painted the picture the following morning, makes very interesting reading. We may almost consider him a pupil of Lecocq, some of whose students he knew.

Millet is another example of a painter, who lounged about Barbizon, apparently the laziest man there, but all the time absorbing the form and spirit of the peasant life around him. Afterwards in his studies he "squeezed the sponge" and produced those paintings, of which the simplicity of the composition, the largeness of the forms and the unity of the whole, make it certain that they were not produced out of doors under an umbrella, and amid the distractions of details and variety, which invariably occur when one is painting from nature.

When one looks at the drawings and paintings of the Chinese and Japanese—all memory work—one is amazed at the intimate character of the expression of form. The familiarity with the structure extends to the minutest detail. Early exercises in memory drawing should take note of this quality and insist on the exercises being of objects with which the students are familiar, or which they can examine closely. The procedure of examination might follow some such steps as these:—(1) general proportions; (2) type form, as cube or cylinder, on which the object is based; (3) main line of

enclosing shape; (4) construction in detail of the object.

Quite another type of exercise consists in asking the students to visualize a familiar object, which, however, is not produced at the time. An interesting exercise is one which Mr. Catterson Smith has initiated, consisting of drawing with the eyes closed. The exercise allows the following of the mental image by the hand without the embarrassment of seeing how far short the drawing comes. Certainly this method gives good results in composition, the movement being generally animated and rhythmical.

In drawing the figure from memory, it will be well to take into account its powers of movement. Most really interesting pictorial material is evanescent, moving, shifting. The clouds chase one another across the sky, birds fly, animals walk, trot or gallop, water flows, breaks into foam, or marshals in waves, people meet and separate, all the time constantly moving. If drawing is attempted in presence of this living cinematographic picture, too often one finds one's sketchbook full of shreds and patches. One is lucky to secure a line suggesting the movement without the detail.

A training in memory drawing of the right sort is wanted, and it should consist in approximating the conditions to those of the world outside the studio.

The life model is posing, say for time sketching. Every period of such work should include at least one memory exercise, and it is well to consider what will be most suitable. All art students will remember attacking a pose which captivated them, but which the model was unable to keep. It is these poses full of action

which are required for the memory exercise. The model should be required to take up a vigorous attitude, such as throwing, running or thrusting, where the limbs and torso are extended to furnish a fine general line, a pose which, as a rule, is the despair of the life room, but in this case to be kept for a few seconds only. The student meanwhile watches the figure, searching the pose for the long line which shall establish the proportions and movement of the drawing. (FIG. 32).

The model then rests, while the students seek to express their first generalization. The pose may need to be resumed several times before a firm foundation for the drawing is obtained. During repetitions of the action the students examine the construction, and especially the placing of the feet if the model is standing. Even the light and shade, so far as it explains the structure, may be memorized. The exercise has the further advantage of forcing the students to draw on right constructive lines. This method also secures good proportion, for working on the right principle, from big to little, the proportions are seized from the commencement, and are often better from this point of view than those of drawings made with the model sitting continuously.

Another advantage is that the student sees what is too rarely found in the life room, the model in strong action. When a model is put up for a long period, the pose necessarily degenerates, because other muscles are brought into play. An experienced sitter is often an adept at making slight compensating alterations in the pose. With a view to assisting the model, aids such as

FIG. 30—These drawings from Japanese copy-books are intended for tracing from until the pupil is line perfect. Not only are they beautiful examples of brush drawing but the objects are associated in a symbolic way, the motives in Chinese and Japanese art having to serve a double purpose. But these trammels seem to stimulate the artist to more original and beautiful compositions.

Fig. 30A—The Japanese masters have left behind precise and direct drawings of every natural or fashioned object existing in their country. It is easy to see what an asset this is to a system of memory drawing. The west is without such a legacy.

FIG. 31—A memory drawing by J. Crawhall in water colour on brown holland.

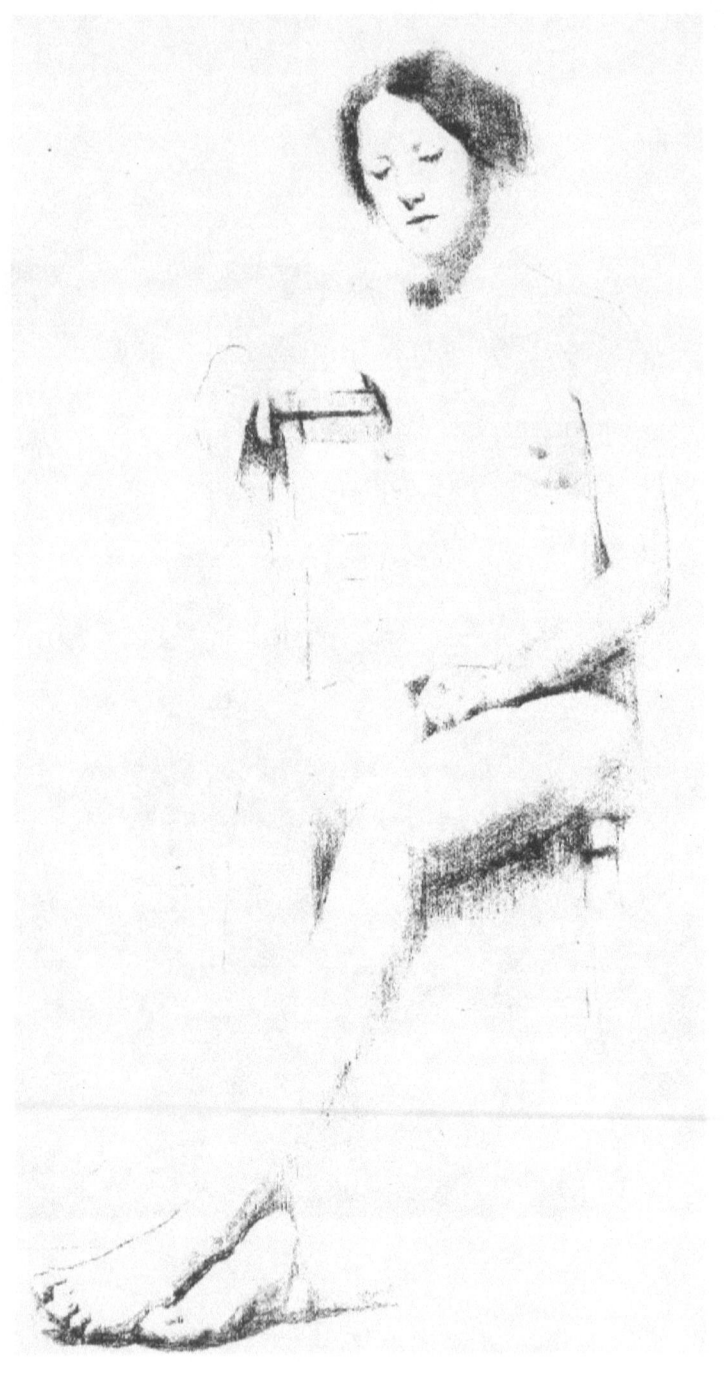

Fig. 31A.—Drawing with charcoal on Michallet paper. The sensitiveness of the contour should be noted.

a wedge placed under the heel when off the ground, are often used, or a hand in the act of pushing is supported, both cases a complete contradiction of the original idea. Students, seeing these devices used, become imbued with the notion that the model posed is a fixed object, and feel aggrieved if they detect the slightest deviation.

CHAPTER XVII.
ANIMALS.

ANIMALS, including birds and insects, are excellent material for study, because, by reason of their rapid movements, they quicken the eye. The student who can follow the changes in position which even a captive dove makes, will find the movements of the larger quadrupeds and of human beings comparatively slow and easy to record.

The bird's plumage is at once a complexity and a simplification. The feathers, by reason of their continuous overlap, unify the contour, but, on the other hand, tend to hide the bodily structure, which, however, may be discerned by careful watching.

A common dove, which requires only a small box or cage, a handful of dari, or other seed corn, daily, and lives for years in captivity, apparently in perfect health, is one of the easiest of creatures to keep. It has none of the nervousness of most other domesticated birds, and may be fondled and examined without fright or suffering. In its plumage it is a model of the beauty of order, and its movements being more sedate than those of smaller birds, render it eminently suitable for study. (FIG. 33).

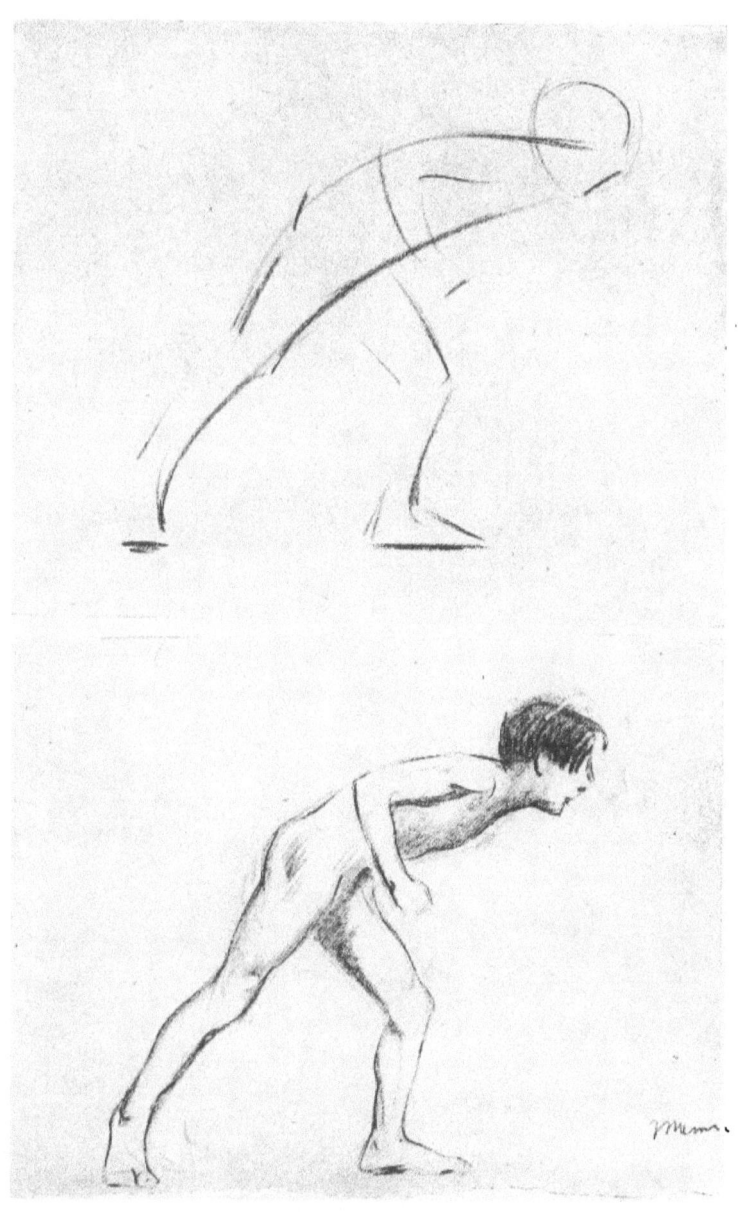

Fig. 32—A memory drawing of a figure in strong action. The upper figure indicates the movement by establishing the long curve running down the trunk and right leg.

FIG. 33.—Sketches of a dove showing the arrangement of the plumage.

It should first be impressed upon the student that birds in their structure approximate to that of animals—are more like than unlike. The wing, for instance, is a specialized arm, and if a dove is handled, the humerus, radius, wrist and thumb can be detected. The butt of

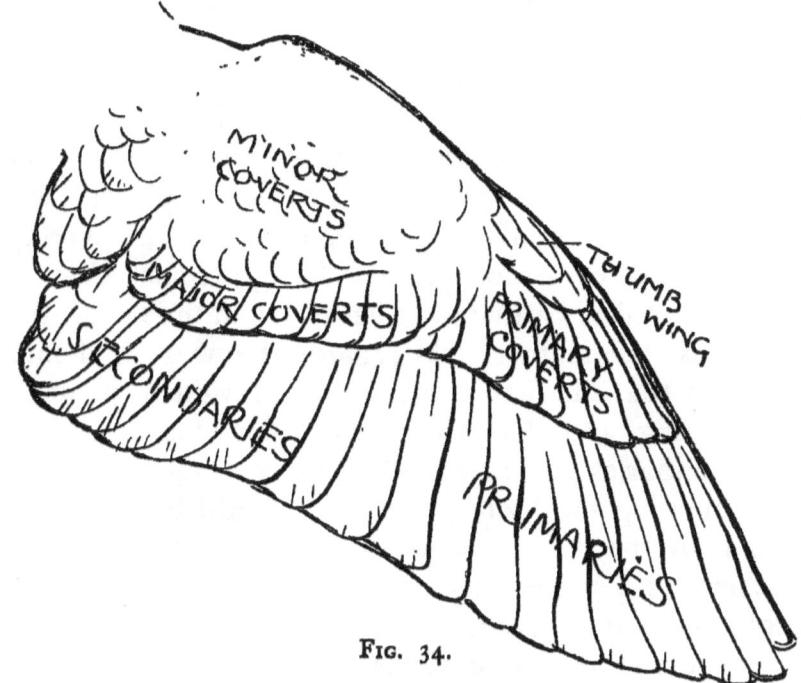

Fig. 34.

the wing corresponds with the human wrist, but it is capable of doubling or flexing more fully than the latter, so that the bird when at rest can pack the wing into a small compass, the humerus, forearm and hand taking the form of a Z. The hand and fingers have coalesced, providing attachments for the strong pinions or primaries which beat the air; the secondaries, softer and weaker in structure, grow from the fore-arm and the

so-called scapulars from the humerus. The bases of the long feathers are covered by smaller plumes or coverts, the whole being bound strongly together by ligaments, so that the removal of the flight feathers from the wing of a large bird demands great force.

Especially should it be noted when handling a bird, that the feathers are not distributed all over the body but occur in tracts, leaving naked areas. If the dove be turned over carefully and its breast feathers blown aside, the large area of the breast, void of feathers, will be seen. Again all the feathers of the upper surface, with the exception of the smaller wing coverts, overlap like the tiles of a roof, so that the uppermost feather might be said to be that next its beak and the lowest the outermost tail feather. As regards the wing, it should be noted that the first primary is the lowest in point of overlapping, and if one watches a bird close its wings the secondaries will be seen folding over the primaries. In examining the living wing care should be taken to hold it by the wrist, and not by the tips of the flight feathers, as a sudden movement on the part of the bird might dislocate a joint. The elbow may be distinctly felt on the reverse side of the wing, but is never seen from above. The thumb may be felt, and its little group of feathers noted. (FIG. 34).

What is known as the leg or shank is a specialized foot, the joint above corresponding with the human ankle. The knee cap may be felt higher up under the skin of the flank.

The back claw is more like the human thumb than the big toe, acting as it does in opposition. It should

FIG. 35—A drawing by J. M. Swan of a puma walking. The feeling for structure should be noted. The lines of the legs are carried right up connecting with their corresponding girdles. The right scapular is raised above the other because its foreleg is nearer the vertical than the left. From behind, the pelvis would appear depressed to the right. [British Museum.

Fig. 36—A drawing of the Dielytra or Bleeding Heart, showing how the plant conforms to a main curve, while the leaf clusters and single leaves follow the same rhythm, the whole being an instance of subordination. The arrangement of the flowers illustrates the same principle.

be noticed that this claw has two joints only, counting its articulation with the foot, the second claw three joints, the third four, and the fourth or outside claw five joints. This is usually the smallest and weakest digit, like the human little toe.

The neck of the bird commonly takes an S shape, slipping in and out of a notch in the sternum. When at ease the S is emphasized with a corresponding fulness in the neck, while when alarmed the neck is stretched the S losing its curvature and the neck its fulness. As everyone knows who has carved a fowl, the lower back or dorsal area of a bird is determined by a fixed bony framework, and hence is quite incapable of change of shape.

The anatomical structure of mammals corresponds more closely with that of man. As in birds, however, the hands and feet are specialized. What is called the knee of the foreleg of the horse corresponds with the human wrist, the hock of the hind leg being analagous with the heel of man. As in man the shoulder girdle is connected with the trunk mainly by muscular attachments. Hence the horse jumping off with the force afforded by the bony continuity of the trunk, and pelvis, lands with an impact of, say, four tons, on its fore feet, which, by reason of the elasticity of the attachment of the shoulders to the trunk, sustain the shock without injury.

This freedom of the shoulder girdle shows itself very markedly in loose limbed creatures like the cat when walking, the slinging of the body between the front legs causing it to sway. When a fore foot is advanced the

shoulder on that side is depressed, because the foreleg on the other side is supporting the weight, the arrangement reminding one of the slant of the hip-basket when a person rests the weight on one leg. (FIG. 35). In the case of broad backed animals as the horse, when a hind leg is advanced or raised from the ground the tilt of the pelvis is very pronounced.

When studying quadrupeds in motion, the student should first try to represent the walk of a slowly moving animal like the cow, which uses its limbs exactly as a crawling child would do. A hind leg moves forward followed immediately by the foreleg on the same side. Then the other hind leg moves, followed by its foreleg. (FIG. 35).

Manuals of comparative anatomy should be consulted for detailed statements of the bony and muscular structures. Here it will suffice to point out that just as in man the arm is continuous with the shoulder and the leg with the hip, so with quadrupeds. The legs should not be considered merely as those parts which protrude from the trunk, for the foreleg includes the shoulder blade, which moves with it, and similarly the hind leg is involved with the pelvis. In both cases structural lines reach to the back. (FIG. 35).

In the case of shaggy and hairy animals like the bear and wolf the set of the hair and the influence of the hair whorls should be studied.

Speaking generally the mental attitude of the student is often shown by the too irregular lines of his drawings of animals. He aims at depicting a large content of forms, where he should look for controlling

lines, orderly arrangement and structure. This is especially true in regard to birds and insects, creatures which fly. The power of flight implies regularity and symmetry. Not seldom a drawing of a bird purporting to be alive, shows, by its raggedness, and by the feathers sticking out in odd places, that it has been drawn from a stuffed specimen.

CHAPTER XVIII.
LANDSCAPE.

DRAWING from still life from the living figure, and from the antique, gives practice in construction, line and tone, but these subjects all suffer from the defect of being relatively small. When students work out of doors, whether at buildings or landscape, new problems crowd upon them. The difficulties of estimating relative proportions, of, as it were, dilating the eye to embrace a large object such as a tree or tower, have to be grappled with, as also the question where one has to begin, what area is to be taken in, and whether the angle of vision is to be wide or narrow. For example, Degas, in his interiors with dancers, embraced a large area, so that one feels oneself amongst the figures, whereas Corot kept his figures much of a size, that is, he *surveyed* the scene from a distance. Then there is the difficulty of aerial perspective, as it is called, quite wrongly, the weakened accent and blurred detail of distant forms as compared with those nearer the eye. A distant cow, for instance, should not be drawn as a foreground object in miniature. At a certain distance the legs and horns disappear. Lastly, there is the more prosaic but immediately press-

ing problem of the vanishing of receding parallels of building, etc., especially those above the eye.

For discipline in all these matters, buildings afford excellent material. Turner, by his early studies of country mansions and ruins, laid the foundation of his facility in handling masses of architecture.

It has often been remarked that the most difficult thing to draw out of doors is the earth's surface—the horizontal plane. Upright things are comparatively easy. Houses, trees, mountains and people correspond in position with the vertical plane on which in theory one is drawing, but fields, roads, rivers, clouds, flights of birds, etc., at right angles to this plane are apt to give trouble. The bias of vision causes such objects to be drawn as if they were oblique planes sloping upwards to a high, vanishing line. Clouds suffer especially, and a "vertical sky" is very common in student's work.

In this connexion a flock of sheep would be a good test of a student's power to depict a horizontal surface. Their backs form a level plane which persists although the individual elements move to and fro. Anton Mauve and Jacque drew sheep well constructed, both anatomically and in the mass.

In reference to this question of the representation of the horizontal plane, it should be noted that ancient art, such as the Egyptian tomb paintings and Assyrian bas reliefs, ignored it in favour of the processional form of composition, in which the feet rest on what corresponds with the ground line of formal perspective. One often finds children doing the same thing; their figures walk along the bottom edge of the paper, the ground plane

being assumed. Some of the great Italian decorators adopted this device, which gave dignity and loftiness to their compositions. It is to be seen in Mantegna's "Caesar's Triumph," at Hampton Court.

One of the most fruitful causes of a failure to obtain horizontality is beginning the foreground too close to the eye. Corot should be studied in this respect, for, as remarked above, he generally began his foreground some distance ahead. In this way his figures are much of a size without the enormous disproportion between foreground and middle distance figures, which constantly startle us in modern work, and which the layman instinctively resents,—and rightly, because such work betrays a failure to understand the necessity of a convention of representation.

Art students too often think of landscape not as material for study of form and composition, but as a mere sketching ground. Incidentally they add to their difficulties by working outdoors only in fine weather, and generally in July and August, choosing also the middle hours of the day. They should remember Corot, who, soon after the sun had risen, shut up his painting box, remarking that the beauty of the scene had vanished. Painting in bright sunlight and heat tax the powers of a well-trained artist, but these very conditions lend themselves to *drawing*, to a certain precision and fixity of form, and yet few art students are seen *drawing* out of doors, compared with the numbers sketching with water colour.

Masters of landscape have studied out of doors with the point from Claude onwards. If composition is the

theme, washes of grey or black will give opportunity for study, which the gay water colour pigments the student loves to dip in do not allow. They divert his attention from the fundamental masses of his composition. Such material as trees, rocks, the surface of water, rough or smooth, the varying aspects of cloud systems, often confuse the student because its appearance, while based on well-defined structural laws, yet in its apparent irregularity of contour, or its fugitiveness, presents great difficulties, and he often fails to discern the underlying structure and order. But if the student is to realize the meaning of draughtmanship, which, however, is of no value unless one has something to say, a message to express, all visible natural phenomena are profitable exercises.

The landscapist, for instance, must make himself intimately acquainted with tree structure, must know one species from another, and must devote much time to drawing rather than painting, because by drawing one arrives at a clearer analysis of structure, the bones, or branching structure as seen in winter, the way this is clothed in summer by foliage, the masses of which have a characteristic form for each species. Even the kind of stroke by which the edges of the masses are expressed must be sought, for example, the saw-like edge of the oak or the more lobate edge of the walnut or horse chestnut. The old drawing books of trees were not so much off the mark, though now considered out-of-date when they began their study of tree forms with a page of scribbled foliage—a recipe as it were for each tree, but which the student will arrive at as a result of his own striving.

The study of rocks, hills and mountains, of reflec-

tions in water, and the forms of waves and tumbling water must be studied by the same searching eye, always watching for structure and orderliness of form. Ruskin's "Modern Painters" contains much that is of great value in this respect and, apart from its art philosophy, should be studied for its practical art teaching. Ruskin was a great art teacher, and his exercises were always well conceived.

This is not a manual of perspective, and indeed students who use their eyes, and occasionally hold up their paper to cover the scene they are working from, will not make outrageous mistakes.

Much of what is known as parallel perspective is worse than useless, but a course of formal perspective on common-sense lines, the conditions approximating to those of ordinary vision and including reflections and shadows, will be of the greatest assistance, because the student's attention will be drawn to the broad planes which form the surfaces of the earth, sea, and sky. These planes being the groundwork of pictorial composition perspective enables the student to define their relations and interpenetration, under the simplest conditions.

CHAPTER XIX.
PLANT FORM.

MR. R. G. HATTON, in a passage in one of his books, speaks of the difficulty he finds in conveying to his pupils his own sense of the peculiar beauty of flowers—a beauty all their own and quite distinct from that of children or women.

Students' drawings of plants often betray their lack of appreciation of the beauty of the form they think they are depicting. Like trees and shrubs, they are invested, by a careless eye, with the same untidy irregularity. Yet this is merely the superficial view. If we consider the delicacy of a seedling, so frail and so liable to all sorts of accident, the wonder is not that it is irregular, but that a plant's appearance is in any way orderly and beautiful. Exposed to a careless foot, cold winds, attacks of insects or plant parasites, and, above all, to the accidental development caused by varying distribution of light, yet it always shows itself true to the laws of its growth, arranges itself according to its order among plants, and in spite of caterpillar holes or broken stems it succeeds, for only a careless eye fails to see this order, and beauty of growth, which we call structure.

A plant in flower may be compared with a beautiful woman putting on her most alluring raiment, and certainly to succeed in expressing this beauty we must allow the plant personality, almost we must imagine that we ourselves are plants, that we desire to ignore the ravages of insects, etc., so that we may see the flower as it desires to be.

To ensure some measure of success in securing orderliness, we must understand that the method of drawing previously used is here of the same value. It is drawing bit by bit, flower, stalk, leaves, as they happen to come, that produces irregularity and ugliness; and unfortunately flowers lend themselves to this method or want of it. The plant rather invites a separate scrutiny of its parts and seems to remain quite like a model sitting passively, prepared for a long pose. It should be noted, however, that the flower is not really passive, that it exhibits *energy* of growth in all its structure, in the unfolding of its leaves and flowers, in the new growth from the axils and in the *line* or curve of its stems, which varies in each species. (FIG. 38).

This energy in the most delicate of plants is often unheeded. For instance, the springing forth of the petals from their base is often rendered with a slack curve quite unlike the vigorous form of the corolla which the flower reveals, just as in the case of human action we have seen that often the drawing makes it tamer and more inclining to the passive. In this connexion Japanese drawings and prints should be studied. Their renderings of the chrysanthemum, for example, have all the vigour and movement that can be desired. The petals unfold and twist,

PLANT FORM.

and yet show the subordinating power of radiation. A student's drawing of the same flower often misses this, the dominant impression being that of slack untidyness.

Therefore, as the first strokes of a drawing of the human figure should show its inclination, and the directions of the torse and limbs, so here the characteristic line of stem and general contour of mass of foliage or flowers should first be set down. (FIGS. 36—38). Mr. Walter Crane once called this the "invisible" line, to which the blossoms or leaves conformed. It is a remarkable fact that if the hand be passed over the flowers or leaves of a plant, it describes a curve varying according to the type, exemplifying the law of growth that parts of a living structure tend to merge into a single form. The authority just mentioned was fond of drawing a bunch of downy ducklings squatting together in the farmyard, producing in the mass a strong resemblance to a full-grown duck. The rounded lines of the elm and chestnut produced by myriads of small leaf forms, and a similar curve formed in winter by the leafless twigs are further examples of the law.

Given a drawing of a plant commenced with main structural lines, it should proceed to the expression of the details in the same manner. The groups of leaves being set down, each leaf may be seen to have its main shape, no matter how many lobes or divisions into which its edge breaks up. Each flower, too, has its type form, often cup-shaped, like the buttercups and wild roses, and no matter how tormented by wind, etc., the separate petals, nor how irregularly they are turned or twisted, the main lines of growth should be carefully looked for, if one

dared to say it, a drawing of a plant should at the commencement be more orderly and regular in its forms than the plant appears.

As to a knowledge of botanical structure, it may be as valuable to the student as artistic anatomy when drawing from the figure, though, as Lewis Day once wrote of plant drawing, if the eyes are well used the structure will not go far wrong.

For purposes of study of form, how far should one take a drawing? There is some difference of opinion here, but one may say that the limit is reached when the student's observation fails him. One sees sometimes plant drawing full of shading that is not so much the result of observation as of industry.

Drawing from the plant in outline is an attempt to express the form as it may be required for purposes of design. But this flat, would-be decorative treatment, defeats itself, for such a drawing is of use only for certain kinds of work—flat pattern. A study can never be bodily appropriated for design purposes. Every etcher knows that his drawing must contain much more than the needle can use.

Therefore the suggestion is made here that the plant drawing instead of being expressed by outline merely, however careful and deliberate, should be carried as far as the student's powers allow, first because as an exercise it is beneficial, showing what degree of refinement and detailed structure is possible in a drawing, and secondly because the more completely a student expresses his drawing, the more likely is he to have mastered the

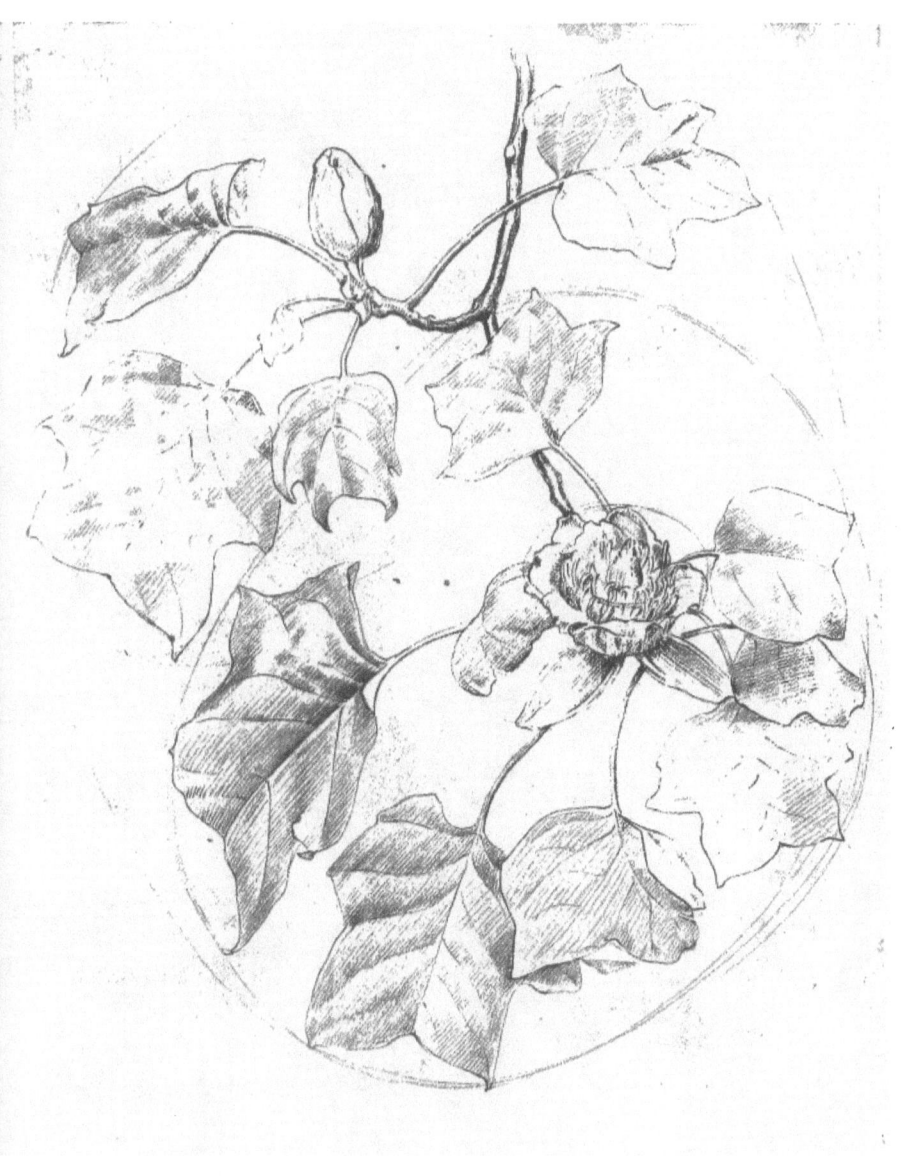

Fig. 37—This sketch of a branch of the tulip tree shows that leaves apparently irregular and wayward in arrangement, conform to underlying rhythmical shapes, in this case ellipses. The flower is beautifully cup-shaped.

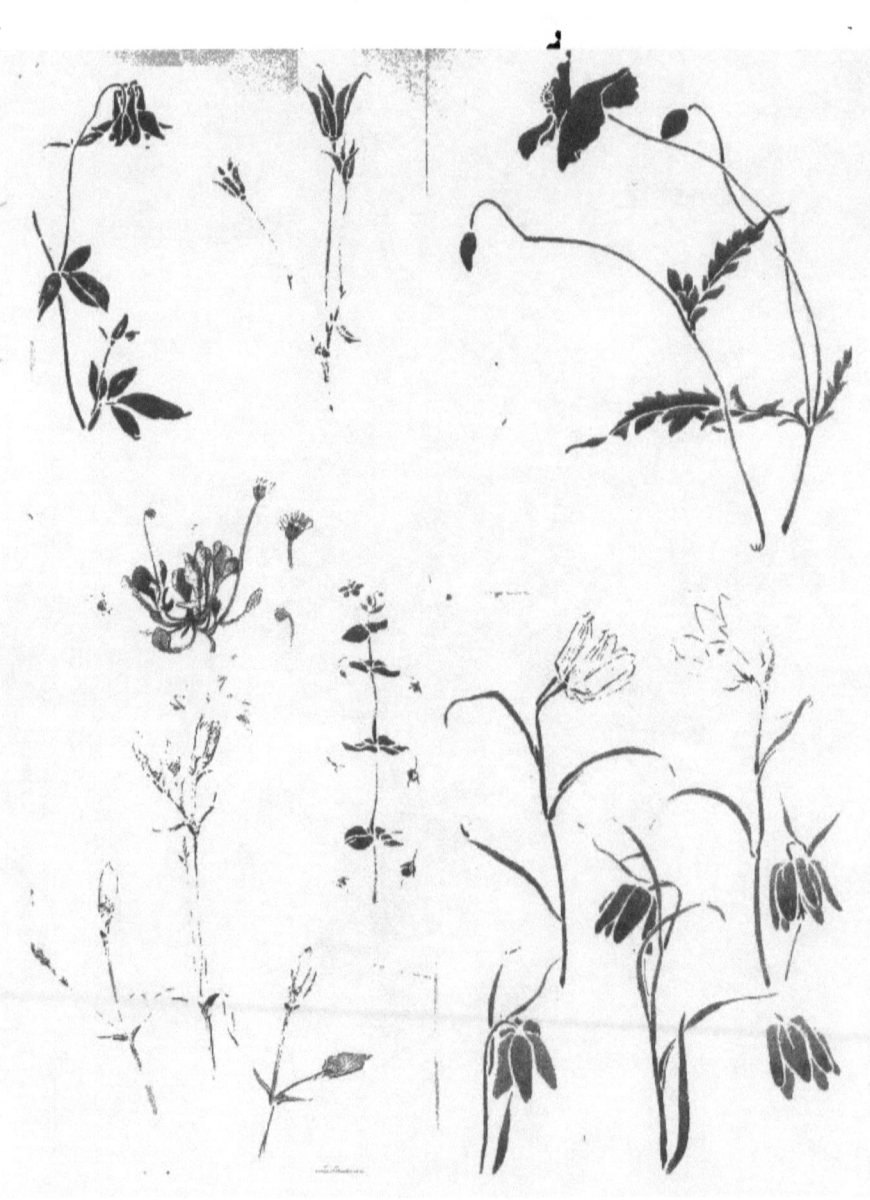

Fig. 38—These sketches of plants show that each species has its own curve or line of growth, too often disregarded by the designer.

PLANT FORM.

structure of the plant, and the more useful will the drawing be for reference.

Design and composition can be treated here only incidentally, but it may be said that the principles underlying these studies, while they may be discovered in all natural form, may perhaps be seen most clearly in plant form. The principles of repetition, contrast, radiation, continuity of line and variety are all clearly exemplified, which perhaps accounts for the instinctive way in which assent is given to its appeal to the sense of beauty, and the general acceptance of plant form as the universal motive for design.

To take one principle, that of radiation, as an instance, it will be noted how the lines of the plant seem consciously, as it were, to obey this law, which is clearly seen in the arrangement of the stems, flowers, leaves, etc. The structure takes cognizance of all the principles, but the plant seems to acknowledge radiation as its first law of beauty in form.

Speaking generally the student of plant form is apt to produce snippets of detail rather than a carefully composed rendering. Without taking liberties with the plant the space at one's disposal and the arrangement of the forms on the page should be carefully considered. Every drawing should be an exercise in composition.

CHAPTER XX.
DRAWING AS A PREPARATION FOR PAINTING.

"MAKE a careful drawing before commencing to colour," is a maxim art students hear very often, yet in spite of it (or because of it?) the advice does not always or often ensure success. It may be conceded, nay demanded, that the study of colour by painting must be guarded by careful search after form, without which colour can hardly be said to exist, and it will be well to discuss what constitutes a useful preparation for painting. The difficulty which confronts a student is that for this groundwork, he must, as a rule, use an implement other than the brush, thus dividing the work into two stages, first a drawing made with a point, then a painting with a brush. With charcoal or pencil one is seduced into doing the sort of work characteristic of the implement. Assuming the exercise to be a portrait in oil, a more or less complete expression of the model is often made with charcoal, pencil, or chalk, outlines of features, etc., being firmly drawn, outlines which one is dismayed to find, disappear under the first broad strokes of the brush, or if one firmly resolves to keep within one's edges, the paint shows hard and meagre at the edges,

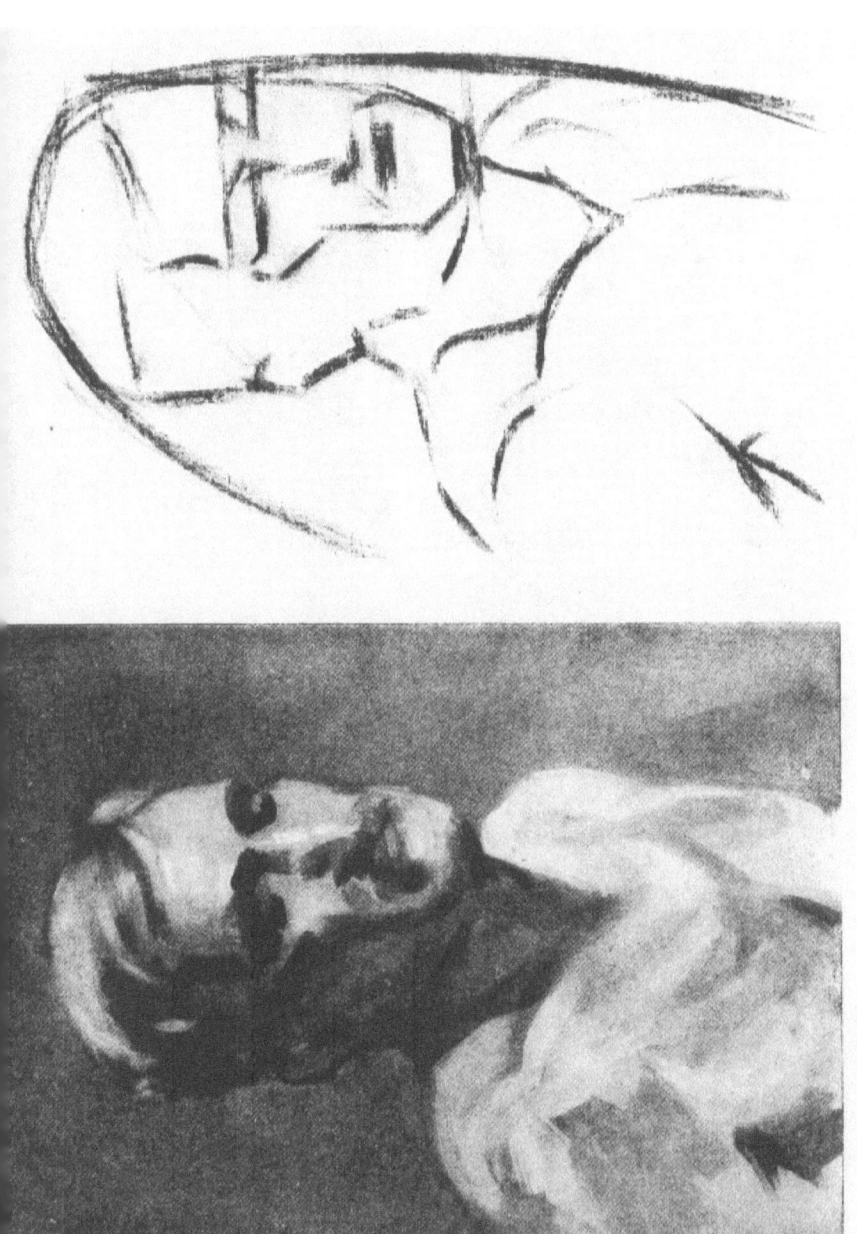

Fig. 39—A "lay in" of an oil study with the charcoal sketch establishing the general line and chief planes.

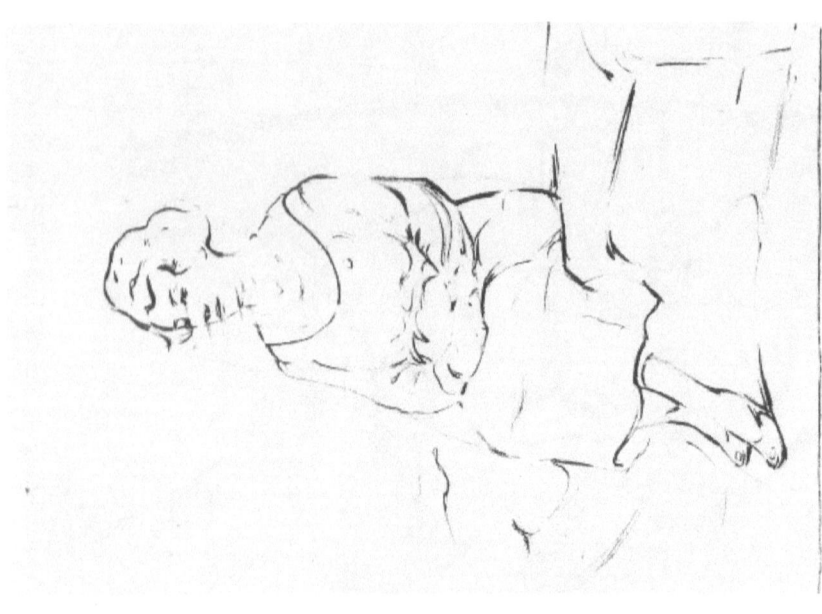
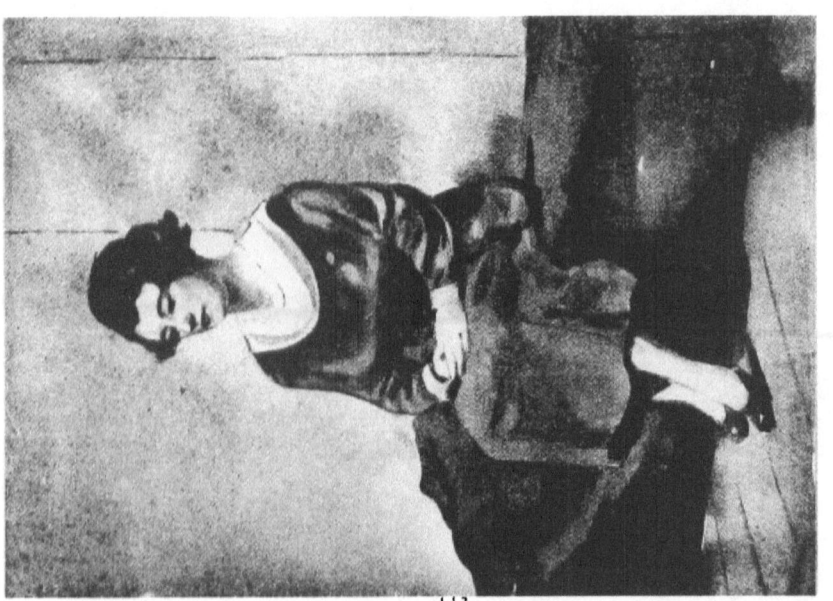

FIG. 40—A costume study in water-colour. In the dark hair etc., the line forms the boundary, and is lost in the tone, but the lines of the light collar, hands and feet, are drawn *outside* the form, being

142

DRAWING AS A PREPARATION FOR PAINTING. 143

and, on the canvas being held up to the light, the contours appear as haloes surrounding the forms, indicating an absence of paint, and consequently a poor way of painting, a wretched technique.

Now it is precisely along those contours that much of the work lies. Here are the "passages" of colour, where tone and colour change or pass across. The student should weld his edges, here melting into a broad envelopment, there being brought sharply together. In the Venus of Velasquez as already mentioned, the contours of cheek and shoulder are blurred, whereas in passages round the knees the edges are well defined, because these areas are more sharply focused.

Therefore, if the student is interested in the painting of his edges, it will be seen that a preparatory drawing in another medium may be a positive hindrance. Further, if he concentrates too early on the details, his planes will suffer. Whether the painting is to be finished "au premier," or in successive stages matters not, the fact remains that a detailed initial drawing of the forms is worse than useless. Nothing written here, however, must be seized upon as an excuse for haste or carelessness; the placing made with charcoal should be carefully considered, and the strokes dusted out if need be, until lines significant of the planes, and showing the general direction of the forms and their proportion one to another have been settled. This is not easy if the student, as is often the case, is gloating over the "portrait," which should be achieved, however, by right method and not consist in tips for securing likeness. Especially should the torse be considered. It is in work-

ing out these broad planes that the student really learns to paint: for, with the background, they afford ample space wherein to wield the brush. The planes, of course, are to be seen in the head also, but they are smaller and more complicated. Unfortunately, students are not seldom so preoccupied with the portrait that the torse receives but a small share of attention. It is perhaps the desire to make a portrait rather than to learn to paint that brings about the distressing medley of colours on face and body often seen on the beginner's canvas. Colour, instead of being united, is isolated, in spots of many hues, unrelated, like a patchwork quilt. But the study of colour, like that of drawing, should concern itself first with the big facts. The novice fails to see that every person has a *complexion* varying in each individual case, and showing not only in the face, but in the hands and throughout the body. Whatever variations are made in local colour should be carefully considered in relation to this general hue. Hence the value of painting from the human figure, giving as it does practice in generalizations in regard to colour, and in looking at colour in the mass, just as in drawing, it demands search for main directions and chief planes to which the detail should be subordinated.

When a study for oil painting is being prepared, charcoal should first be used to search out the composition, the relations of the masses and the directions of the forms, all details being disregarded. (FIG. 39). This can then be lightly dusted off, so as to leave no extraneous matter on the canvas, and a brush dipped in umber and rubbed on the palette until nearly dry, may

DRAWING AS A PREPARATION FOR PAINTING. 145

be employed to fix the main forms, and carry the preparation a stage further. The brush should be *dragged* over the surface so as not to fill up the tooth of the canvas with paint. This broad edge suggests envelopment and discourages tight painting. If desired, a clean brush dipped in turpentine may be used to sharpen the contour where contrast is required. That is, the whole of the passages may be studied in line before painting begins.

It is however in water colour that the evil effects of a bad preparation are most clearly seen. The drawing is done according to tradition with the lead pencil, the seductive influence of which leads the student to make a study *complete in itself*, the addition of colour resulting in a muddled and inartistic performance. This confusion comes from making a sharp distinction between drawing and painting, as earlier it has been seen to be made between drawing and shading. But whereas oil painting *is* painting, it is better to consider water colour as drawing, especially when used transparently on a white surface, a method which should be practised by every student before attempting gouache or mixed methods. All judges speak of water colour *drawings*, and in the early artists' colourman's catalogue, the water colour brush is referred to as a "pencil," a name which it would be useful to resuscitate, for beginners seem to regard a brush as an implement for *spreading* or flooding colour, ignoring its chief merit and one which its makers show most care in obtaining, a flexible point surpassing even the pen in incisiveness and fluency. It may be noted here that while in the west, one or two brushes, all of the same shape are generally considered sufficient

equipment by the student of water-colour, in Japan brushes are made specially for certain effects, wide flat brushes for broad washes, long pointed ones for drawing and writing, etc., so that the outfit comprises many brushes.

It might be mentioned, also, that students are often the proud owners of brushes that while effective once have long outworn their usefulness. A watercolour brush, the point of which has disappeared, can only be used for rough work. For successful drawing, a student must periodically add to his stock of brushes.

The Japanese painter does no preliminary sketching. He at once makes his drawing, and backs it up with washes of colour. The western student, aiming at other results feels the necessity for a more tentative method, and certainly, if the caution that he is throughout making a *drawing* in colour be insisted on, there is no reason why the pencil preparation should betray a lack of unity with the following stage in colour. And as it is to be a drawing done in transparent colour, directly and without rubbing or washing out, there is need for this preparation to be more intimate and complete than in the case of the oil study.

But students, ever anxious to indulge their taste in colour, are prone to slur over this preparation. They have a notion that the strokes of the brush need not show, forgetting that every time it is laid upon the paper it makes a mark of definite shape, whether dark or light. The most frequent cases of insufficient preparation occur in outdoor landscape composition, where the boundaries of the forms are hastily sketched without regard to their

DRAWING AS A PREPARATION FOR PAINTING. 147

structure or their edge contrasts. In such study the students are faced with a fresh complication. In their studio work, from the figure or still life, the comparative simplicity of the forms has allowed of a fairly complete rendering. But out-of-doors there are numberless small shapes which, though merging into larger ones, yet distract the eye by their multitude and complexity. The multitudinous forms, such as blades of grass, leaves of trees, cloud forms, etc., present a real difficulty to the beginner. Often he solves the problem in a utilitarian and inartistic fashion by stroking, spotting or dashing irregular splashes on the paper to imitate this apparent irregularity, and in the process loses the orderliness, the series, the radiating arrangements of leaves and branches.

Here an insistence on a right preparation may save the student from falling too low in the artistic scale. He can be shown that the more complex the subject the more necessary is it to search out the significant forms, that likeness must be got through choice and not through dashing the brush on the paper in the hope of securing happy shapes, and that everything that is to be coloured should first be plotted out. Some of Turner's unfinished drawings should be examined from this point of view. Such importance did he attach to a good preparation, and so sure was his colour sense, that he not seldom made his drawing in pencil, giving all the time to this stage, and coloured it when away from the subject. Close scrutiny shows that his lines really prepare for the colouring; the work is not a drawing painted over.

In beginners' work one often finds pencilling which

is of no use to the colouring, but rather a hindrance; features, hands, etc., are sketched in carelessly and with a profusion of strokes that takes no count of the subtlety of the brush point and its power of definition. Shading especially is out of court, leading, as it does, to dirty colour.

On the other hand, all should be carefully drawn, as for instance the space for two hands clasped in the lap of a female sitter. (FIG. 40.) Every portion of the composition should be prepared, the main masses and their relations, the directions of forms, while the position of details, such as the features, should be indicated without being completed in terms of a pencil. Such preparation strengthens the composition, gives emphasis to the connecting lines, and finally gives the brush full play in its charming power of elaborating detail.

The pencil work, of course, may be carried very far so long as it does not interfere with the right function of the brush.

A simple exercise would be a still life group (FIG. 41), and it may be noted here that a subject which suits oil painting, revelling as it does in rich dark colour, is quite unsuitable for water colour if its quality and charm are to be considered. That is to say, if the student is to be given opportunity of *studying* his medium, in this case water colour, the masses should approach lighter tone rather than darker. Rich, glowing hues in water colours are only possible if the study is kept small in scale.

Finally, the contour of the dark area should be drawn *within*, that of the light, *outside* the form.

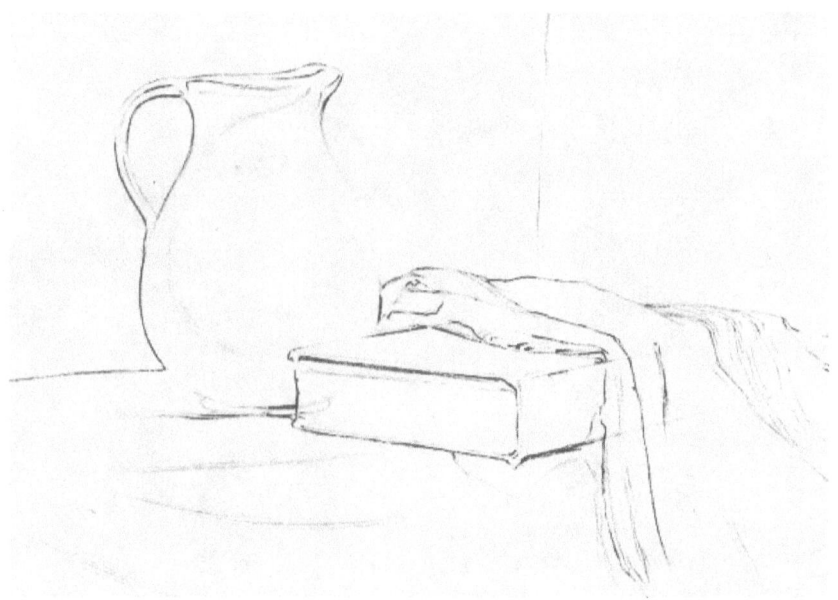

Fig. 41.—A water colour study of still life with a pencil preparation. The pencil lines are emphatic where strong passages occur, but are lighter or even disappear according to the degree of envelopment of the edge. The pencilling is not a drawing, but a preparation.

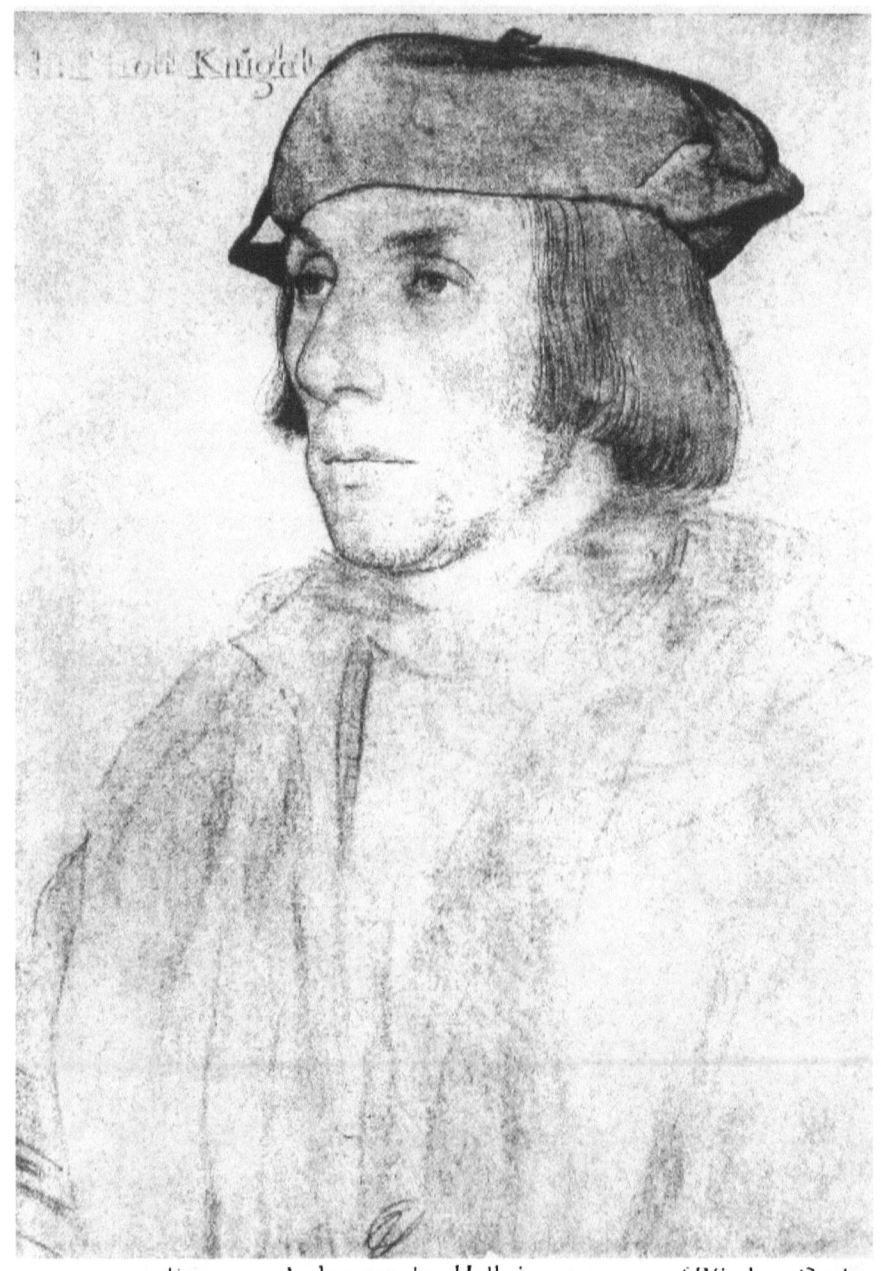

Fig. 42—A drawing by Holbein. [Windsor Castle.

CHAPTER XXI.
CONVENTION.

HITHERTO drawing has been treated as based on appearance. "Is it like?" has been the test, though always accompanied by the proviso that selection must be the student's aim. To draw everything the eye can discern is impossible, and it has been shown that the beginner's mass of unselected detail reveals his low level of artistic outlook. Though truth to nature has been insisted on in so far as the planes of the figure, and indeed, the beauty of its pose are revealed by light and dark, yet constantly in these pages the student has been cautioned that absolute fidelity to nature is impossible, and that any attempt in that direction leads only to a pseudo-photographic presentment essentially vulgar and inartistic. But if it be assumed that the student has some control over his vision, that he can face his subject calmly and set down with some precision his selected facts, the time has now come for him to see that this is only the beginning, that the practical convention of the particular form of art he has chosen will compel him still further to select and co-ordinate his facts in harmony with the necessary simplifications which his art demands, whether

it be painting, engraving, mural decoration or illustration.

Of course drawing may be an end in itself. The portrait drawings of Ingres show that. One might have added those of Holbein, but for the fact that these were made as studies for portraits. Here is a typical instance of what is meant by convention. Holbein, following the custom of his day, and a very good one, understood it to be his business to master the *forms* of his portrait, especially the features of the face. Whether he intended to transfer them to the canvas is a secondary matter. He certainly drew as if he did. What he wanted was the actual limiting lines of his subject's features—all including the construction of the planes was subordinate to that, and in consequence, while drawing these boundaries with the most scrupulous care, he ignored in a great measure, and necessarily so, the give and take of the lighting, the envelopment, the forward and backward movement of the edges. Thus in the drawing of Sir Elliott Knight (FIG. 42) the nose is drawn with a firm line throughout, though it is certain that under the general condition of lighting that part of the nose seen against the cheek would not in actual vision supply so strong and accented a line. But Holbein wanted to be sure of his form, and without conscious intention on his part, his convention created itself. Within these limits what delicacy and subtlety of vision can be discerned! Almost it seems as if the restrictions under which he worked enabled him to see and represent with a maximum of refinement. If the line between the closed lips for instance be examined, it will be seen how it varies,

how unlike it is to the hard wire-like one might ignorantly assume would suffice for Holbein's purpose. It varies throughout its length, softening here, tightening there, showing that far from drawing it as a mere line, Holbein searched out the form of the line above, below, and especially the two ends of it. One might examine all his forms, with a like result. It seems ungracious after this to point out that Holbein is uncertain sometimes of the alignment of his features, that he occasionally places the eyes too high, and that he frequently makes the further eye too large, while noting however its distinctive forms.

Starting then from Holbein's method we might assume a priori that each form of art demands its own convention of drawing, which has linked with it a dependent grace and beauty. The sketches of Alfred Stevens have already been referred to as examples of drawings made for a definite end. They are mainly studies for sculpture, and in them are seen the master's efforts to attain his ideal. He demanded the highest degree of plasticity, drawing his figures with solidity and weight, for they were to be translated into stone or bronze. He ignored the accidentals of light and shade, and rough hewed his figures with broad strokes indicating the actual structure, much as a biologist cuts up his tiny bone into a number of sections, or a geographer constructs a relief map by contour lines. (FIGS. 61, 62).

More important still to Stevens was the *movement* of his figures. Here the meticulous exactness of Holbein's forms is replaced by a rain of lines, one might say scribbled in, but always with the aim of securing the

utmost freedom of movement and poise. He moved the lines, say, of the back twice or thrice, he drew an arm in several positions. In a word the master used drawing for his own artistic purpose, made of it a tool to express his ideals.

Each form of pictorial representation in turn could be taken and shown to demand from drawing a convention suited to its needs. The etcher seizes on the great planes of his subject; he makes use of force to hold his foreground forms near the eye, but with the tenderest delicacy his distances float away from it. FIG. 43 shows that the drawings have been made by an etcher; without the sub-conscious prompting of the acid bath it is not likely that the force of the darks and the delicacy of the more distant parts would have been rendered so directly.

Similarly FIG. 44 a study for an etching shows clearly that it has been made with the resources of the craft always in view. The great sign and foreground darks dominate the composition, while the background is kept tender and quiet, as would happen were it lightly bitten on a plate. But more than this, there is the knowledge of the limitations of etching, that it is a convention and not an imitative process, that it depends on variety of line and shape, hence an insistence on these. Every window in the background has its individual treatment: no two are alike; also many parts are worked to a closer degree of finish than the etching was intended to display, for it is impossible to put the whole of a drawing into an etching; one must have more than one can use in needling the plate from a drawing.

FIG. 43—Drawings in lead pencil on smooth paper. The sharp accents of dark under the eaves, around the chimneys and elsewhere, are the promptings of a vision influenced by the convention of etching. The character and direction of the lines also show this.

FIG. 44—A drawing in lead pencil and black chalk on cream-coloured wrapping paper.

The history of illustration in black and white provides further examples of convention. The illustrators of the early sixties, who had succeeded in throwing off the thraldom of the engraver with his cross hatching tools, mechanical aids and ruled lines, though insisting on their work being followed in facsimile, yet found a convention necessary, one with freedom though still based on that of Bewick, and one that followed more or less closely what has been set forth in these pages, that form is expressed in light areas by darks, and in dark areas by lights. In the dark areas they used the white line in the way we associate with Bewick. But in the light areas they emphasized their forms clearly with the black line. Examples of these illustrations may be seen in old volumes of the "Cornhill," "Once a Week," "Good Words," etc.

Phil May, who built up his own convention by elimination, sometimes omitted the line of the white collar. It might be said that this was a retrograde step, for the omission suggested an objective vision which contrasted oddly with the rest of his very abstract convention. But he perhaps considered it as a joke, or more probably it assisted in giving that looseness and freedom which he desired.

His work is rather misleading to young students who think that they can do easily the same sort of thing, but his method as disclosed by his friends and himself is another example of the strenuous drawing necessary to the convention he employed. He really drew most minutely and carefully; then went over the drawing with his fat line, omitting details, or redrew from memory. A

friend told the writer of a policeman posing in May's studio. The artist made drawing after drawing till the floor was littered, then, the sitter paid and gone, another drawing was made embodying the character as learned in making the previous sketches. The two methods employed both led to the same result, insistence on character by quality of line and omission of superfluous detail.

If the subject be that of mural painting, which preserves the flatness of the wall by the absence of concentrated composition, or of violent colour and forcible lights and darks, a convention of representation must be followed which harmonizes the above conditions. One naturally turns to the Italian traditional practice of the thirteenth and fourteenth centuries. There the technique of buon fresco, the only method of painting without vehicle other than water, on fresh or damp plaster necessitated a clearly defined contour. The work had to proceed with some speed, for in a short time the plaster dried, rendering further progress in the same manner impossible. Thus the conditions militated against realistic work in light and shade even if such had been understood in those times. The outline cartoon was traced on the still soft plaster, and the colouring proceeded without delay.

Unfortunately the climate of our great cities has been declared unsuited to this simple and beautiful technique, although Mrs. Sargant Florence asserts that it stands the ordinary weather conditions of this country very well indeed. She points out that pure fresco flourished in districts with a high rainfall. Her own frescoes at Oak-

ham and elsewhere have stood the test of this climate satisfactorily. The influence of fresco has been felt by succeeding styles of mural painting, although for a time the craft wandered in the dangerous paths of realism.

Mural painting then may be taken as the type of a number of crafts where drawing is viewed without insistence on light or shade, or rather the emphasis is laid on the line and structure, the accidents of light being ignored. Moody's interesting chart of the styles of painting should be consulted in this connexion. In this he shows that the lights and darks, sparkling but spotty, of the imitative Dutch panel pictures contrast with the broad simple shadows melting into the light, of the Florentine frescoes.

This supplies the clue to drawing practice in the life class. While students are studying the principles on which the representation by appearance is based, it is well to make the problem as simple as possible, avoiding complications of lighting. These arrangements have been noted earlier. The lights should be kept strictly in one direction and limited in area, so that the planes are clearly separated by light and dark.

But the advanced student should prepare to study the figure under less restricted conditions. The light should be expanded so that it envelops the figure, reduces the strength of the dark planes, and eliminates small spotty darks, while the contour becomes more completely visible, this being assisted by varying the background, making it lighter than the bulk of the light areas of the figure, or darker than the masses of dark. In the early Florentine frescoes, the backgrounds are generally

light in tone, while the backgrounds of the frescoes of Pompeii are dark in tone or rich in colour, the forms telling light against them.

Under such conditions the student will be constrained to adopt to some extent a linear convention. The light and shade are still there but reduced in intensity, and subordinated to the contour. But it should be understood that structure and movement are more important than ever, for on them success will mainly depend.

It is needless to investigate the conventions of other forms of plastic art in order to see what part drawing plays; the heedful student will do that for himself. But ever as he advances in the study of drawing, he is conscious of new complexities; the better he draws the more conscious will he be of his limitations and his inability to achieve what he desires, and it is well, for one who draws with facility and ease is on the downward path of mannerism and stereotyped form.

CHAPTER XXII.
DRAWING FOR ILLUSTRATORS.

THERE comes a time when the student leaves his school, has *finished* (save the word) his period of study. He is to begin his art career, whether as sculptor, painter, illustrator or designer. What is his attitude towards drawing? Does he regard it as a discipline from which he is at last happily emancipated? In his freedom he may be pardoned for at first feeling a little contemptuous of the methods and precepts of the classroom. He is now a professional with no longer unlimited time to build up the stages of his work, which has to be turned out with regularity and promptness. It *must* be done in some fashion, and whether he be a portrait painter or the merest hack advertisement draughtsman, the same bond of necessity lies heavy on both vocations. In other words, the newly-fledged art worker is in danger of becoming merely a professional, and ceasing to be a student.

But if the student's interest in form has been aroused and stimulated, if logical methods of work have been faithfully pressed upon him, he will have acquired an attitude of mind which can never be eradicated. Granted

that the special conditions of his life work are onerous, that they tend to crush the artistic spirit, yet the *artist* rises superior to commercial and almost degrading trammels, and produces good work in spite of, perhaps because of these fetters. Of course every art worker must know his job. The portrait painter must be able to produce a likeness, the etcher must know how to bite a plate with all possible precision, the illustrator must be able to use his pen and brush freely. But beyond that, in the doing of the work, no matter how poorly paid or how uninteresting it may be, the worker, if he is an artist, will give something above what he is paid for, some touch of the art spirit within him which sustains him and reminds him that art is his career.

That is to say he studies at his craft, he remains a student and as such drawing will be his life-long companion. Take for instance the illustrator, who is asked to depict scenes and incidents often chosen by authors and editors without any eye to artistic motive and effect. But in spite of that he need not despair, for the poorest situation includes the most interesting material in the world—people—and if he has the illustrator's spirit he will not fail to be interested in his work, and make it interesting to others. His will be a busy life, for to him all people are possible subjects for his pencil. His study in the life room was only the beginning; now he must look for his models everywhere. He will always be searching for type and character. He may use a sketch book, but his memory training will be of still more value to him. Thus the lot, the happy lot, of the illustrator is to study continually and by remaining a student, his

work will show increasing character, freshness and pliability.

The designer on his part, must accept this necessity for the search for form. The flowers of the field, insects, birds, clouds, lines of land and sea, animals and people, are all his province. The methodical worker will store his studies in portfolios; the others will make them on backs of envelopes and lose them, but it matters not if the eye is quickened, and the mind stored with form.

All branches of art exhibit the same dependence upon drawing. The numberless pencil studies of Constable show his interest in tree structure, the momentary sketches of Rodin, his search for new and unexpected movements, while the drawings of Gainsborough suggested the composition and arrangement, and enabled him to revise his ideals freely, unhampered by the fetters with which oilpaint once laid upon the canvas and left to dry binds a painter's freedom to choose and alter. The portrait heads of Holbein have been already referred to as an example of drawing put to a direct practical use by the painter, and certainly few portrait painters like to attack a canvas without preliminary studies. Reference may be made to the masterly charcoal drawings by Mr. Sargent preparatory to painting. Here the material is used with directness and force, its qualities being exploited with great skill. The evident intention of the studies is to investigate the character of the sitter, not to obtain actual outlines for tracing as in the case of Holbein, but as a means of getting into close touch with the personality, searching for the forms and accents

which give at once likeness and character. Lastly one may refer to an immediately practical form of illustration. The number of publications and magazines devoted to engineering of all kinds is increasing and will increase. In regard to the illustrations required, photography once so depended upon is proving a failure, for its focus just misses the precision required, while it becomes impossible, when dark interiors have to be revealed or when exterior coverings are assumed to be removed to show mechanism.

Therefore a new convention of drawing machinery is growing up, demanding a high degree of appreciation of the appearance of things together with a sound knowledge of perspective, geometry and mechanical structure. The draughtsman by the unaided use of his pencil, without quadrants, tee squares and pearwood curves must be able to explain in his drawing how a machine works, and express with precision the relations of such mechanism as elaborate gearing and valves seen in perspective. Only the well-trained student can grapple with the formidable difficulties such subjects present, while the simplicity of the means brings about its own convention, and with it a clear articulate expression, apart from the practical value of the drawing. That is to say, a drawing of machinery in the hands of an artist becomes a work of art.

One returns to the truth that what the artist chooses to interest himself in is suitable for art expression no matter what may be its nature. We are emancipated from the sham ruins and picturesqueness of the 18th century, those mannerisms of the great Italian style from

Botticelli onwards which later ages appropriated while losing its spirit. The early Italians, the Trecento and Quattrocento artists were too interested in their own time to hanker after the picturesque. They drew buildings for instance, raw new as they saw them. And to-day we may find suitable material for the study of drawing close at hand without travelling round the world for strange and stimulating forms. No longer need the world be divided into two categories, interesting and commonplace, for students are using their eyes as did the Italians of the fourteenth century, and find interest of form in the commonest material. Even to fully express a matchbox would tax the powers of the best trained artist.

CHAPTER XXIII.

THE DRAWINGS OF THE MASTERS.

THE first known drawings and paintings by man are to be found in the caves of the Pyrenees and the Dordogne district, once tenanted by the later Palaeolithic race. Much attention has of late been paid to these works, and reproductions are fairly common, a series being on view in the Natural History Museum at South Kensington. The paintings of bison and other animals on the ceiling of one of the chambers of the cave of Altamira in Northern Spain, may be instanced among the finest of the examples of this early art. They show the preoccupation of the men of this period. They were hunters, had no domestic animals with the doubtful exception of the rough ponies of the period, no pottery for drinking from, and practised no tillage. But in physical form and brain capacity they were the equal of modern races and must not be confused with the earlier beetle browed Neanderthal man of whom nothing is known other than that he fabricated stone implements, possessed fire, and buried his dead. Practically all the cave paintings, with the scratchings on bone, and the bone and ivory sculpture, represent animals, though here

Fig. 45—From an Assyrian bas-relief. [British Museum.

FIG. 46.—A brush drawing from a white Athenian vase (cylindrical). Though there are puzzling details such as the smallness of the man's hands, the parallelism of his feet, etc., yet the purity of line and the suggestion of form should be closely studied.
[British Museum.

THE DRAWINGS OF THE MASTERS. 169

and there are found statuettes of female figures mostly gross in form.

The roof of Altamira is covered with full-sized coloured drawings of paintings of animals, bison, horses, deer and pigs. They are outlined in black and washed over with red, brown and yellow pigments made from various iron and manganese earths. They show a correctness of proportion and a freedom of movement which have never been surpassed while the extremely simplified conventions used to express the structure and hair growths, have nothing in common with the childish scrawls of most living races of savages. The placing of the legs is practically in accord with photographs of moving animals testifying to the artist's quickness of eye and keenness of observation. In particular some drawings of mortally wounded bison in the last death spasm, with their legs crumpled beneath them and the tail vibrating over the back show how well the draughtsman memorized a phenomenon with which he must have been perfectly familiar.

Other famous examples are the drawings of mammoths, deer and horses on the walls of caves and on bone. The drawing of the reindeer, from Thayngen, and the three red deer crossing a river, from Lorthet, (*Ancient Hunters. Sollas*), show a close observation of the animals and a certain ease and freedom in representing them. They reveal the anatomical knowledge of one who has repeatedly skinned and dismembered his prey, the habits and movements of which have been his lifelong study. And these drawings were made by a man so primitive that like the beasts of the field he had to go

down to the river to drink. It may be said here that though he may have had to risk the sabre-toothed tiger and the great cave bear, yet the strange, enormous reptilian creatures, with whom he is sometimes associated in certain modern humorous drawings, had become extinct ages before.

Of what we call composition we must not expect much. On the roof at Altamira the creatures are fitted in as closely as possible, some being superimposed on others, the idea apparent being to give the impression of a great herd. Elsewhere we get the usual panoramic composition of early art much as in the Egyptian and Assyrian freizes. One animal follows another, and occasionally there is a somewhat impressionistic representation of a herd of horses or deer indicated by a row of heads and foreparts much as one would see glancing along the front rank.

What strikes one is that this earliest art is representational rather than consciously decorative. It may be that the artist connected his picture with the desires of his appetite, much as children, in the absence of the object they desire say a boat or doll, will draw it and thus to some extent satisfy their craving. Apparently this early man desired his drawings in line and colour to be as like as possible, which is perhaps why Mr. Clive Bell dislikes them. They may even be symbolic of food to be used by the soul after death as in Egyptian art which also exhibits exceedingly well-drawn animals.

But in Egypt had grown up an ancient civilization where the priesthood ruled and prescribed minutely the conventions of the forms in the paintings which min-

Fig. 47—A chalk drawing by Durer. Full of weight, movement and structure. Every mark has a meaning, expresses a form. Durer has appropriated the position of the legs in a trotting horse for use here in the slowest of paces, probably because it gave him more sense of movement than the walking position. [British Museum.

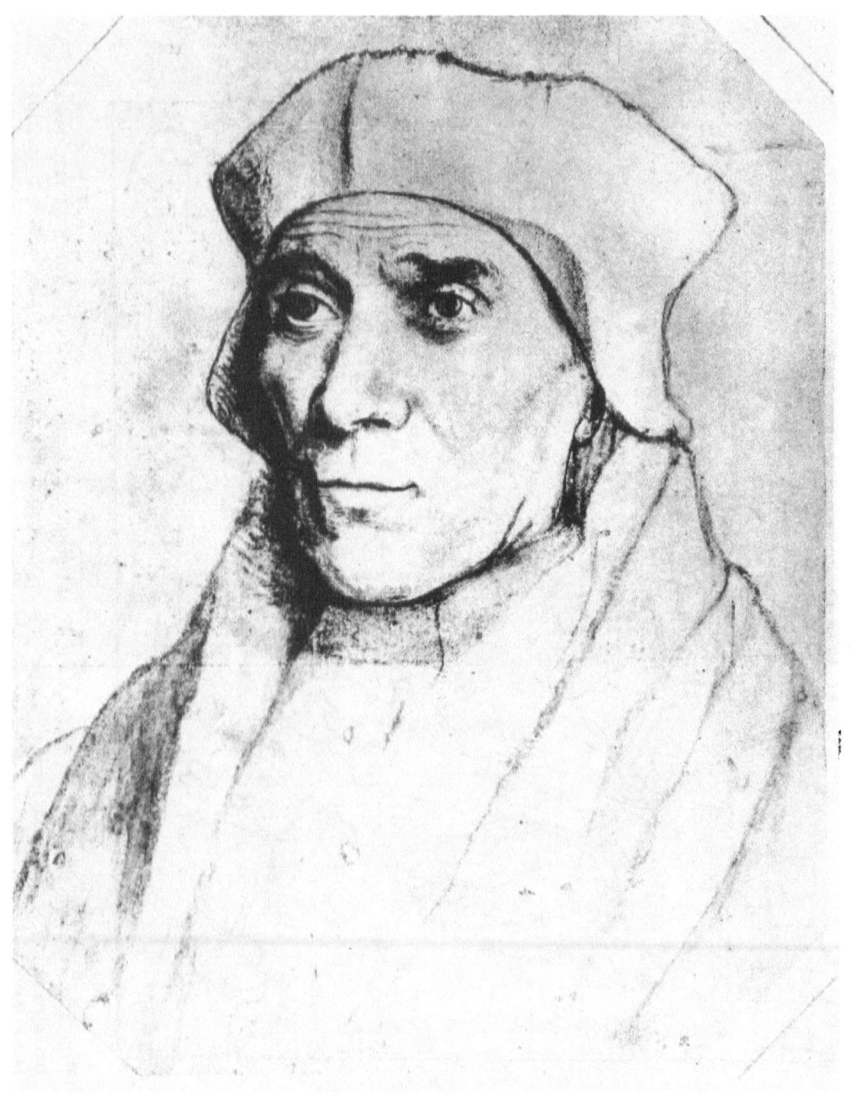

Fig. 48—A drawing by Holbein. Great care has been given to the eyebrows and the line between the lips. The far eye appears somewhat too large. [British Museum.

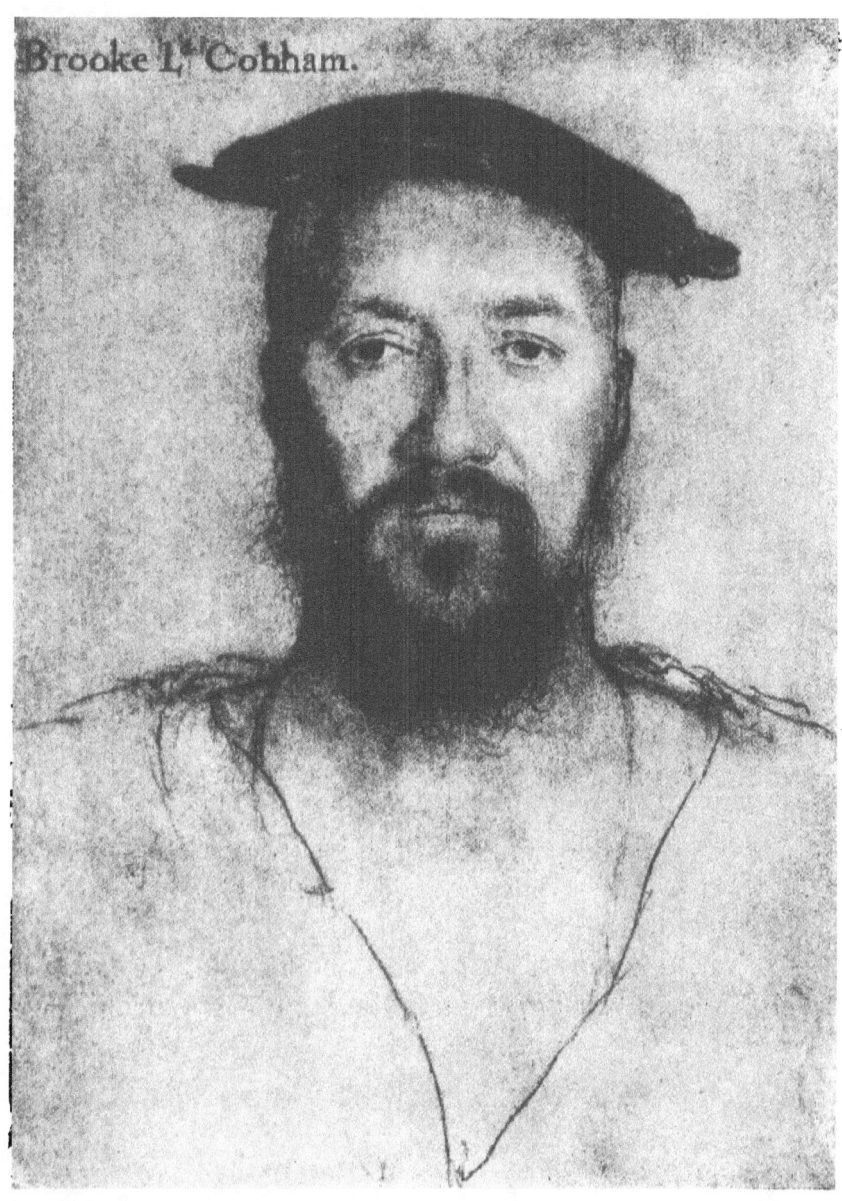

FIG. 49—A drawing by Holbein. Certain forms which were evidently deemed essential to the likeness have been carefully redrawn with a hard point on the thin films of charcoal or chalk. These are the eyelids, the nostrils and the line separating the lips. [Windsor Castle.

Fig. 50—In this drawing by Leonardo da Vinci the features have more veracity than the fanciful armour, and bear a great resemblance to the elder Tedeschi, a model known to a generation of art students. Such a profile could only have been drawn of an Italian by an Italian. [British Museum.

istered to the national religion. Reference has been made already to the way in which man was portrayed in the Egyptian canon of form. Apparently however the animals had escaped the attention of those who laid down the rules of representation, and in consequence as we see if we consult the book of the Dead, reproduced by the British Museum Authorities, or the wall paintings and drawings, the cats, dogs and especially the baboons and birds are lifelike in their proportions, structure and movement, drawn as they are in much the same simple convention as was used by the cave men.

Assyrian art runs a parallel course. The bas-reliefs in the British Museum are cut in soft gypsum or alabaster, the work of a victorious people in a hurry, and often the relief is so slight that the work may be considered as a drawing. Here again there is a convention of the human figure, with swollen muscles on a brawny frame, and again also the sculptors seem to have looked at animals with a clearer eye than when they attempted men. Their horses are good, and their lions better, the most famous being the slab whereon is depicted a lioness dragging herself along the ground, her hind quarters having been paralysed by an arrow. (FIG. 45.) She is roaring, the skin of her nose wrinkled in agony. The relief is little more than ¼ inch, and again one can say that the artist must have witnessed this sight, and set down with convincing clearness his memory vision of it.

Following the line of successive nationalities one inquires what drawings were made by the Greeks. Fortunately their drawings are plain to see on their vases. At last the artists have become *interested* in the forms

of man and though we may assume that the vase painter was little more than a workman yet the best vase paintings lag but little behind the best Greek sculpture. It will be convenient to examine the white vase paintings, where the backgrounds are not painted in. They are called paintings but they are really brush drawings and done with an ease, and fluency of expression that makes them worthy of the closest study. The draughtsman must have worked with some speed; he had to turn out a quantity, and his convention arose out of the necessities of his occupation. He used his line with the utmost economy, but his eye, his draughtsman's soul was all the time concentrated on the point of his brush, which produced a line of the utmost flexibility and sensibility. (FIG 46.) From the Greeks to the medievals is a long step both as regards technique and sentiment. Once more drawing has been grasped by the priesthood to serve religion. The figure has to express hope, fear, reverence. The features are expanded until they fill the face; the hands stretched out with stiff fingers implore, deprecate, or command. The figure is hidden in the long lines of the draperies. The line is still there but it is now the convention of a craft of which the conditions are necessarily stringent to a degree—that of stained glass. The form is subordinated to the leads of the window, the angularity of the medieval forms being associated with the special quality of the material—glass.

Another step, and one comes to the man who stood at the parting of the ways—Albert Durer—who inherited the gothic tradition of angular forms, piped draperies and scriptural subject matter, yet reached out to the

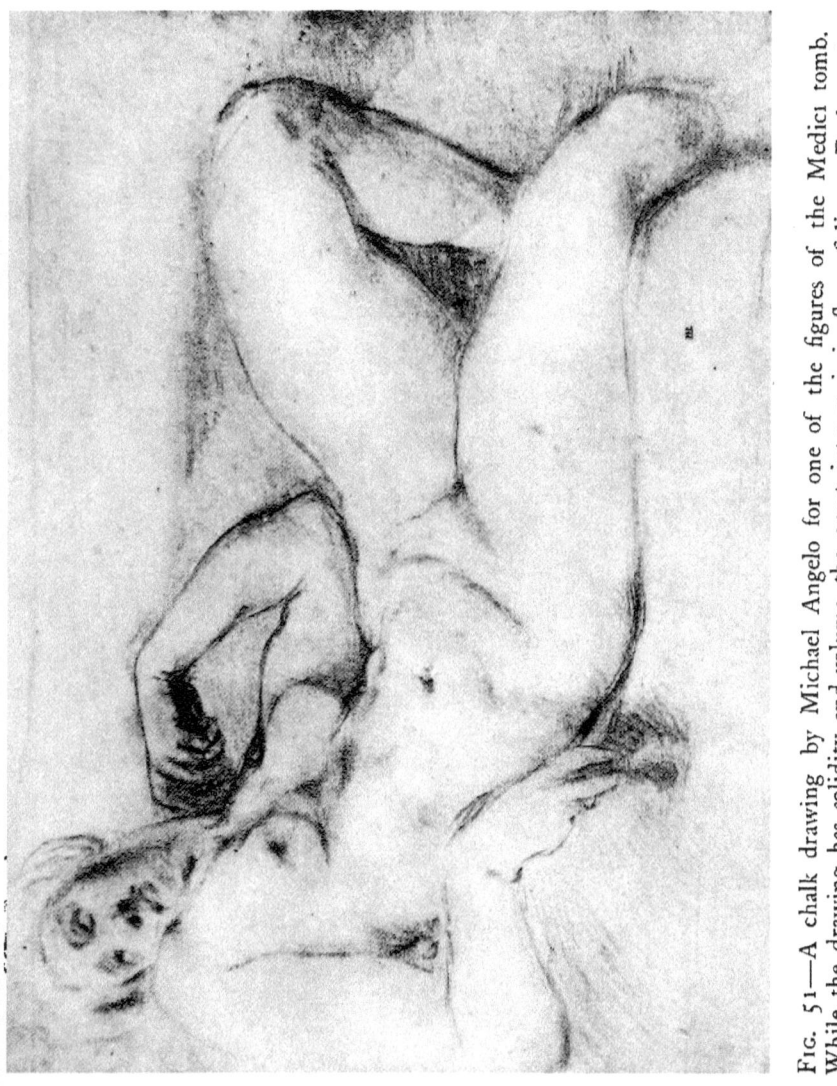

FIG. 51—A chalk drawing by Michael Angelo for one of the figures of the Medici tomb. While the drawing has solidity and volume, the great interest is in flow of line. Each stroke is a rhythm echoing the great, ample curving lines. Compared with this the rhythm of the Raphael drawing overleaf seems slow and broken.

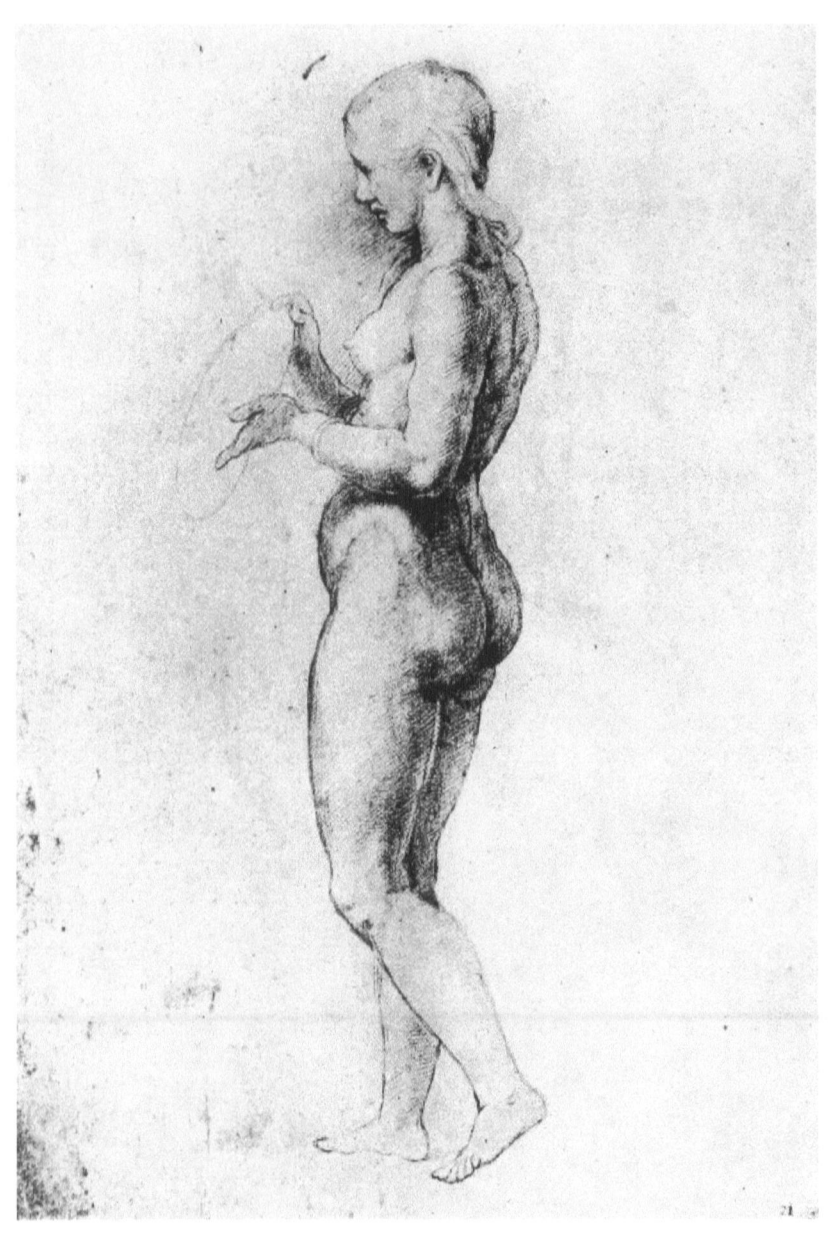

Fig. 52 A chalk drawing by Raphael. The interest in form should be noted. It is full of overlapping contours. The drawing is but little concerned with the photographic aspect of the model.

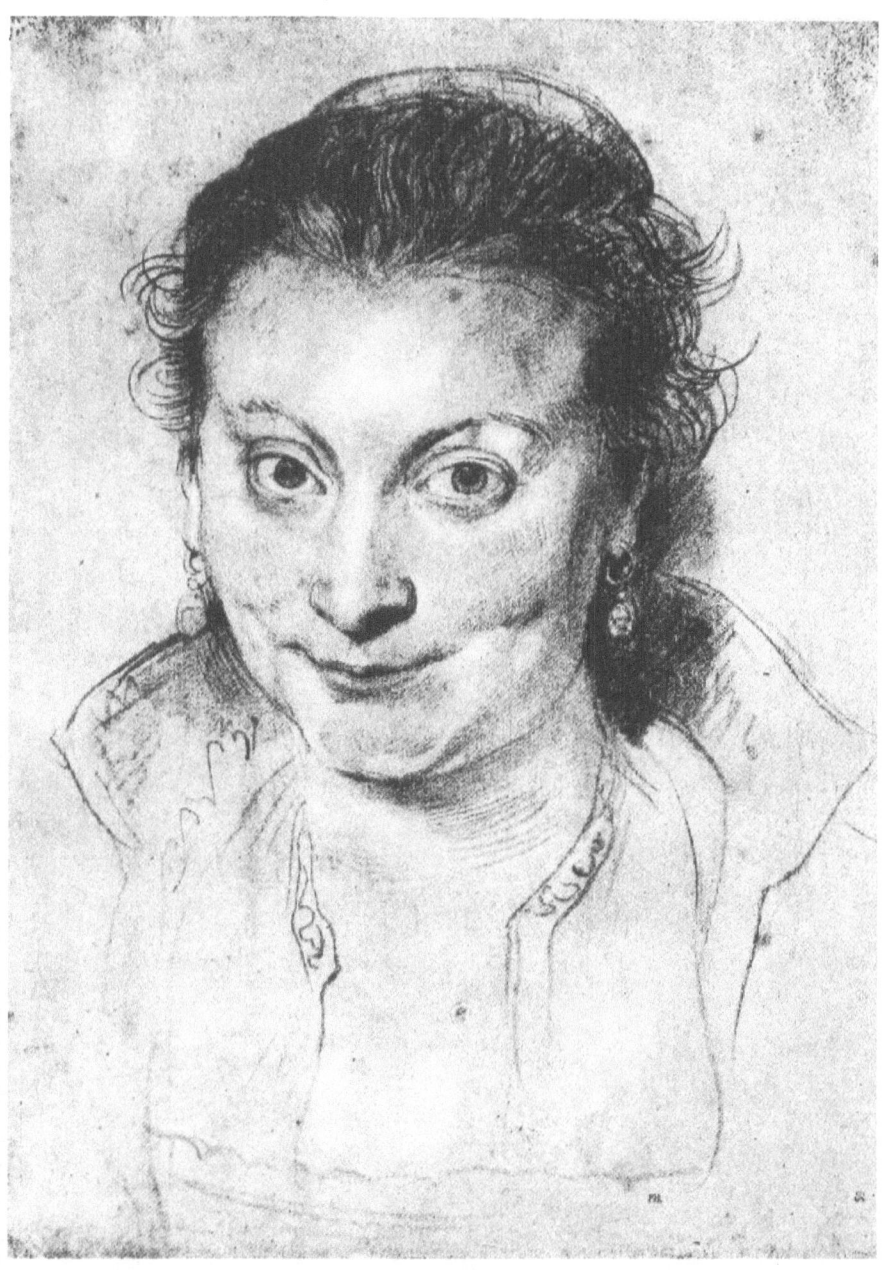

Fig. 53.—A drawing by Rubens in black and red chalk. He drew more by the lights than the darks. We may be certain that there was more tone under the chin than is shewn by him. But he wanted this to be not a light and shade study merely; the expression of the sitter, alert, listening, arch, is what he has achieved. The drawing is full of vitality. The face seems alive. [British Museum.

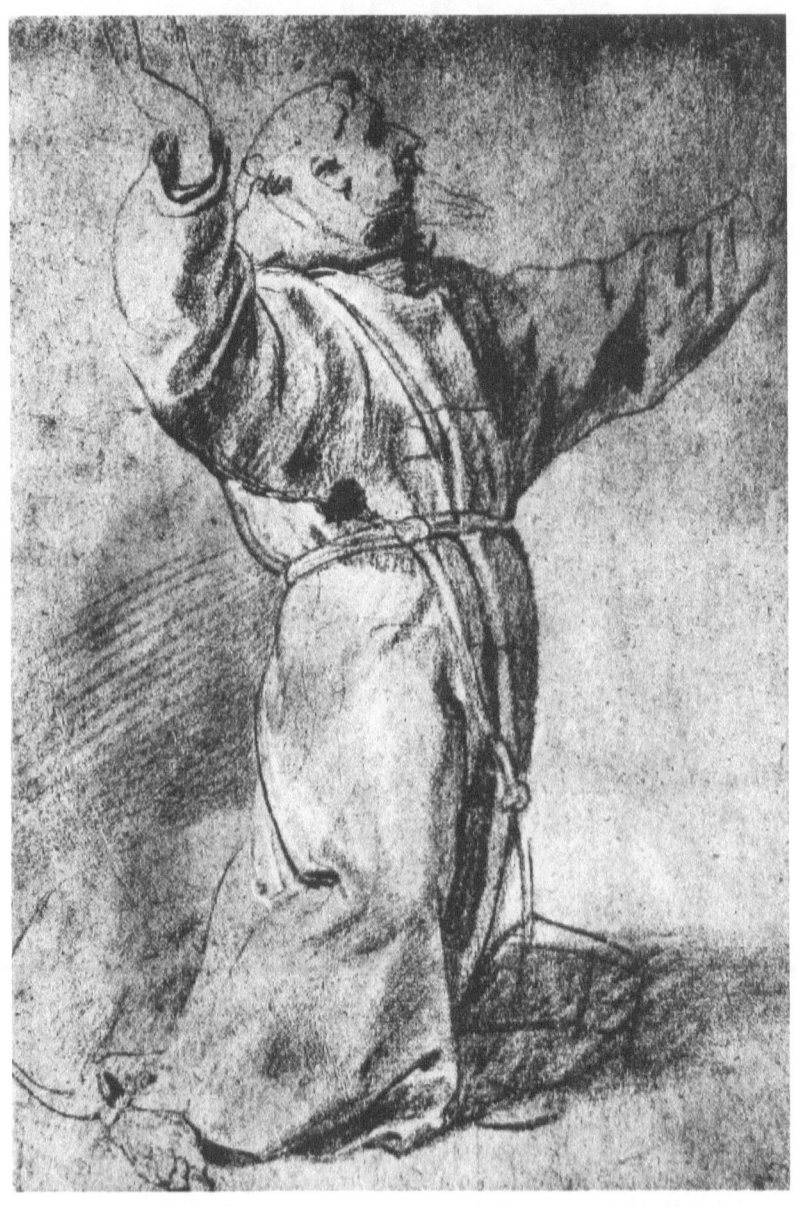

FIG. 54.—A chalk drawing by Rubens. The fine line descending from the head to the knees should be noted as also that uniting the arms.
[British Museum.

Renaissance, with its renewed interest in the unclothed figure as seen in classic myth, and in the mass of architectural and other forms which accentuate the new style.

The conditions of Durer's career as an artist made him the very type of a draughtsman. He was to be the world's great illustrator, and as such he had an intense curiosity in the forms of things. He drew the ancient roofs of his native town, horses, men in armour, everything he might want in his engravings and woodcuts, and as an illustrator he makes use of all his drawings. Like the Japanese he drew and redrew his subject until he was line perfect, and like them he was always simplifying, refining his line down to its lowest terms, often until it became a mere decorative motive, a trick of the pen. But this simplification forced him to study structure, with the result that every stroke of Durer's represents a definite fact; his simplest drawings are full of anatomy, whether they be of plants, animals, or persons. (FIG. 47.) Walter Crane must have studied Durer, and his mannerisms came from his efforts to make his line express as much as possible of the form, the bend of the wrist or ankle, the twisting of the neck, and the radiation of the toes or fingers, with the result that people who were not interested in structure cried out that he was deforming the figure. The criticism shows the necessity of a draughtsman constantly comparing his convention with natural form, of self criticism. He should avoid, and it is the most difficult thing to do so, falling into ruts of expression, mannerisms, that is unnatural form. It is the young student curiously enough whose work is full of undigested conventions for he seems to absorb them from

the nursery onwards. He unconsciously abstracts from the work of the artist he admires, its tricks of handling, rather than the good qualities revealed only on close study. That is why *copying* is to be deprecated, for this practice does not always imply *study*. What study is and what it involves students will do well to ponder over.

Of Holbein much has been said in these pages. Like Durer he was a great pen draughtsman, and could design with facility in the new style, with its classical mouldings, capitals and acanthus. But when he confronted his sitter he put all the new forms and conventions aside, and looked at his model with an eye cleared of Italian motes and beams. (FIGS. 42, 48, 49.)

In Italy Giotto broke away from the more formal Byzantine manner. His figures have weight and power, though his accessories, his hills, trees and animals are the merest recollections. But he took the turn towards naturalism and all through the fourteenth century the Italians were examining nature and trying to draw and paint *like* the model, though not knowing quite how it was to be done. Botticelli has been referred to as one who used the nude figure constantly with much poetic grace, yet without a clear knowledge of its structure and articulations. It was Leonardo da Vinci with the inquisitive scientific spirit and full measure of the organizing faculty who did everything to form what may be called the academic convention, especially in regard to light and shade, except actually to set up a school of art. (FIG. 50.) The study of perspective, involving shadows and reflections, and of anatomy with its dissections did much to direct the study of art in the same path.

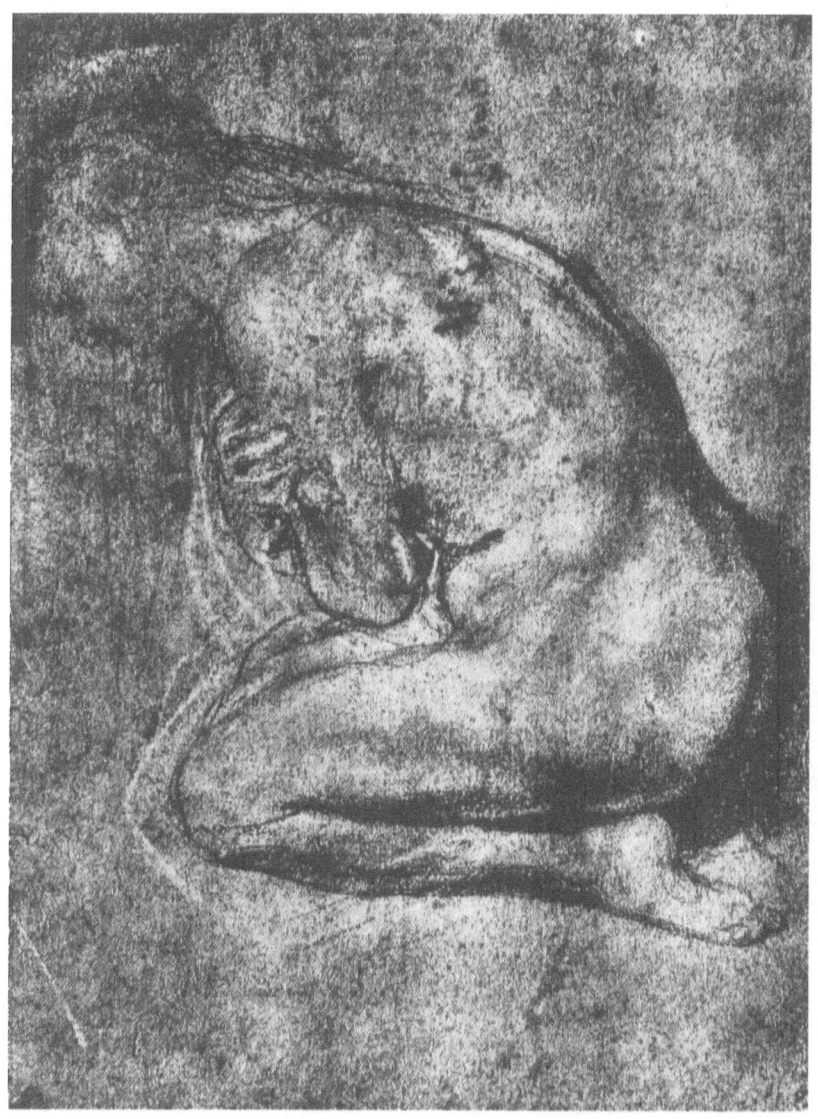

FIG. 55—This unassuming drawing by Rubens shows beautiful rhythm of line. The pose quiet as it is, is full of action. The feet should be noted, drawn as one form, and the difficult turn of the head has been attacked. Many students do not realize the loss of length in such a pose and make their sitting and crouching figures much too high. [British Museum.

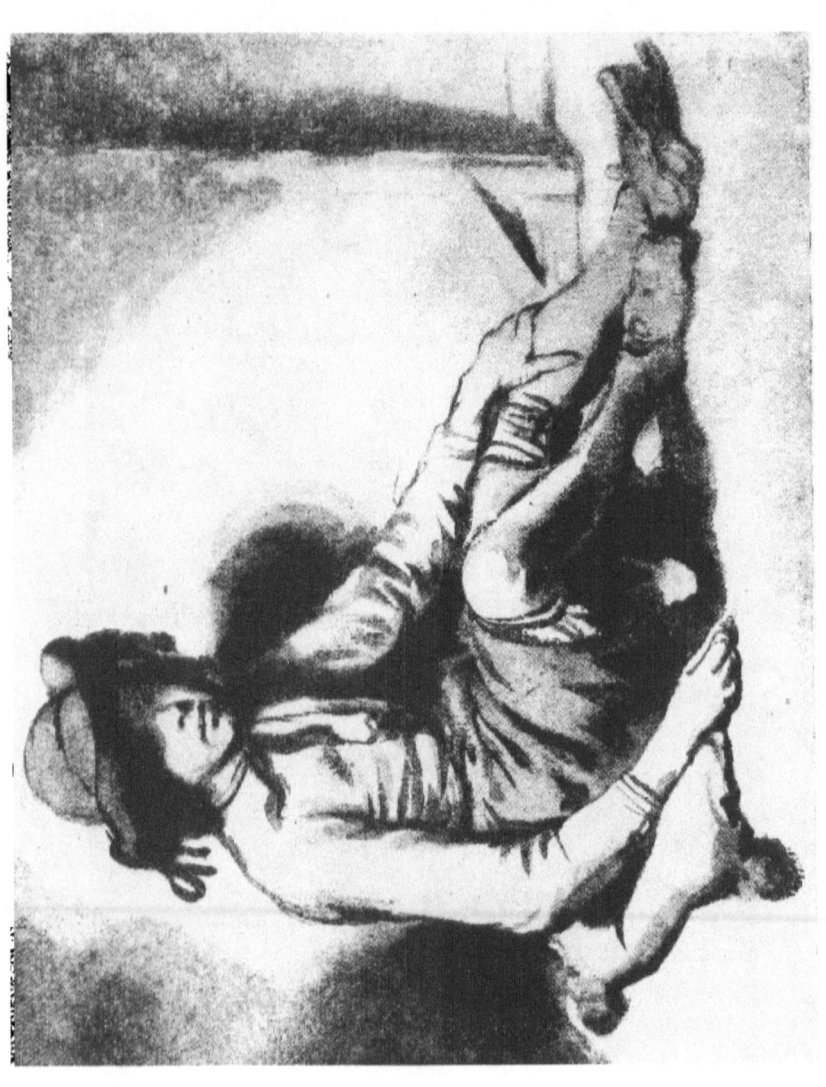

FIG. 56—A very simple and direct example of drawing made with the brush from the school of Rembrandt. The lines flow from the head and shoulders down the arms to the legs and feet. The accents of dark are well placed. [British Museum.

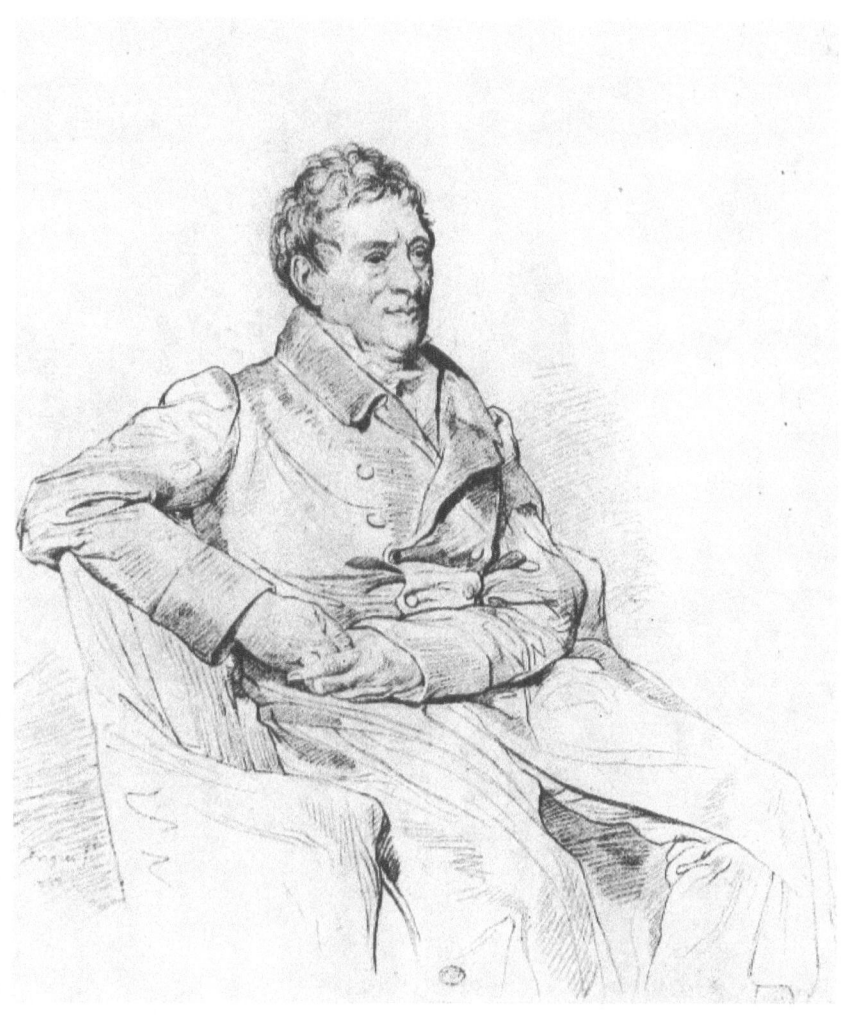

Fig. 57—One of Ingres' portrait drawings of which he made a great number while at Rome. Full of search for form and rhythmical line. Note how the two arms have been unified. Every fold in the clothes tells of the form beneath.

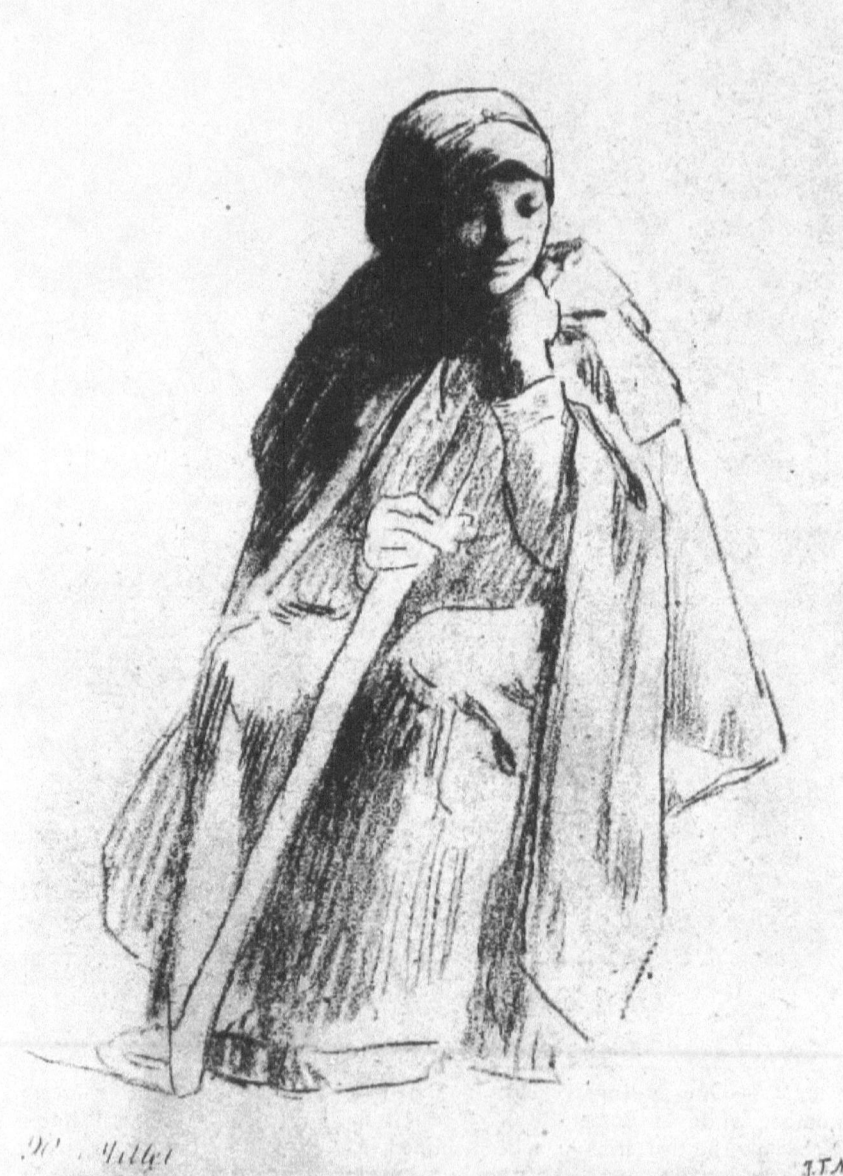

Fig. 58—A chalk drawing by J. F. Millet which shows his method clearly. He has been quick to seize the forms which emerge from the heavy, hanging garments. The drawing has a rhythm of its own.

In the drawings of Mantegna one sees a closer return to the classic spirit. So insistent is the line that the shading is simpler and more summary in its method than the convention used by the northern draughtsmen, of whom Durer may be cited as the chief example. Durer covers his forms with lines drawn round them each suggesting a section through the mass, a convention much used by the northern engravers and etchers. Mantegna's shading consists of straight lines drawn diagonally, the easiest movement of the hand across the paper. This convention while it does not allow of a certain over-realized, almost stereoscopic form which is seen in work produced by the northern engravers, is simple and direct and defines the planes more clearly. The tendency ever since has been to adopt it for the study of form, and mediums like charcoal, chalk, pencil and pen lend themselves to it. Even a modern pen draughtsman like Mr. G. D. Armour uses it almost exclusively.

Michael Angelo, though a giant yet learned all his academic teachers could impart, and transformed his study by his volcanic genius. When he drew it was to reveal structure, and especially the overlapping of contours, rather than the appearance, though if he chose he could load his surfaces with shading in the correct Italian style. He was preoccupied with the figure as his raw material in design; he combined nudes, grouped them, flung them together in ropes, festoons and swirls, held together by his great line running round torses and along limbs. (FIG. 51.)

Rubens trained in Italian methods made numberless drawings and sketches for compositions; many of the

latter however are painted in monochrome. His work shows how a man is dominated by his own temperament, and also by the tendencies of his age. Women smile, men strike flamboyant attitudes, horses prance, curtains swirl in the wind, and vivid masses of red energise the composition. The Philip and his Queen painted by him are portraits of people well pleased with themselves and in robust health. When one turns to the portraits of the same people by Velasquez, a man of their own race and therefore more likely to realize the national character, very different personalities are revealed, cold, indifferent and passive.

The drawings of Rubens show equally this exuberance of spirit. He is one of the very few who could command a full measure of vitality and action; his figures move with freedom, with an amplitude of gesture as well as of form. (FIGS. 54 55.) His study of Michael Angelo shows in his work though mingled with his own temperament; in place of the latter's elemental violence he substituted a jovial turbulence. But he drew as he painted with a mastery over his material. He exercised a strict economy of means. In his drawing of a woman's head (FIG. 53) he went far beyond a mere portrait; he is concerned with the pleasant disposition of his sitter. In other words he drew the smile rather than the features, and achieved both with the minimum of light and shade. He refused to dirty his drawing with mere masses of dark and gained his end rather by working round his lights, for to him the lights were the essence of the form.

In Holland, Rembrandt among the Italianizing

Fig. 59.—A drawing in pencil by Lord Leighton.

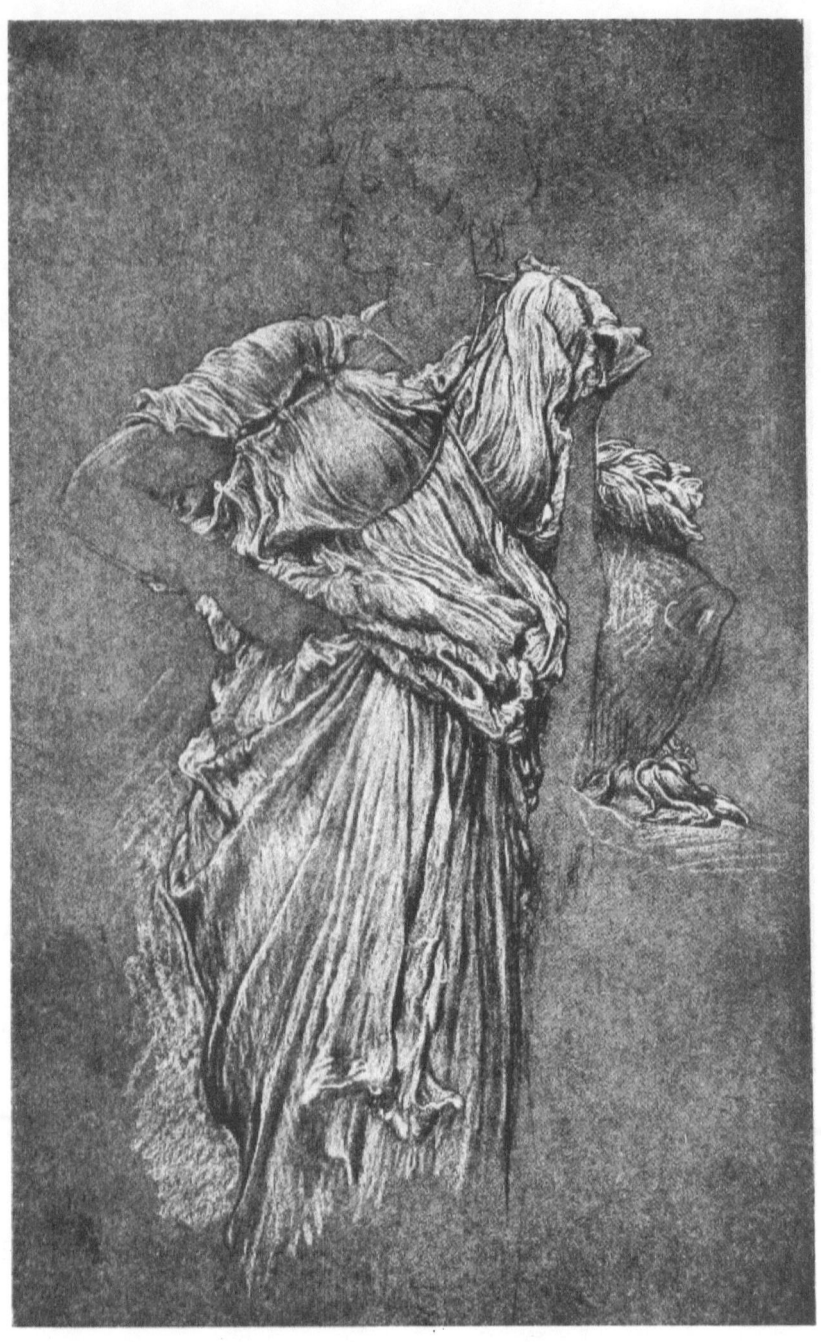

Fig. 60.—A drawing by Lord Leighton, made with black and white chalk on brown paper.

Dutchmen stood alone. Here again like Durer and Holbein, his subject matter for his etchings is from the Bible, though he sat at his window and accepted the types and costumes of the Jewish folk who swarmed below as they do to this day. He like Durer was always accumulating material, though many of his so-called drawings are compositions set down hastily as they came into his head, and often with splendid emphasis on the significant lines. He is the very type of an artist. Every event, and there were some sombre ones in his career, seems to call forth from him not speech or letter, but drawings, in which he sought new ways of expressing himself, a new outlook. When his wife lay dying, he made a slight pen-drawing of her, pinched and wan in bed. After her death he wandered by creeks and hamlets outside Amsterdam drawing with simple pen strokes what he saw, the roads, trees and tumble-down houses, which latter cannot be found there any more; for in Holland all is now clean and tidy, especially the fishwives of Marken, who hasten themselves and their children into their ancient dress when they see an excursion steamer, full of tourists, approaching. These drawings are models of compressed expression, for while Rembrandt was thus trying to solace himself for his loss, he was subconsciously working out like Durer a method of putting things down in their simplest terms.

Many painters have left but few drawings, a prominent instance being Velasquez. It has been thought that he attacked his composition on the canvas without preliminary work for there are pictures by him where strips of canvas have been *added*, because, as he pro-

ceeded, the development of the subject demanded more space. But the absence of drawings is no reason why the student of form should neglect Velasquez for he was one of the greatest of draughtsmen. He had not the swagger of Rubens, the feeling for humanity of Rembrandt, nor the clearly defined edge of Holbein, but in his brushwork he showed a knowledge of and a means of suggesting atmosphere, which no other master quite reaches. He draws with the brush in a real sense, for he goes far beyond the earlier technique of painting, the bringing of two surfaces of paint sharply together in a contour. With some painters if the canvas is held to the light haloes appear round the forms where the paint is non-existent. But Velasquez welded his edges together so that they became one passage; he placed accents in different degrees of intensity to suggest nearness to the eye, or by blurring edges he quietened the forms farthest from the centre of interest.

Some of the dwarf and jester portraits painted with less of the decorum and stiffness of the court portraits, as if he did them to please himself, show the height of his powers as a draughtsman.

In France during the Renaissance, the artists looked largely to Italy for inspiration and guidance. But it was Jean Clouet from Flanders who founded a great school of portrait drawing. He settled in Paris and with his descendants painted a vast series of small portraits. For these, as did Holbein some years later, he first made drawings in black and red chalk, the latter medium being already much in use in Italy. The Clouets and their followers made numbers of these por-

trait drawings, justly famed for their delicacy and precision.

Later Watteau and other artists of his period used the method with more vigour applying it to figure composition generally.

Mr. W. Strang, followed by other modern draughtsmen, has revived the method for his series of portrait heads.

Claude is noteworthy as one of the first painters to study or sketch outdoors. But these drawings made mostly with the brush, are rather studies of composition—how the light falls on groups of trees and tree trunks, and divides the composition into masses of shade, though he certainly drew twining ivy and slender branches of foliage against the sky.

One wishes but vainly for some drawings of still life by Chardin, to note how he indicated the volume of his fat bottles, and their effect against his quiet backgrounds.

Watteau left numberless drawings mostly with the red and black chalk handed down from the Clouets. Here was an artist who valued drawing for what it was worth to him. He wanted above everything movement easy and langorous perhaps on the surface but suggesting a hidden fire, vivacity and alertness. (FIG. 24). The lady seated on the ground with her hand on the arm of the gallant is about to rise. The impression of movement is conveyed, while the contrast of the rising torse with the scrumpled legs hidden in the voluminous skirt is stated with conviction. Watteau used the chalk rather than the brush in making his studies, because he

knew that the hard point enabled him to deal more trenchantly with structure and movement. It is pre-eminently painter's drawing or rather drawing for painting. How often does the student make his studies for a picture, in say water-colour only to find that this medium has its own convention, demanding the disregard of everything not essential to it, with the result that the water-colour study contains little that is of direct use and worse still has not impressed on the mind facts of structure and line required for the carrying out of the work? Drawing with charcoal or with the point would have helped him to arrive at the essentials, without imposing on him conventions clashing with those special to the material which he proposes to use.

The modern era is now reached. Jean Dominique Ingres, the upholder of the academic banner against the romantic movement had perhaps the most skilful pencil of any draughtsman early or recent. His cleverness approaches legerdemain, so that there are those who declare that to place his drawings before the student is to court disaster, luring him to attempt by trickery what no one but Ingres could accomplish. His methods however, are plain in his drawings, reproductions of which may be seen in Newne's edition (now out of print). He surveyed the pose, sketched in the leading lines, studied the structure beneath the clothes with light strokes before he concentrated on details. He made many portrait drawings while in Rome for a few francs apiece, and as time was short, gave most of it to the head, the remainder of the drawing being left with the first strokes showing. The finish he gave to the surface forms of the face is of

course possible only to himself, though well worth the keenest attention, for it could have been compassed only by a close study of the structure. (FIG. 57.)

Jean Francois Millet is to be noted among the Barbizon groups for his drawings. He was a type of artist who painted in series. A picture was influenced and suggested by an earlier one, to which it formed a corollary, and as it were completed it. He wished to depict the whole life of the French peasants of his time, their labours and privations and how these varied during the year. His mode of study required first and always close observation rather than actual painting from the model and scenery, which he despised as tending to triviality. Consequently he made numberless notes of figures engaged in rural occupations, mainly from memory. His drawings show without finicky detail the character and bodily structure of his subject; even the drapery seems to have its appropriate weight and coarseness of texture, while the action leisurely and untheatrical is expressed with a sombre strength. (FIG. 58).

Puvis de Chavannes worked after the great schools of art in Paris had established themselves and settled their methods, and therefore made the studies for his great mural decorations with charcoal the implement commonly used for drawing from the life. His drawings are excellent, so solid and weighty are his figures, the feet firmly planted on the ground and the structure cared for throughout. Mr. C. H. Shannon has one squared off for transferring to the canvas.

Of the drawings of the great French master Degas, only the studies of the ballet dancers are familiar to

English students, and these mostly from reproductions. Degas, and not without prolonged study, achieved an extraordinary degree of intimacy in his drawings. His people never look like models stuck on a throne, and so quietly and naturally do they move that the artistic mastery is only observed after careful scrutiny. This feeling of what one may call "at homeness" though Degas did not always seek his subjects at home, is not easy to analyse and account for. His drawings are the opposite of diagrams or maps of form. His figures are always depicted in relationship with their surroundings and one of the secrets of his power in this respect may lie as has been pointed out, that he drew as it were with a wide angled lens, not as if he were surveying a stage or scene from a distance, but as if sitting among those he depicted so that one would have to turn the head to take in the width of space taken up by the drawing. And as one might expect Degas was very careful over the placing of his accents, and equally so with his non-accented passages, those where the form merged into the background. The Burlington Magazine recently published some illuminating articles on the master by Mr. Walter Sickert, and also reproduced three views of a head.

In Germany Adolf Menzel during a long life made more drawings than any other painter. They are all painter's studies, that is for use in his pictures, which were mainly historical in character and needing the closest attention to details of costume, architecture, etc. They are highly realistic and made mostly with black chalk and charcoal. A characteristic selection is reproduced in Newne's series, but there are very few

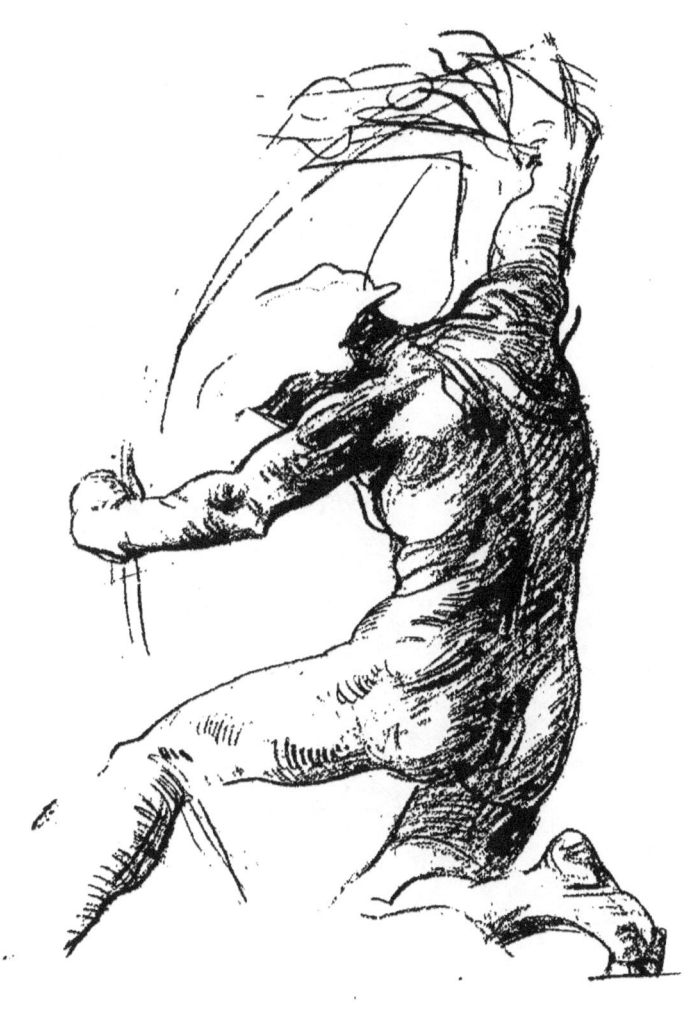

Fig. 61—A drawing in red chalk by Alfred Stevens.

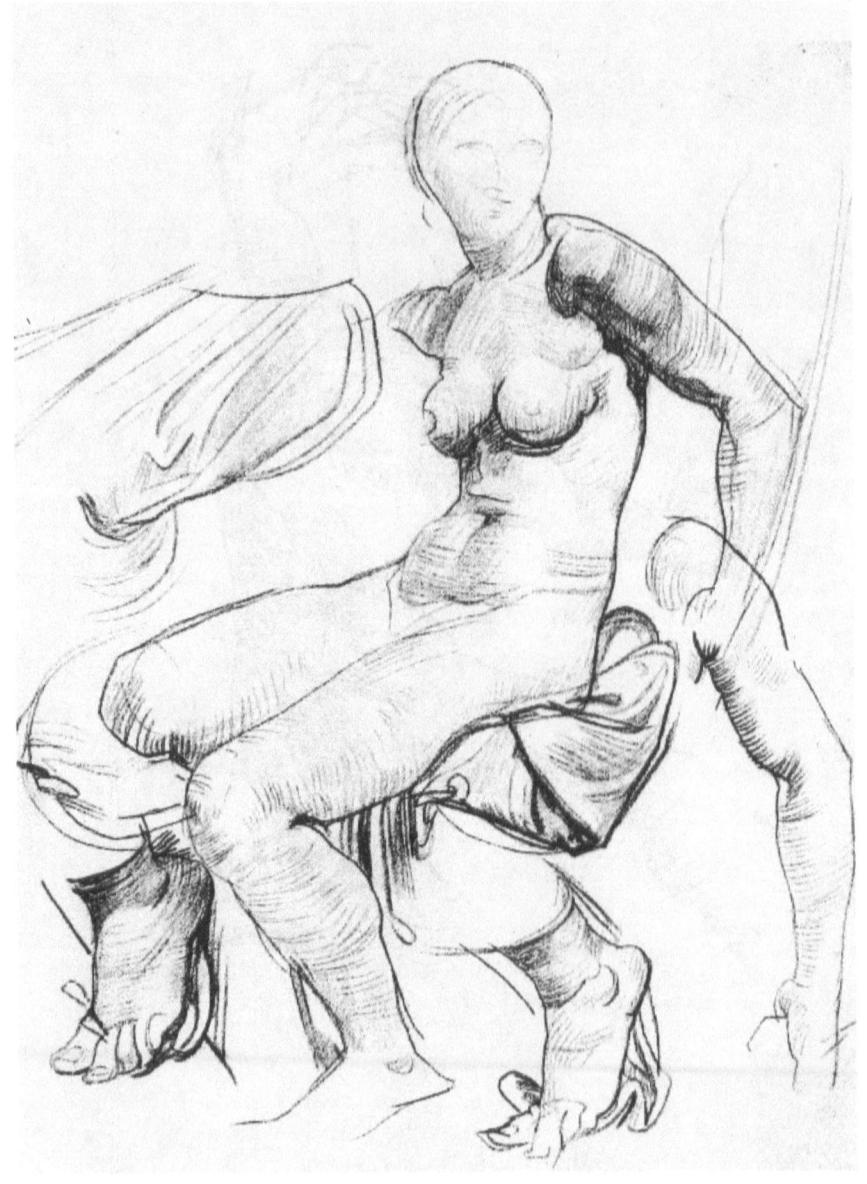

Fig. 62—A drawing in red chalk by Alfred Stevens. Red chalk should be avoided by *students*. The colour distracts their attention from the form.

originals to be seen in Britain. In his insistence on structure and in his tenacity he reminds one of Durer, though with an almost photographic vision, a result attained however not by stippling, but by direct and summary methods. There is a chalk drawing of the two reclining female figures from the Parthenon which must have been made at top speed and yet everything is there. The figures were indicated and their ample forms suggested by smudges of chalk, the accents of the drapery etc., being set down firmly on this preparation. Holbein must have used a similar method, for several of his portrait heads show the silvery shading done with stump or finger the pen drawn accents of the features for some reason having been omitted.

Menzel's methods must have aroused much interest on the continent which perhaps account for the exclusive use of charcoal, a favourite medium of his, in the art schools. Menzel spared no pains to get on intimate terms with his subject material, the current military and court life of Germany, the most exacting in details of equipment and social custom. His importance as historian was acknowledged, and on several occasions important conferences suspended their business, while Menzel took out his sketch book and made notes of costumes or grouping.

In England, of the brilliant group of portrait painters, Gainsborough is most famous for his drawings, perhaps because he had more time. He obtained a beautiful silvery quality but the portraits are rather quick sketches for composition than studies of form, and the same may be said of his landscapes.

The illustrators of the sixties the magazines of which period should be bought and treasured by every student of figure composition, Millais, Charles Keane, Fred Walker, Sandys, and many others, by their enthusiasm made that decade perhaps the brightest in the history of British art. The illustrations are really drawings though at second-hand through the medium of the engraver. The ignorant and youthful student on turning over the pages of these magazines glances at the pegtop trousers and crinolines, and pronounces the illustrations old-fashioned. The fashions however are nothing, the art is everything, and the student must look beyond the one to absorb the other. The period is not yet far enough removed as is the dress of the eighteenth century, to seem romantic.

It must be remembered that these draughtsmen had not the freedom of the present-day men to draw to what scale they liked, but drew on the wood the actual size of the print and in reverse, which sometimes added immensely to their difficulties.

Turner left the nation thousands of sketches, an astonishing number when his output of what he considered finished work is considered. He influenced Ruskin who emphasized the need for close study of growth and structure. Of late his art teaching in this direction has been somewhat ignored partly because he advocated the copying of bits of Durer etc. But he gave reasons for all his exercises and not a few have never acknowledged or perhaps even understood their debt to his teaching. Turner himself as Ruskin has pointed out, in his drawings of landscape displayed ex-

FIG. 63—A drawing on dark paper of an old woman's head by Matthias Grünewald. A work of great vitality and force. The skull high at the back as in women shows clearly through the head covering which, though the draughtsman must have been quite familiar with, he draws with inquisitiveness as if he had seen it for the first time—the right attitude for a student of drawing. [British Museum.

Fig. 64.—The reproduction does not give a good idea of the delicacy and silvery quality of this silver point drawing by Lorenzo de Credi. [British Museum.

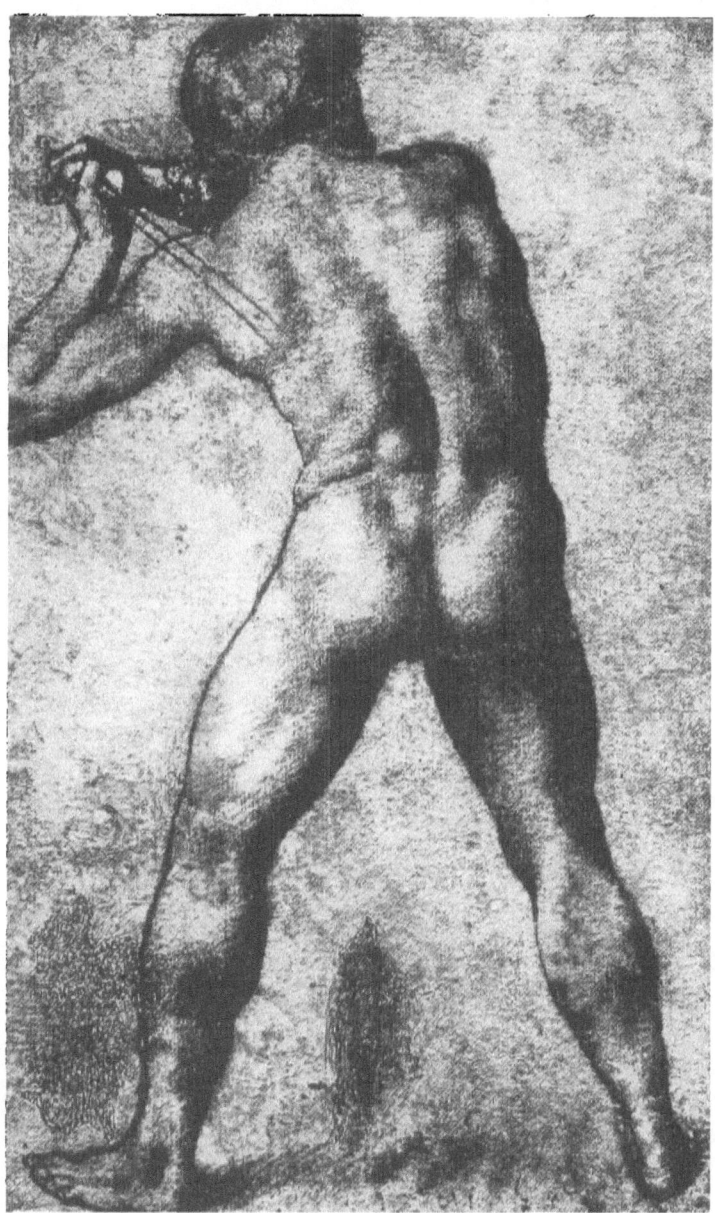

Fig. 65—A drawing in red chalk by Giorgione of a nude in strong action. The dominant line of the pose starts with the head and then travels down the neck along the spinal column to the legs. The head, hands and especially the feet shew less observation than the torso and limbs.

Fig. 66—A composition by Fragonard. An example of drawing with the brush. The abrupt square rhythm of stroke is very evident. The drawing is full of movement, secured by giving the "directions" their full degree of obliquity. [British Museum.

traordinary knowledge of the structure of natural form; the lie of the ground, the cleavage of rocks, the folds of the hills he made clear, and was equally at home in showing the perspective and arrangement of cloud forms and the movements of water. He had a keen perception of rhythm and a profound understanding of composition. He made the salient points of his masses whether mountain, trees, or city wall conform to large invisible curves, and was master of the art of leading the eye into the picture to some desired point.

Of drawings by modern masters those by Lord Leighton are well known by reason of their frequent reproduction, and exhibition in schools of art. His early drawings of plant forms were in line with Ruskin's teaching.

Delicacy and precision are shown in FIG. 59, yet a full range of curve and movement is given to the stalks and leaves. The emphasis though not insisted upon is sufficient to detach the forms. The subtly varying lines of the flower stalks should be noted. The arrangement of the flower heads has been observed. No two are on a level and the spaces between are unequal.

Leighton's drapery studies (FIG. 60) show a technique which has been widely adopted. They were made with black and white chalk on brown paper. He took pains to understand the forms under the drapery, sometimes making a preliminary drawing from the nude. The study must be looked upon as a working drawing, to be used in a painting, and therefore giving the fullest possible content of forms, which accounts for its over accentuation.

Alfred Stevens has already been referred to. FIGS. 61, 62, should be studied carefully. In FIG. 61 movement and structure were the pre-occupation of the master. It should be noted how the curved form grasped by the model, dominates the pose, a curve repeated in reverse by the figure. The joints are well marked. The line of the arms is continued across the shoulders and back. The repeated attempts to place the right arm and hand show that the involuntary movements of the model were seized on to give increased vitality to the pose. Stevens was one of the few draughtsmen who give *all* the movement the human figure exhibits.

In FIG. 62 the shade lines are used to suggest the planes, and to give the weight and solidity of the body, which is insisted upon as much as in any "cubist" drawing. A curious instance of academic "shading" occurs in the rendering of the left shoulder. In the arm repeated below, the linear method is reverted to. The amplitude of the forms should be noted.

Whistler is said by Cuneo to have deprecated the study of drawing as practised in the art schools yet his numerous drypoints and lithographs which are essentially drawings prove him to have exploited drawing to the utmost. He cannot be called a skilled draughtsman, and the structure and details of the hands in his portraits gave him great trouble, yet he will always be studied for his delicate perception of the sinuous and flexible in line, of the gradation of tone and the value of the right place of accent. According to Mempes he once described his method of drawing which however went on all fours with that of other masters. He first

Fig. 67—A sketch in pen and ink and wash by Guercino. Everything is subordinated to the action and rhythm of line and the placing of the accents of dark. [British Museum.

Fig. 68—A wonderfully detailed drawing by David Loggan. The head seems too low in the oval. "Dynamic Symmetry" might be able to show that this is so because the features do not happen to coincide with important divisions of the rectangle enclosing the ellipse. [British Museum.

placed his focus of interest, it might be a figure, tower or bridge, where he wanted it. From this he threw lines establishing the masses of his composition, and his mind at ease he went on to express in detail whatever part he chose to work at. Reference is made elsewhere to the way he trained his memory.

While so many masters must be omitted necessarily, one may barely mention Vierge that master of line and of the placing of darks. His work should be closely studied by all illustrators.

This chapter will close without any reference to living masters or to new movements in the study of form, though the student will take a keen interest in the controversies of to-day and will certainly admire and perhaps found himself upon the work of those whom he feels most in sympathy with. The omission must not be taken as implying that there are no great draughtsmen living, or that the new movements are negligible.

But all in these pages has been concerned with form in its three-fold aspect of movement, structure and appearance as revealed by light. If the student has been well grounded on some such lines, the new theories of form will have no terrors for him, nor will he be confounded by their results; but it is evident that in this book only those methods which have been sanctioned by the practice of the long line of masters could have been dealt with.

INDEX.

N.B.—The figures in heavy type indicate those pages on which Illustrations occur.

Anatomy, 94, 98
Animals, 118, 127, 120, 123
ARTISTS :
 Botticelli, 4
 Correggio, *Frontispiece*
 Crawhall, 109, 115
 Degas, 3, 196
 Durer, 4, 171, 176
 Fragonard, 204
 Gainsborough, 199
 Giorgione, 203
 Giotto, 182
 Grünewald, 201
 Guercino, 5, 91, 207
 Holbein, 4, 90, 150, 152, 172, 173, 182
 Ingres, 4, 185, 194
 Leighton, 189, 190, 205
 Leonardo da Vinci, 174, 182
 Loggan, 208
 Lorenzo de Credi, 202
 Maclise, 38
 Menzel, 196
 Michael Angelo, 177
 Millet, 186, 195
 Raphael, 178
 Rembrandt, 4, 5, 184, 188
 Reynolds, 89
 Rubens, 5, 179, 180, 183, 187
 Ruskin, 27, 132
 Stevens, 153, 197, 198, 206
 Velasquez, 191
 Vierge, 209
 Watteau, 82, 193
 Whistler, 206
 Assyrian Bas-Relief, 167, 175
 Athenian Vase, Drawing from, 168, 175

Backgrounds, 60
Bias of Vision, 7
Birds, 120, 121
Botticelli, 4

Chalk Drawings, 99, 100, 171
Charcoal Studies, 41, 42, 47, 48, 54, 63, 69, 70, 92, 116
Chinese Drawings, 110
Clouds, 27
Composition, 5, 139
Construction, 30—33
Convention, 151—160
Correggio, *Frontispiece*
Costume Study, 142
Crawhall, 109, 115
Cylindrical Forms, 23, 24, 25

Degas, 3, 196
Design, 139
Durer, 4, 171, 176

Edge Study, 85
Etching, Pencil Studies for, 154, 155

INDEX.

Face, 22
Figure Studies, 19, 20, 32, 49—84, 53, 54, 55, 59, 63, 64, 70, 92, 118, 119
Figure, Time Sketching, 73—79
Form, 103—106
Form, Search for, 39, 61-72
Fragonard, 204

Gainsborough, 199
Giorgione, 203
Giotto, 182
Grünewald, 201
Guercino, 5, 91, 207

Head, 22
Holbein, 4, 90, 150, 152, 172, 173, 182

Illustration, Drawing for, 161—165
Ingres, 4, 185, 194

Japanese Drawings, 110, 113, 114

Landscape, 128—132
"Lay in" of Oil Study, 141
Leighton, 189, 190, 205
Leonardo da Vinci, 174, 182
Light and Shade, 34—46, 41
Loggan, 208
Lorenzo de Credi, 202

Maclise, 38
Memory Drawing, 107—117, 119
Menzel, 196
Michael Angelo, 177
Millet, 186, 195
Movement, 51, 52, 53

Oil Painting, 141, 144

Painting, Drawing as a Preparation for, 140—148, 141, 142
Pencil Drawings, 43, 44, 156
Perspective, 14
Planes, 22
Plant Form, 133—139, 124, 137, 138, 189
Post-Impressionists, 7
Proportion, 3, 13—21

Quadrupeds, 29

Raphael, 178
Recumbent Forms, 20, 28
Related Figures, 80—84, 81, 82
Rembrandt, 4, 5, 184, 188
Reynolds, 89
Rubens, 5, 179, 180, 183, 187
Ruskin, 27, 132

Sincerity, Quality of, 3
Stevens, 153, 197, 198, 206
Still Life, 42
Style, 4
Sub-consciousness, 11

Tone Study, 34—46
Toned Paper, drawing on, 101 102
Type Forms, 22—29

Velasquez, 191
Vierge, 209
Vision, Bias of, 7—12

Water Colour Drawing, 142, 149
Watteau, 82, 193
Whistler, 206
Wrist, 26

www.ingramcontent.com/pod-product-compliance
Lightning Source LLC
Chambersburg PA
CBHW020901180526
45163CB00007B/2588